Philosophy of Ancient Indian Education and its Reflections on Swami Vivekananda

Ambill S.

CONTENTS

		Page
Preface		*i-iii*
Chapter I	**Introduction**	**1-19**
1.1	Relation between Philosophy and Education	3
1.2	Relation and aim of education in life	4
1.3	Protection and enhancement of culture and civilization	5
1.4	Cultural objectives of education	6
1.5	Theme Presentation	7
1.6	Aims and Objectives	14
1.7	Review of Literature	15
1.8	Methodology	16
1.9	Lay out of thesis	16
Chapter II	**Philosophy of Ancient Indian Education**	**20-61**
2.1	Uniqueness of Ancient Indian Education	23
2.2	Concept of Vidya	26
2.3	Teachers	27
2.4	Ancient Indian Theory and Education	28
2.4.1	Three Debts	28

2.4.2	Life and Values	29
2.4.3	Concept of Truth	29
2.5	Aim of Education	30
2.6	Period of Ancient Indian Education	30
2.7	Vedic Period	31
2.7.1	System of Education	33
2.7.2	Evaluation system in Vedic period	34
2.7.3	Vocational Education in Vedic Period	37
2.8	Period of Upanisad	39
2.8.1	Theme and Message of Upanisad	40
2.8.2	System of Education	40
2.9	Manu Panini Period	43
2.9.1	Educational Institutions	43
2.10	The Epic Period	47
2.10.1	Bhagavad Gita and Relevant Themes	48
2.10.2	Aims of Education in Gita	49
2.11	Concept of education in Jainism	51
2.11.1	Aim of Education	52
2.12	Buddhist Period	52
2.12.1	Philosophy of Buddhist Education	54
2.12.2	Method of Teaching	57
2.12.3	Debates and Discussion	58
2.12.4	Nalanda University	59

Chapter III	Western Perspectives on Education	62-95
3.1	Modernism and Education	68
3.2	Marxian concept of Education	71
3.3	Language analysis and Education	74
3.4	Post modernism and Education	76
3.5	Idealism	78
3.6	Naturalism	80
3.7	Realism	82
3.8	Perennialism	85
3.9	Pragmatism	86
3.10	Essentialism	89
3.11	Progressivism	89
3.12	Behaviorism	90
3.13	Humanism	91

Chapter IV	Educational Philosophy of Swami Vivekananda	96-139
4.1	Philosophy of Education	100
4.2	Means of Education	106
4.2.1	Freedom in Education	108
4.2.2	Vivekananda's Concept of Curriculum	108

4.2.3	Medium of Education	110
4.2.4	Physical Education	111
4.2.5	Moral and Religious Education	111
4.2.6	Teaching and Learning	114
4.3	Synthesis of Science and Vedanta	117
4.4	Concentration : The Essence of Education	118
4.5	Aim of Education	122
4.5.1	Proximate aims of Education	122
4.5.2	Ultimate aims of Education	123
4.6	Education for Character Formation	125
4.7	Fulfilment of Svadharma	127
4.8	Education of Self Development	128
4.9	Education for Realization	129
4.10	Education of Women	130
4.11	Education of the masses	131

Chapter V	**Educational Philosophy of Rabindranath Tagore**	**140-197**
5.1	Literary Movement	145
5.2	Tagore's Philosophy of Education	145
5.3	Aims of Education	158
5.3.1	Integral development	161
5.3.2	Physical and Mental aim	162

5.3.3	Moral and spiritual aim	163
5.3.4	General Aim	164
5.3.5	Harmony with environment	166
5.3.6	Education of the whole man	166
5.3.7	Education for Individuality	167
5.3.8	Education for freedom	168
5.3.9	Education for aesthetic and Creative development	169
5.3.10	Education for social awareness and national integration	170
5.4	Means of Education	171
5.5	Mass Education	172
5.6	Harmony and love between man and nature	173
5.7	Freedom of mind and world peace	174
5.8	Educational Trinity	175
5.8.1	Santhiniketan	175
5.8.2	Viswabharathi	181
5.8.3	Sriniketan	186
5.8.4	SikshaSatra	189

Chapter VI **Conclusion** 198-221

Bibliography 222-232

CHAPTER – 1
INTRODUCTION

The philosophy of education in India is rooted in Indian culture. The basic character of Indian culture is its integral approach to life. The integral approach of education is the perfect blend of idealism, pragmatism, rationalism and humanism. It brings out the unity in diversity which enables the harmonious co-existence of the individual, the society and the nature. The function of education is to ignite the process of the thinking in individuals and generate fearlessness in pursuit of truth, compassion and fraternity in dealing with fellow-men, science instead of superstition, rationality in the place of obscurantism, strength and effort to realize the divinity. The major objective of education is creation and transmission of knowledge.

Education is the manifestation of the inherent potentialities in man. It is a labour "that changes an ideal into real making what is potential into an actual transfiguring the natural man into a spiritual man" (Rosenkranz 55). The aim of has two aspects collective aspect and an individual aspect. From the collective point of view education is expected to turn the individual into a good citizen i.e., a person who has harmonious relation with other members of community, who is useful to society and fulfills his obligation as a citizen. On the other hand it may be expected that education will give to the individual strong and healthy body, help him in building up his character and training in self mastery, and provide him good opportunities for discovering and developing his natural abilities. Life is a great gift and an

important objective of our existence is to be happy ourselves and contribute to make others happy. Education helps us in this endeavor.

The word education has its origin in the Latin Word "educatum", composed of two terms 'E 'and 'Duco' . Education imphes a progress from inward to outward while "duco" means developing or progressing. In its most literal sense, education means becoming developed or progressing from inside to outside. Thus education is the processes of developing inner abilities and powers of an individual. Education is both retrospective and prospective. It is both conservative and progressive. Education transmits the culture of one generation to the other. Education takes place when present ideas combine with the old, something new is constructed by the synthesis of the two and this process go on through life and for life. This means that education is a continuous reorganization and integration of activities and experience. It is a constructive agency for improving individual and society.

Education is defined as acquisition of knowledge in relation to the definition of philosophy as love of knowledge. The famous Greek philosopher Socrates had said 'Virtue is knowledge and he who is knowledgeable is virtuous and just'. According to Francis Bacon 'Knowledge is power and knowledge of the universe around is instrumental for the progress of society'. The Bhagavad Gita says, 'knowledge makes a person Sithaprajana, a person of equanimity, poise and mental balance'. Hence the concept of education as acquisition of knowledge was prevalent since the dawn of civilization.

"The primary aim of philosophy is knowledge of being or reality which is more comprehensive, fundamental and ultimate than the knowledge which can be provided by the

organs and methods at the disposal of the special sciences" (Dewey, *Problems of Man* 5) .The traditional view of philosophy is that it is composed of four major branches: Metaphysics, Epistemology, Logic and Axiology. These divisions of philosophy relate education very directly.

1.1 Relation between Philosophy and Education

The relation between education and philosophy depends on the meaning attributed to philosophy. Philosophy determines goals of life and education is an attempt to realize these goals. According to Henderson "educational aims cannot be determined apart from the ends and aims of life itself, for educational aims grow out of life's aim. To determine what constitute worthy living has been one of the chief tasks of philosophy" (Henderson 105).

Philosophy is said to be the contemplative or speculative side and education is the dynamic or active side of life. In the words of Sir John Adam Smith "Education is the dynamic side of philosophy" (Sindhu 105). Philosophy and education are the two sides of the same coin. Philosophical outlook proceeds educational effort and educational effort precedes from philosophical outlook. The dynamic relation between philosophy and education was visualized by John Dewey, "Philosophy is the general theory of education" (Dewey, 30).

Education is a practical activity of philosophical thought. Education is a set of techniques for imparting knowledge, skills and attitudes. In other words philosophy is the foundation and education is the superstructure, i.e., "without philosophy, education would be a blind effort and without education philosophy would be a cripple" (Aggarwal, *Principle of*

Education 45). It may be said that philosophy of education is the application of philosophical ideas to educational problems. The practice of education will lead a refinement of philosophical ideas.

1.2 Relation of the aim of education to life

The early notion was that man has to fight with the nature to ensure his existence. But in the changing scenario it is understood that man has to live with the nature for his existence sustenance and also to ensure the successive generation to exist. The aim of education is determined by human life.

Human beings always live in group because they cannot fulfill many of their needs alone. Social life is based upon the fulfillment of certain duties, responsibilities and obligations by the individuals. Hence the objectives of education are to train the individual to lead a fruitful social life. Education is the mirror of society and the progress of the latter depends on the former. The formulations of educational aims have been done by parent, philosopher, ruler, politician and thinkers.

- Education provides opportunities for spiritual development of the individual.
- Education provides opportunities to the individual for the attainment of values of life.
- An individual should be able to perfect himself in the field he chooses to be in or the circumstances throw him in.
- Education should provide opportunities for mental and intellectual growth.
- With the help of education, individual should be able to improve upon his conduct and moral character expected of him in the prevalent society.
- All-round and balanced development of all the faculties of the individual.

- Education should enable attainment of right judgment and appreciation in the individual.
- Education should bring the feeling of universal brotherhood and sociality.
- The education of the individual in the society has the following aims.

Whatever is acquired in human life is the result of formal or informal education. When the child is born he has no knowledge of his surroundings. Gradually he comes to recognize his environment by using his sense organs and by coming in contact with other people.

1.3 Protection and enhancement of culture and civilization:-

As compared to other animals man has progressed more because human society has succeeded in protecting its knowledge and in conveying it to future generations. This has been done through the medium of culture and civilization. A child born in the present time does not think of everything from the beginning. His thinking and modes of behavior are determined by customs, traditions and social institutions, which are the repositors of experience and thinking of his ancestors. For this reason societies which have a more ancient culture show signs of greater organization, systematization and greater stability. Hence it is now universally accepted that culture and civilization should be protected and allowed to grow through new developments. This is mainly achieved through education. The child receives the social heritage in the form of education. Through education the child develops his own knowledge, character and personality and becoming capable of contributing to the cultural and social life of society. Developments in art, literature, sciences etc. were all the efforts of educated people.

The educational institutions in ancient India were Gurukulas, where the initiation of learning could be at home by the father or by a teacher, who runs the residential school known as the Gurukulas attached to his house or ashrama. It is reasonable to assume that some of the moral attributes and mental disciplines insisted up on as are pre-supposition of the instructions. They are actually preparatory means to the goal of human life, the realization of the knowledge of Brahman, rather than the pre requisite for successful career in the material worldly life. The Indian educational system advocated by the ancient gurus was not merely a means for a successful worldly life limiting to a certain age of life, but a means to embrace the entire course of life consisting the four successive Ashramas that ultimately leads to Atman. Thus education aimed at in the Upanisads call for the application of the whole life through all its stages. The Vedic education was imparted or presented and transmitted through various organizations and institutions developed in the course of time known as Gurukulas, Sakhas, Ashramas, Parishads, Gothra, Agrahara, Mutts, Ghatikas and Salas.

1.4 Cultural objectives of education

The first factor in the cultural objective of education is the transmission of the social heritage from one generation to the next. Education aims at imparting values, traditions, customs, and pattern of life etc. of the particular social group to the child so that he can conform to these patterns and make his own contribution to the cultural development of his group. In the second place the objectives of education is to lend sophistication, grace and polish to the child's behaviour. But in this respect there are differences of opinion. Hinting at this difference Vivekananda commented to an American lady, "madam in your country it is the tailor who makes a man cultured and gentleman but in my country it is the character which

makes a man cultured and gentleman'. Recognized patterns of behavior, such as greeting a stranger, showing respect to one's elders, showing love and affection etc. vary from culture to culture. Hence education aims at acquainting the child with the patterns recognized in his own society. Obviously, then culture can be interpreted liberally as well as narrow mindedly. In its more superficial and limited sense, culture implies the mode of dress, external manifestations of behavior etc. but in its broader and more liberal sense culture implies values, thinking, self development etc. Consequently the possession of a certificate of formal education is no guarantee of culture, because culture can be found only in that individual who has achieved some degree of self development, both mental and spiritual and has some notion of values of life.

1.5 Theme Presentation

Indian systems of education have conformed to the ideals and objectives of our life, culture and tradition. These ideals and objectives have changed from time to time. It was influenced by the Vedas, the Upanisads, the Puranas, as well as the orthodox and unorthodox schools of philosophy. The Buddha and the Mahavira, and a large number of known and unknown sages and philosophers contributed to shape and modify it. We cannot point to a fully articulated and monolithic structure of thought that can be regarded as the Indian philosophy of education. From the diverse discussions on education by different sages and philosophers built up a concept of dharmic society and a well fare state.

This ancient Indian Education is an outcome of the Indian theory of knowledge and a part of corresponding scheme of life and values. Indian education takes full aspects of man which indicates both life and death. This gives a clear perspective and dimension to

differentiate material and moral, physical and spiritual, temporal and permanent values in life. The most significant feature of the ancient Indian outlook on life was its comprehensiveness. It sought to hold all levels of life with all its diversities in one common unity. The concept of the world as a dynamic movement or samsara is found in almost all schools of Indian philosophy. The belief in the continuity of life beyond the grave is an essential ingredient in Indian thought. Atman migrates after death into new bodies of living being, of animals or even of plants. The ancient Indian belief in the indestructibility of the soul as well as actions of individual found its most characteristic expression in the doctrine of Karma. Education was thus the key to man's self fulfillment. It could serve its purpose only if it took due cognizance of the different elements and levels which together constitute the human personality.

The concern of ancient Indian thought in the development of the total human personality expresses itself in many diverse ways. One of the most interesting classifications in Indian traditional philosophy is the concept of the four Ashramas. These Ashramas correspond to four stages through which the individual was required to pass through in the ideal life cycle of his existence in this phenomenal world. The first stage was the stage of Brahamcharya or the life of education and preparation, the second was that of Garhastya or life of the house holder where he performed his social duties and acted as an earning member of the community. The third stage was the stage of vanaprastha, life of retirement and meditation. when he gradually withdrew from his personal benefits to fulfill his social obligation in the role of a member of the society. The fourth stage was Sanyasa when he entered a saintly life of renunciation and cut off all social and family ties in order to attain moksha. Thus he had to serve as an apprentice in the school of life, discharge his duties to

family and society and remains as an elder but detached member of the community prior to seeking individual moksha. Chanakya has described it humerously but succinctly in a verse.

> Prathamena arjitha vidhya
> Dvitiya na arjitha dhanam
> Tritiya na arjitha dharma
> Chaturtha kim karishati ?

(If learning is not acquired during the first, wealth during the second and virtue during the third, what an ancient man going to do during the fourth stage of his life.)

The concept of education as an all inclusive process is seen in the list of subjects which ancient student had to study before he was considered fit for receiving instructions in the knowledge of Brahman. The Upanisads divide all knowledge or vidya into two broad categories, namely Para vidya and Apara vidya. Paravidya is known as higher or spiritual knowledge; it reveals unity and oneness with the absolute. Aparavidya is known as lower or empirical knowledge and is associated with diversity and multiplicity of the phenomenal world. Aparavidya or subsidiary knowledge is divided into a number of classifications varying with different schools of thought. Some have regarded even knowledge of vedas and vedangas are aparavidya. The term Veda is extended to sciences which have nothing to do with religion. Thus there are references to dhanur- veda or the science of archery, ayur veda or medical science and so on. Even erotic becomes subject for detailed study in ancient times and we find it in Vatsayana's *Kama sutra* which is the most elaborate study of the psychology and the practice of sex. Vatsayana held that "every art is based on an underlying science which should be explored and cultivated". (Ramakant 65) Man's life of passion must be preceded by a life of study, self control and cultural training.

Bhagavad Gita is the part of *Mahabharatha* which express divine compassion for humanity, nishkamakarma and svadharma. In the modern times when all the efforts of world peace seem to rest on walls of sand, Gita's teaching of universal brotherhood may very well guide humanity. The ultimate end according to Gita is the consolidation of society. Gita has not only preached for the welfare of human being but even that of all living being as such it advocated integral perfection. It preaches renunciation through action.

Indian philosophy regarded education as essentially a process of drawing out what is implicit in the individual. It develops his latent potentialities till they become actualities. The implication of this has not always been fully realized. If education is the enfoldment of personality, it cannot be equated to mere training for vocation. All schools of Indian thought hold that human life is a great gift and opportunity. It is a great gift because man is regarded as the crown of all creations. It is a great opportunity because man can develop his power by knowledge and virtue and thus free himself from ignorance and attachment. Man can thus attain to Godhead and acquire ultimate knowledge, power and bliss through his efforts.

Indian philosophy of education emphasises the principle of samanvaya or cooperation as the guiding principle of education. Education in its true sense must recognize fullness of expression as fullness of life if it is to help man to achieve internal poise and external harmony. Inner poise can be achieved only if the different elements in man's nature are developed in a balanced and integrated form. External harmony depends on man's adaptation to his physical and human environment and realization of the unity of all knowledge and all being. Education must therefore take note of not only his body, mind and

soul as an individual but also of the cooperate activities which bind him to his fellow to the society.

Comprehensiveness as the basic principle of education is also seen in the definition of four fold aims of life. They are Artha or wealth, Kama or enjoyment of desires, Dharma or the attainment of moral virtue and Moksha or liberation from attachment and suffering. The Indian outlook on life is often represented as one of unqualified asceticism. The social obligations of the individual is even more clearly seen in the conception of the three kinds of debts which he must discharge before he is entitled to renounce his worldly ties. He must discharge his obligation to the Gods, to the sages and his forefathers. The debt of Gods is discharged by sacrifice which may in modern term translate as worship and reverence for the absolute. The debt to the forefathers is discharged by undertaking the obligations of parenthood, so that human species may continue. Education was essentially the training which prepare the individual for the discharge of all these three debts. The individual must lead a family life so that the blood lineage of his forefathers is continued beyond him. He must acquire knowledge and extend its frontiers so that the cultural and social heritage of man is preserved and enriched. He must have a sense of reverence and worship so that he may live in harmony with man and nature and achieve his unity with the heart of things.

The philosophy of Swami Vivekananda is a gospel of humanism; man is fulcrum of his life and teachings. Man, manliness, man – making these were his constant manthras. It arised from his own realization of the divine that exists in himself and all. He therefore raised the dignity, mystery and worth of man to the pinnacle of divine excellence. To him the final goal of education is the realization of the self ie, realization of the perfection already in man.

He advocates a type of education which is man making, life building and character making process. Education should also help for the development of originality, excellence and creativity. It should unfold all the hidden powers in man. A child should learn to accept pleasures and pain, misery and happiness as equal factors in the formation of character. What India needs today is c strengthening of will. This can be achieved through man making education.

According to Vivekananda the medium of social reform was education. In trying to improve socially oppressed poor people, he wished to bring a total change in their outlook and thus root out the cause of their degeneration. Speaking on educational scheme for India, Vivekananda said "what we want are western science coupled with Vedanta, Bramacharya as the guiding motto, and sraddha and also faith in one's self. These constitute the mechanism by which perfection or goodness is realized in individual and social life" (*Complete Works* Vol. V. 336). Vivekananda laid great emphasis on Guru Grihavasa. In this Gurukula system the people served the teacher, who in his turn helped the pupil to achieve knowledge. There is no economic relationship between the teacher and the taught. He held that renunciation and service are the national ideals of India. In his philosophy of education Vivekananda synthesized spiritual and material values. He felt that India needed a system of education based on the ancient Vedanta but at the same time worthy of making individual earn his livelihood so that the country may progress. He maintained that no profession is bad provided it is done with a sense of service and sacrifice. "What a man learn is really what he discovers. by taking the cover off his own souls. which is a mine of infinite knowledge" (Ramakant 93).

Rabindranath Tagore's philosophy of education aims at developing a system of education for human generation. Man is in the centre of all his thinking, his philosophy, literature, poetry, social activities and educational programme. He is considered as humanist and an integral humanist. The basis of his educational system based on essential human virtues such as freedom, purity, sympathy, perfection and universal brotherhood.

Santiniketan, Viswabharathi and Sriniketan together constitute Tagore's educational trinity. Through his education trinity, Rabindranath Tagore tries, to develop an ideal system in India. His aim of education is one of the most comprehensive, including various aspects of human personality and different strata of Indian society and world community. He lays emphasis on physical, mental, moral, religious and spiritual aspects of man. Thus he developed his plan on a very holistic perspective. His educational plan is activity oriented. It develops an all round human personality. Freedom is the key note of Rabindranath Tagore's system of education. That means all sorts of freedom, intellectual, decision, knowledge, action and worship. This freedom can be achieved by the practice of equanimity, harmony and balance.

Tagore placed great stress on the relation of education to human environment. Emphasizing on life of the individual and of the rural masses he want to develop a sort of communities with man and nature. To him education must be inspired by a philosophy which seeks fulfillment through harmony with all things. He declared that the mission of all education is to lead beyond the present and achieve points of view which include the past and future as integral part of the present. "To attain full manhood is the ultimate end of education" (N. Dash 43).

1.6 Aims and Objectives

The major aim of this thesis is to understand the philosophy of Indian education conceptualized by Swami Vivekananda and Rabindranath Tagore.

The objectives include.

- To understand the nature of philosophy of ancient Indian education and its scope.
- To highlight the educational practice present in the period of Vedas, Upanishads, Manu Panini period, Epic period and also Jainistic and Buddhistic and approach.
- To explore the features of Gurukula education
- To analyse and compare the theories and principles of education put forth by western thinkers, from early Greek to post modernism, with the education philosophy of eastern thinkers.
- Analyse the metaphysical, epistemological and psychological schools of thoughts and educational philosophies on Western context.
- Highlight the educational principles of Swami Vivekananda and its significance in the contemporary Indian context.
- To examine the status of Vivekananda's Man making education in the 21^{st} century.
- Significance of Mass-education and its possibility.
- To understand the nature and scope of philosophy of education by Rabindranath Tagore.
- To understand the philosophic under currents in Tagore's educational ideas.
- Efforts to highlight the Universal brotherhood.

* To understand the educational practice at Shantiniketan, Sriniketan and Viswabharathi.
* Highlight the similarities of Vivekananda and Tagore, on their thoughts on education and its relevance to modern Indian education system.

1.7 Review of literature

The primary sources which are available and relevant to the topic are as follows.

Complete works of Swami Vivekananda (1964), Vedanta and the Future of Mankind (1993), Thoughts of Power (1192), State, Society and Socialism (1989), Practical Vedanta(1958) and a large number of articles and books on Vivekananda and Indian philosophy on education which are referred in the running text and given in the bibliography of give a clear account of the various ideas about his educational philosophy.

In addition to Rabindranath Tagore's major works like Creative Unity (1929), Sadhana – The Realization of life (1954), Religion of Man (1993) , Githanjali (1912), Personality (1961) articles and books which are reviewed in various chapters of thesis. To draw significance of the educational philosophy of Rabindranath Tagore with relevance to the present investigation.

The work such as Manusmriti of Manu, the Astadhyayi of Panini (1891), Kautilya's Arthashastra (1929) of Shamashastry, The Mahabharata (1919), The Ramayana (1915) and The Bhagavad Gita are of great value to understand the concept of knowledge its genesis and its transmission in ancient India.

1.8 Methodology

The methodology used in the preparation of the thesis is descriptive analytical and comparative. The nature of the study is explanatory utilizing the original works and writings of Swami Vivekananda and Rabindra Nath Tagore. It is analytical as far as it identifies and describes the various educational views of those two philosophers. It is an effort to compare and contrast the educational views of Vivekananda and Tagore have conducted in depth study on the educational concepts of eastern and western philosophies.

For citations and references. the 7^{th} edition of MLA Handbook on research methodology is followed. In text citations, author's last name followed by the page number referenced in the work has been used. The reference in the running text or maintained and quotes are given in parenthesis at the end of the sentence. In the reference list at the end of the chapter corresponds to the parenthetical reference in the text. In some places, where the author's name is repeated in the narrative, only the page number appears in the parenthesis. Each note is also given at the end of each chapter for necessary descriptions. For titles and sub titles, numbering system is followed. Consolidated references of the dissertion are given separately as bibliography at the end of the thesis.

1.9 Layout of the Thesis

Chapter 1 is an 'introduction' to the thesis. It deals with the general aspects of Philosophy of education including its aims and objectives, the relation between philosophy, education and culture and analyse the salient features of human mind. Chapter 2 is entitled as the 'Philosophy of Ancient Indian education', tracing the roots in Vedas, Upanisads, and

Epics, mainly Panini period, Buddhist literature etc. It also deals with the aspects of cultural, social, religious and moral outlook in education. It is also attempt to explore the features of Gurukula educations.

Chapter 3 under the title 'Western perspectives on Education' gives a comprehensive account of occidental educational principles. It give an over view of the perspective on education given by various western thinkers from earlier Greek to post modern times. An account of philosophical schools, like realism, idealism, pragmatism and essentialism, behaviouralism and humanism are discussed in detail.

Chapter 4 entitled 'Educational Philosophy of Swami Vivekananda' focuses on the principle of man making philosophy and man making education. It highlights that education should strive towards character development by which we mean the development of will power leading to courage, stamina and fearlessness. It also focuses on value education. It is an attempt to explain that education should foster universal and eternal values oriented towards the unity and integration. Such education should help to eliminate obscurantism, religious fanaticism, violence and moral defects. It analyses, concept of Svadharma, Svadhyaya, Shraddha, Mass education, Women education, etc.

Chapter 5 is entitled as 'The educational philosophy of Rabindranath Tagore'. It is an attempt to explicit that the mission of education seeks fulfilment through harmony with all things. To attain full manhood is the ultimate end of education. His theory of education is marked by synthetic, naturalistic, aesthetic and international character. It focuses on Tagore's interpretation of education in the light of the metaphysical principle. His philosophy of

education aims at developing a system of education for human regeneration based on the virtues like freedom, purity, sympathy, perfection and universal brotherhood. It is an all round growth and development of individual in harmony with the universe. Education provides to our personality, unity, harmony and wholeness whereby no separation of relationship exist in the perfection of the intellectual, physical, social, moral, economic and spiritual aspects of human life. Through education man becomes an integrated personality. He believed that 'The widest load lending to the solution of all our problem is education'.

Chapter 6 is 'Conclusion'. It includes an indepth study of the philosophy of ancient Indian education and its contemporary relevance. It explores the nature of ancient Indian education and analyses how Vivekananda and Tagore conceptualized the ancient educational themes to modern education system. It summarizes the findings and solutions to the chosen theme of the work and also makes a comparative qualitative analysis.

Reference

Aggarwal, J C. *Theory and Principles of Education*. New Delhi: Vikas Publishing House Pvt Ltd, 2002.

Dash, B.N & Dash Nibedite. *Thoughts and Theories of Indian Educational Thinkers*. New Delhi: Dominent publishers and distributors, 2009.

Dewey, John. *Problems of Man Introductory Note. Newyork:* Philosophical Library, 1946.

Henderson. *Introduction to Philosophy of Education*.Chicago: The University of Chicago Press, 1947.

Dewey, John. *Democracy and Education*. London: Macmillan and co. N.Y 1967.

Rosenkranz, Johann Karl Friedrich. *The Philosophy of education*. NewDelhi: Cosmos Publication 2008.

Shukla, Ramakant. *Philosophy of Education*. Jaipur: Sublime Publication, 2003.

Sindu, I.S. *Philosophical and Historical Basis of Education*. Meerut: International Publishing House, 2005.

Vivekananda, Swami. *The Complete Works of Swami Vivekananda*, Vol. V. Calcutta: Advaitha Ashrama, 1993.

CHAPTER 11

Philosophy of Ancient Indian Education

The edifice of modern Indian education has been built primarily upon the foundation of ancient educational ideals. The practices of modern education have been largely moulded through the process of past experiences. As we cannot cut off the root of a live tree and still make the trunk and the branches grow, we cannot cut off the past practices from a growing educational system. India's ancient knowledge and thought process has contributed to its culture and civilization. "A philosophical tradition refers to the belief, customs, ideas and ideal and ways of thinking handed down to the people of India from generation to generation or handed down to us by ancestors" (Aggarwal 413).

We can see the influences of ancient Indian education in all spheres of modern education. In ancient India everything related to education was religious in character. The sacrificial ritual itself gave birth to some of the sciences. The elaborate rules for the construction of altars led to the science of Geometry and Algebra being developed. The desire to find out auspicious times and seasons for sacrifices and other purposes gave rise to astrology, from which Astronomy developed. The care taken to preserve the sacred text in its purity led to the development of grammar and philology while the deep questions with regard to the universe and man's place in it which were discussed in the Upanisads led to the formation of elaborate philosophical systems and the study of logic, in fact and most of the sciences as the offshoots of ancient literature.

The modern system of introducing schools in different parts of our country was actually originated from the 'Gurukula' system of education in ancient India. No doubt, Shantiniketan founded by Tagore is only a modernized form of the forest universities prevailed in ancient times. The idea of starting boarding schools in natural surrounding also copes with the principles of Rousseau, Pestalozzi etc. who were perhaps inspired by the teachings of Great Indian preceptors.

Ancient educators of India laid the greatest emphasis on the spiritual development and the formation of the character of the students. This seems to influence some of the western educationist also. According to Froebel, "to give firmness to the will, to quicken it and to make it pure and strong and enduing is the chief concern in education" (Achyuthan 90). The German educator Herbart was also a staunch supporter of the formation of character as the aim of education this rightly resembles with Manus opinion that "Conduct is the highest virtue as included by the smriti and the sruti " (90).

According to Sayana the great commentator of Vedas, there were three categories of students: The mahaprajna the Madhyama prajna and Alpa prajna ie, very intelligent, normally intelligent and sub normal respectively. According to Kautilya pupils are of three kinds, those of sharp intelligence, those of stagnant intelligence and those of perverted mind. Knowledge was imparted by the perceptors according to the ability of each pupil. Modern theory of intelligent quotient (I.Q) difference, aptly resemble with the aforesaid practices.

According to Vachaspatimisra the 'adhyayana' (the hearing of words) 'sabdha' (apprehension of meaning) 'Uda" (reasoning leading to generalization) suhrt prapti

(confirmation by a friend or teacher) and Dana (application) are the five steps for the realization of the meaning of a religious truth. Curiously enough these steps correspond wholly with Herbartian steps and with those of Dewey.

According to the modern educationists, discipline practiced in ancient India was very severe. Education would not take place in such situations. They advocate more freedom to modern scholars to develop natural resources. We can apply most of the ideals of ancient education in the present situations also. Today the relationship between the teacher and the student have changed applying the high principles of celibacy in the day to day activities of the pupil it is advisable to all modern educators to study and assimilate the worthy ideals of ancient preceptors for the betterment of their educational activities.

Philosophy in India is a practical attempt to realize truth than a mere theoretical discussion of ultimate principles. Indian philosophy began in wonder. The sages of the Veda wondered 'why the hard black cow gives the soft white milk. all rivers flow to the sea but the sea is never full'. They looked to nature with awe and wonder and tried to discover the reality behind. But the aim of this endeavour was not only to satisfy an intellectual curiosity, it aimed at finding out a way for better life, a truer, higher and more happy life. The extroversion of Vedas was replaced by introversion in Upanishads. Their aim was not only knowing but being. They wanted to realize the truth and to incorporate it in their lives. The rishis of Upanisads, prayed. 'Lead me from falsehood to truth, from darkness to light, from death to immortality'.

2.1 Uniqueness of Ancient Indian Education

India has explicitly recognized the supreme goal of life as self realization. The aim of education is the attainment of fullness of being. The special characteristics of ancient Indian educational system was that it was fully and compulsory residential. The students had to live in the house of his teacher for the whole period of his studies and learn from him not only what was taught but also observe how his teacher responded to different situations arising in daily life and learn from it, stress was laid on having a personal relation between the Guru and the Shishya. Upholding the dignity of labour, provide good training for social economic and religious duties, preservation of culture, character and personality development and cultivation of noble ideas are their aim.

The ultimate aim of Indian Philosophy is to get rid of sorrow. Ignorance is the fountainhead of this sorrow: so it is clear that mere spiritual practice will not suffice. If one wants to realize his life-mission, knowledge is equally essential. Knowledge coupled with practice, can alone enable man to attain his destination. Veda means knowledge and Darsana means the realization of that knowledge. Vedas occupy a very important place in Indian philosophy. On the basis of the respect for Veda Indian philosophical systems have been divided into two classes Astik and Nastik. According to astika darshana of education is an essentially a process of drawing out what is implicit in the individual. It develops latent potentialities till they become actual one. All schools of Indian thought except Charvaka hold that human life is a great gift and opportunity to develop his power by knowledge (vidhya) and Virtue (dharma). Thus man can attain to God head and acquire unlimited knowledge, power and bliss through his efforts. Sankhya, Yoga, Advaita and Vedanta as well as Jaina and

Buddha philosophies holds that liberation can be realized in this very life. Nyaya Philosophy as a form of direct realism stating anything that really exist is in principle humanly knowledge. Nyaya treated epistemology as pramana satra. The pramanas are perception, inference, comparison and verbal testimony. Epistemologically Nyaya developed as a sophisticated precursor to contemporary realibilism, centered on the notion of knowledge sources.

Vaiseshika system is a realistic pluralism. It emphasizes scientific thinking and is an advance on the materialistic stand point. In Vaiseshika liberation is the cessation of all life all consciousness. The liberation is the absolute cessation of all pain. The liberated saint retains his own peculiar individuality and particularity and remains as it is knowing nothing, feeling nothing, doing nothing.

Logic of Sankhya system impels to embrace idealistic monism or absolutism but it clings to spiritualistic pluralism and dualistic realism. To them bliss is the product of sattva guna, i.e. transcendental in character, kaivalya recognize absolute purusha. Samkhya Philosophy implies the logical or rational consideration of self and non – self, purusha and prakriti, without a rational thinking, knowledge is impossible. Yoga is the practical path for the realization of the theoretical ideals of samkhya philosophy. Both samkhya and yoga philosophies maintain that liberation can be attained only by knowledge. But the attainment of this knowledge requires the suppression of the physical and mental modifications and gradual control over body, senses, mind, intellect and ego so that the pure self may be realized. Yoga is the practical aspect of Sankhya Philosophy to the world. The eight fold path of spiritual practice is a singular contribution of Indian Philosophy to the world. It leads to a unique

concentration of human energy by which yogis could achieve tasks. Its aim was cessation of the various impulses of the mind and to make it calm. From Pathanjali to Sri Aurobindo Indian Yogis constantly experimented to improve the method of yoga to harness the powers in man and to transform and divinise him. In India yoga was essential for Philosophy, since philosophy was not a mere love of wisdom but a realization of ultimate reality.

Sankaracharya's Advaita Vedanta is the highest spiritual thought ever conceived by human mind. It is like a cold breeze in the hot atmosphere of mutual enmity, Jealousy, exploitation and competition. It pacifies the mind. It indicates the meaninglessness of the human efforts employed toward attainment of momentary worldly pleasures. According to Sankara a spiritual aspirant should follow the four -- fold disciplines for the direct knowledge of Brahman.

Nitya Anitya Vastu vivekam, which is the discrimination between real and unreal that is a firm conviction of the mind to the effect that Brahman is real and the manifold is unreal. *Ihamurtha artha phala Bhoga Viraga* dispassion for the enjoyment of all fruits of action here and hereafter including the life of the cosmic soul as a result of the understanding of their futility. ie, Leaving the craving for all mundane and supra mundane pleasures. *Sama Damadi Sadhana Sampad:* The six fold assets, control of the mind and senses, withdrawal of the mind, the cessation of distractions, fortitude, that is being unaffected by the pair of opposites. faith in the words of the preceptor and the Vedanta, concentration of the mind on Brahman.*Mumuksutvam:* A living desire for liberation. After the acquisition of these means, hearing of scriptures (Shravana) meditation (manana) and concentration (Nididhyasana) is necessary for acquiring knowledge.

Every school emphasized the realization of truth as its knowledge. Gautama Buddha laid more emphasis on eightfold path than the discussion of soul and rebirth. Nirvana was the ultimate end which Buddha preached. Jainas also aimed at the renunciation from all kinds of Karma. Tri Ratna, the right realization knowledge, character were prescribed for the attainment of liberation. ie. Kevala Jnana. The five means of non – violence, renunciation of lies, non – stealing, celibacy and not hoarding have been propounded and can be considered the chief means for the attainment of salvation or emancipation from this world.

2.2 Concept of Vidhya

'Vidhya' comes from the root of 'Vid' (to know) i.e. knowledge, science, learning, lore educations scholarship and philosophy. Ancient educationalist considered knowledge as the third eye of man. Vidhya shatters illusions, removes difficulties and enable us to realize the true value of life. It increases our fame, destroys our difficulties and makes us purer and more cultural Vidhya was considered to be the root of all human happiness, increasing our efficiency and enabling us to get fame and wealth by securing respect in public assemblies and royal courts. Vidhya thus promotes our material as well as spiritual welfare, both in this, as well as in the life after.

Life without Vidhya is utterly futile and worthless. One human being is superior to another, not because he possesses an extra hand or eye, but because his mind and intellect are sharpened and rendered more efficient by Vidhya. Educations remove our prejudice and make us comprehend the diverse view points. It sharpens the intellect, improves the grasping and

develops the faculty of discrimination. It protects us from falling into errors. Education strengthens our moral nature and enables to stand the severest temptations of life.

'Vidhya' was regarded as "a source of illumination and power, which transforms and ennobles our nature by the progressive and harmonious development of our physical, mental, intellectual and spiritual powers and faculties" (51). Thus the term that the ancients used namely Vidhya having multiple meanings; in its various forms, the root gives us at least five distinct meanings indicating, knowledge reality, attainment, discrimination and sublime emotion. It appears, as though the ancients used the term 'Vidhya' to cover all these meaning, each one of which has deep significance in human life and development.

2.3 Teachers

In ancient times there were four kinds of teachers (a) Guru (b) Acharya (c) Upadhya (d) Adhyapka.

Guru: - One, who is having performed all the rites with 'Garbadhana', delivers instructions in the Vedas. Literally Guru means 'great'. He was to be really great in learning and moral conduct. Manu defines a guru as "one who performs the various sacraments and provide boarding for his students" (36).

Acharya: According to Manu, Acharya is one who initiates a pupil and teaches him the Veda with the Kalpa and the Rahasya. i.e. secret portions of the Upanisads or the extremely secret explanation of the Veda or Angas. An acharya was to lead the life of renunciations although most of them used to lead a family life. Hindu cultural historians ascribe the authorship of every Sastra to one Acharya. Sometimes they were styled as Munies. Renowned Acharya

have been like Vatsyayana, the author of works on erotics, Charaka and Susruta, the author of works of medicine and surgery, Bharata the author of a work on Dramaturgy, Pingala the author of great Bhasya on grammar. Thus these teachers were of advanced knowledge. Thus Acharyas usually lived outside populous place to avoid inconveniences of city life, to concentration on student, to inculcate the habit of renunciation and simple living among the pupil.

Upadhya: An Upadhaya is one who teaches only a portion of the Vedas. According to Vishnu, he who teaches an entire Veda in consideration of fees or a portion of the Veda and any of the vedantas is said to be an Upadhaya. He takes something from his pupils for his livelihood.

Adhyapka: He is considered as an ordinary paid teacher. He has nothing new to teach to the world but only impart worldly knowledge. The term teacher is used in a highly dignified sense as well as in ordinary sense.

2.4 Ancient Indian Theory of Education

The theory of education propounded by the ancient Indians is on the basis of the following. (a) Three Debts (b) Life and Values (c) Concept of Truth.

2.4.1 Three Debts:

It is also known as rnatraya. The moment an individual is born in this world he incurs three debts. First, he owes a debt to Gods and he can liquidate it only learning how to perform proper sacrifices and by regularly offering them. Religious traditions of the race were thus

preserved. Second, he owes a debt to the Rishies, or the savants of the boy gone ages and he can discharge it only by studying their words and continuing their literacy and professional traditions. The rising generation was thus enabled to master and maintain the literacy and professional traditions. Third debt to his ancestors which can be repaid only by raising progeny and by imparting proper education to it.

2.4.2 Life and Values:

Indian theory of knowledge is a part and parcel of the scheme of life and values. Life includes birth and death and the two forms the whole truth. It gives a particular angle of vision, a scheme of perspective and proportion in which the material and the moral, the physical and spiritual, the perishable and the permanent interests and values of life are clearly defined and strictly differentiated.

2.4.3 Concept of Truth:

In this system of education, one has to study the fundamental truths of life and do not care for half truths and intermediate truths. His one aim in life is to solve the problem of death by achieving a knowledge of the whole truth of which life and death are parts and phases. He perceives, it is the individual that does not the whole or absolute. In this light the aim of education is 'chitta vritti Nirodha' , the inhibition of those activities of the mind by which it gets connected with the world of matter and objects.

2.5 Aim of Education

Aim is a fore seen and that gives direction to an activity or motivates behavior. Good arms are related to real situations of life. Since education is purposeful and ethical activity, it is unthinkable to have no definite aims of education. Aims of education provide foresight to an education planner. Certain factors have been influencing the aims of education. The prevailing philosophy of life is often reflected in the aims of education. Political ideologies social and economic problems and higher ideals of life have often determined the aims of education. In fact the supreme aim of education should be character formation of students. According to Dr. Radhakrishnan "The troubles of the whole world including India are due to the fact that education has become a mere intellectual exercise and not the acquisition of moral or spiritual values" (Bourai, 49). Today moral and social values are deteriorating. Religion is losing its hold. Power and knowledge are being misused for vested interests. Nations do not trust one another black-marketing, barbarism, indiscipline, violence and crime is spreading in our country. Knowledge has increased but morality has lagged behind. Therefore a system of education which is not clear about its aims or which bears undesirable ends is bound to fail.

2.6 Periods of Ancient Indian Education

The ancient Indian Education system is one of the oldest of the world civilization and has survived even after the repeated assaults and outraga made to destroy it from time to time. The system is followed even today in many old pathshalas and Gurukulas existing in many town and cities. Varanasi holds an important place in this regard. The glimpse of some of the

important aspect of ancient Indian education eg: observing Brahmacharya and pious relation between the teacher and the taught can still seen in these pathshalas, though the methodology and the curriculum of teaching have undergone a vast change.

The ancient Indian education has passed through the following spells.

1. Vedic Period (Pre historic period to 800 BC.)
2. Upanisadic Period (800 BC to 600 BC)
3. Manu – Panini period or sutra period (600 BC to 200 BC)
4. The epic Period (between 1000 BC to 800 BC)
5. Period of Jainism and Buddhism

It may be mentioned that neither any border line can be drawn to mark the duration of a period nor any precise division is possible. In fact there have various steams of education surfaced from time to time in ancient India. In most of the above cases also more than one stream were going on simultaneously. It is the dominance of literature and the institutions belonging to stream influencing the masses governing the naming of a period of stream. It is also possible that besides the above, some more streams would have appeared but since these could not wield any appreciable influence among the masses and failed to make any dent, therefore, dried down soon.

2.7 The Vedic Period

Vedic period is the most ancient period marking the dawn and meridian of Aryan civilization when the Aryans mostly got settled in small villages surrounded by forests. In fact the origin of Hindu Civilization lies in forest rather than the metropolitan cities or towns, as

Rabindranath Tagore has rightly pointed out 'Here in India, the forest not the town is the fountain head of all its civilization'. "It is the forest that has nurtured the two great ancient ages of India, the Vedic and the Buddhist" (Narain, 15).

Vedas which are considered very sacred literature of Hinduism and are the oldest literary work, especially the Rigveda have a very important place in the history of world civilization. The hymns of Vedas are still looked upon as revealed words of God. In fact the entire culture and religion of Hindu Civilization has been evolved on the bed rock of these Vedas. The word 'veda' generally means knowledge from the root 'vid', to know and refer to the collection or compilation of sacred knowledge or supreme knowledge.

Out of the four vedas, Rigveda is considered as the most ancient of all scriptures and gives an idea of the sublime doctrine and fountain of the Hindu Civilization building up through ages. The famous Gayathri Mantra includes worship of sun God for intellectual development. The principle of Rta is a typical principle for ethical development. At that time education is an important instrument of bringing about unity. The last hymn of Rigveda invokes unity. Let your minds be all of one accord". (Pandey 45-46) In Sama Veda many of the verses have been taken from Rig Veda and the text is treated as collection of special melodies, complete text of the songs for some rituals. The yajur Veda contains the prayers and mantras and the sacrificial rituals which the priest has to perform and consists of mantras in verses and in prose giving the sacrificial rites. It also prescribes the religious scheme and ordering the Hindu life in the course of ceremonies and the sacrifices to be performed at different occasions. The Atharva Veda comprises of prescription of herbs as remedy against diseases like fever, jaundice etc.

2.7.1 System of Education

The education in Vedic times therefore comprised of learning these hymns by recitation of sacred text which was cultivated as an art itself. The text of Veda was to be learnt by the method of hearing it from the lips of the teacher. Writing of Veda as an aid to memory and education was not allowed and was considered as sacrilege. The Vedic education was, not confined merely recitation with correct pronunciation, the contemplation and comprehending with meaning of hymns were more important. Learning without understanding has been condemned repeatedly. Grasping and understanding the meaning of sacred text was a very difficult and prolonged process where thinking, meditation and concentration were utmost necessary together with strict discipline sustained by a life of austerities, tapas and yoga for then only realization of truth was possible.

In Vedic period the educational system was working on the basis of some standard and well established ideals and practices. There were domestic schools run by Rishis or teachers admitting pupil in small number. The studentship started with a ceremony called "Upanayana" by the chosen teacher. Before granting studentship, the Acharya, the teacher would satisfy himself regarding the suitability of the pupil for being imparted education. It was believed that through the Upanayana ceremony the teacher would hold his pupil within him to impart him a new birth. Divija (twice born). He would be a changed person both externally and internally. Now the student would be called Brahmachari or Vratachari and would live with his teacher under prescribed discipline and regulation. Dedication to Acharya was most important.

In the times of Rig-veda the education was imparted into two stages. At primary state the pupil were given recitation and memorizing of text resounding like croaking of frogs after rain. The second stage which was the advanced one comprised of tapsa and yoga. Every pupil had to undergo concentrated contemplation and depending upon their mental and spiritual capacity, their dedication and sincerity, variation was noticed among them. They were compared like tanks of varying depth. Those of average calibra were sent to engage themselves in different occupations i.e., agriculture, ploughing, carpentry etc, while those in the higher grade in terms of their spiritual and mental aptitude were only sent for higher learning. The students found unfit to undergo tapsa and yoga exercise were weeded out. The higher education was not meant for all. Only those belonging to higher grade i.e., Mahaprajanan and were eager for quest of higher truth and supreme knowledge and also were able to undertake concentrated contemplation were allowed to pursue. They were also required to undergo meditation and tapa to seek truth. However during the period of Sama Veda, Yajur Veda the higher education began to center more and more in ceremonial and sacrificial rites. Priests and theologians started replacing Rishis and truth seekers. Subjects of higher education were the elaborate details and procedure of various sacrificial ceremonies and mechanical aspects of worship. After the period of Rig Veda, the higher education was meant for learning priesthood and ritualistic religion.

2.7.2 Evaluation System in Vedic Period

System to be followed in a particular age or period of history has a definite co-relation with the mode and kind of education being imparted in those days. In Vedic period the education comprising of text of Vedas to be recited orally with particular phonography

followed by meditation aiming at seeking of truth, evaluation though conducting a single or terminal examination would have no meaning. Also there is no direct reference available to spell out the methodology followed by the Acharyas to judge the adequacy of knowledge of his pupil. However, from the study of various hymns and stanzas some inference could be taken out as reference.

The common practice being followed in those days for granting studentship was that the aspirant lad would approach his chosen Acharya or Rishi with fire wood in his hand and oral prayer for initiating him. The Acharya would ask his name and put to him some questions to judge his moral standard and sincerity and suitability to receive Vedic education. The following citation quoted from Nirukta furnishes an idea about the guidelines to be followed by the Acharya for granting studentship to a student.

"The Goddess of learning approached Brahmana saying 'protect me; I am thy treasure. Do not expound me to the following unworthy persons – him who is jealous who wants in simplicity and straight forwardness or who is devoid of self control" (20). This has also been put in sutras by 'Manu' in his work 'Manu smriti'. This suggests that a Acharya while agreeing to the granting of studentship must enquire about the antecedents of the student and through casting his searching look on the boy and putting some relevant searching questions would satisfy himself about the suitability of the pupil on the ground of moral fitness for being granted studentship. there was a simplest form of aptitude or entrance test for admission. The studentship commenced by initiating the student through a ceremony called Upanayana which lasted three days at the end of which the student was reckoned as Brahmachari as already mentioned.

After having been granted the formal studentship or taking to Brahmacharya, it was compulsory for the student to live with the teacher. So that system of continuous assessment and evaluation as transpires from the guidelines contained in an old text quoted in Nirukta which reads. "The teacher must avoid teaching isolated syllable and he should teach only such a regular pupil as well as one who is especially qualified by his intelligence or asceticism or thirst for knowledge" (20). In an old text, the discipline of Brahmacharya has been stated one of the essential conditions for continuation in studentship. This also suggests that a pupil who does not observe his duties was liable to be expelled.

It has been mentioned in Rigveda that the student who have studied the same shastra may possess equal senses like eyes and ears but may not be equal in respect of their speed of mind of the knowledge or wisdom just like tanks of varying depth. "Sayana' a famous commentator on Veda has inferred that the student was given three grades, students of high ability were placed in Maha Prajanan grade, students of medium ability were given Madhyama Prajanan grade, students of low ability were given Alpa Prajanan grade.

These grades were given to the students as a result of their continuous assessment by their teacher. The system can be well compared to that followed by various examining bodies nowadays on the basis of paedegogical research. Students placed in the highest grade i.e., Maha Prajanan were only allowed to pursue the higher knowledge. While those of Madhyamam Prajanan grade medium ability were expected to be settled in their occupations i.e. ploughing, looms etc. However pupil evaluated as low ability students i.e., Alpa Prajanan grade were to be weeded out i.e., dismissed from studentship.

2.7.3 Vocational Education in Vedic Period

The Vedic period was not the age of saints and seers alone. In fact the Vedic education was limited to a few only. Hymns of Rigveda provide a glimpse of the various crafts and vocation as were being pursued in those days. Cottage type industries and agriculture laying a strong foundation of economic development that India was reckoned for its wealth and riches. Rigveda records that a sizeable population of society was engaged in various crafts and vocations. "We different men have different aptitudes and pursuits. The carpenter deals with broken things, the physician a patient, the priest someone who will perform sacrifice" (71). This shows the diverse economic pursuits as were being followed by the members of a family. Agriculture was the favourite vocation of ancients. A considerable part of Atharva Veda is devoted to the treatment of different ailments like, fever, leprosy, jaundice etc. The science of architecture was also in the developing stage.

Vedic age marks the beginning of formal and informal system of education in India. The Vedic people had a keen desire to make progress in the field of knowledge and science. They were eager to discover new knowledge and they were also eager to transmit their knowledge to the younger generation. The aim of Vedic education is to enable the people to lead a moral life. The principle of Rta is a typical Vedic principle for ethical existence. It is the cosmic creative principle, the rhythm of life and cosmos. No doubt, Vedic education aimed at acquisition of knowledge. Vedic education appears to have laid emphasis on equality of educational opportunity. There was equal distribution of wealth the men who possessed more than his need were not respected in the Vedic society. There was no discrimination on the basis of caste or creed. No distinction on the basis of sex could be found in social living

and men and women enjoyed equal status. Memorization was the centre of method of learning and teaching. Children and adolescents were educated to interpret what they recited. Creativity was honoured. Students were also trained in the skill of debating. They received voctional training in weaving, bow making, arrow making, surgery, agriculture etc. were being taught to the rising generation along with the literary education. Pessimistic outlook towards life, society and education could not find place in Vedic people. A very optimistic Vedic outlook on life is revealed in Vedic hymns. Vedic people enjoyed pleasures of life. They derived joy from the world but at the same time they lead an ideal moral life. The description shows that character building, development of personality and national integration must have been regarded as aims of education. Origin of philosophy, theology, history, geography, arithmetic, ayurveda, dhanurveda and several other subjects which are being taught today can be easily traced back to Veda. The methodology concerned in oral tradition was in vogue. All the four Vedas were taught orally. This oral tradition has remained unparalleled in world history. There were six Vedopangas which may be said to be philosophical studies, which are an elaboration of the Upanisads. The orthodox systems of philosophy are consistent with theology and metaphysics of Veda. Education was considered as necessary for becoming a great scholar, an efficient administrator, a skill full mechanic etc. Women education was not unknown during Vedic period. Vishvavara, Sikata, Chosa, Nivavari, Apala and some other women were the author of some of the Vedic hymns. At the time of performing Vedic sacrifices men had to be accompanied by his wife who also had to recite verses and naturally she could do so only by learning them by heart. Her education, was, thus a social, familial and religious necessity.

2.8 Period of Upanisads

This is the period when Indian education envinced a rare intellectual attainment and highest quality of philosophical thoughts emerged out which have no parallel even today. The message of Upanisads is still awakening the world, unfolding the physical mysterious and human speculation regarding some of the ultimate problems of life. According to the modern historians, the period of Upanisads is considered in between 800 B.C to 600 B.C (Ghosh 43). The Rigveda discusses two clear streams of thoughts. The original stream of pure thought was that enunciated by rishis – the direct seers of truth and is marked by meditation, contemplation and tapas. However the second stream comprises of sacrificial rituals and priesthood. By the end of Vedic period rituals became dominated and religion was bogged down by ceremonial sacrifices with its details more and more elaborated. The following kind of literature emerges out the two streams.

Brahmanas are the massive texts in prose and the subject matter is practical in directions for the performance of yajna or sacrifice. It is the literature of priesthood. At the end of Brahmanas are certain treatise known as 'Aryanaka' or forest book ie, to be studied in forest by the sages. Upanishads deals with philosophical speculations and because the vehicle of metaphysical and mystical truth. The number of Upanisads is as many as two hundreds. The oldest Upanisads Chandogya and Brihadaranyaka Upanisad are considered to be the oldest and supposed to belonging to 600 B.C. The word Upanisad means literally sitting near devoted (Upa- near, ni – devotedly, shad sitting). The word is also used in sense of secret teaching; the knowledge of Brhaman, for such knowledge destroys the buildings of ignorance and leads to the supreme goal of freedom. This highest wisdom can be learned by sitting

devotedly at the feet of a teacher who himself possesses it and realized it in life, and communicates the same to those who have attained purity of heart though previous self – discipline.

2.8.1 Theme and Message of Upanisads

Upanisads speak of the supreme knowledge, the knowledge after knowing of which nothing remains to be known and this has been termed as 'Para Vidhya' which means the knowledge through which the ultimate reality is known. All other kinds of knowledge ie, Vedas, Vedangas, grammar, phonetics etc and other subjects of study are included under Apara Vidhya the conception of Ashramas took its birth from Upanishads which later on formed the bed rock of Hindu way of life according to which the whole life span of an individual has been divided in the four stages. Brahmacharya Ashrama. Grihasta Ashrama, Vanaprasta Ashrama, Sanyasa Ashrama.

2.8.2 System of Education

The tradition evolved in Vedic period for imparting education were, by and large continued in Brahmana Upanisadic period. The admission into studentship was granted through Upanayana ceremony. A unique method of teaching and learning of Upanisads was based upon discussion in the form of questions and answers between the teacher and the taught with explanations supported by stories, parables and illustrations.

During the period of Upanisads three types of educational institutions were functioning.

(1) Domestic School: Under the normal system of education prevailing in those days, a teacher would admit students of tender age at his own settled home to give instructions. When a student wished to become pupil of a teacher of his choice the recognized way of making request to him was to approach him with fuel in his hand. The admission of student was formally made though the ceremony of Upanayana or initiation as per ceremonial procedure prescribed for the purpose. The normal period of studentship was twelve years and only on permission, the student would leave for home after taking a ceremonial bath followed by the prescribed ceremony called 'samvartan' and was considered as having completed the study. (2) Mobile Debates: The student who wished to pursue advanced study with the quest of further knowledge would travel far and wide with a view to receive instructions from celebrated teacher or to improve their knowledge though mutual discussion with other wandering scholars. There was a system in those days that advanced scholars would wander through the country in quest of knowledge and philosophical discussion were held in mobile debates where the knowledge gained in Vedic schools would get mature though discussion and friction of minds. These could also be termed as debating circles. (3) Conference: Assemblage or congregations were sometimes convened by the kings where in rishis, thinkers and learned men throughout the length and breadth of the country were invited to exchange their views and to discuss philosophical issues. These could be well compared to the conferences being held in modern times.

The Upanishads which from, the concluding part of the Vedic literature or Vedanta reveals a systematic account of education. In Upanishad, education has been understood as something which makes a man self reliant and selfless. According to Upanishads the

knowledge of the inmost self in us is the spiritual knowledge which alone can lead us to spiritual freedom. Thus for the sages of Upanisads education is a process which liberates a man from his bondages and leads to spiritual freedom or Moksha, ie, 'Savidhya ya Vimuktaya'. In order to attain the highest goal of life a well planned scheme is essential to follow the younger generation, that is Ashrama Dharma.

The Upanisads furnish a glorious picture of educational system prevailed in ancient India. One major achievement of education is the Gurukula system, which is considered to be one of the major contributions of the Indian Civilization to the world of education. The Upanisadic seers made no distinction between philosophy of life and philosophy of education. In the Gurukula system the student gets the opportunity to spare the life with the teacher in as much as a member of the family and gets spiritual attachment with Guru which helps to mould his character also. The mere acquisition of knowledge without disciplined life was not given a high place in our system of education. This system stresses education through work, which is quite different from mere book reading. It aimed at the development of the inherent potential faculties through work by the growing consciousness of strength acquired by overcoming resistance, simultaneously with the spiritual growth of a person. According to Altekar "Education has always been regarded in India a source of illumination and power which transforms and enables our nature by the progressive and harmonious development of our physical, mental, intellectual and spiritual powers and faculties" (Altekar 8).

2.9 Manu – Panini Period

This period is marked by a galaxy of preceptors like Manu, Panini, and Gautama etc. whose thoughts and ideas continue to be a veritable mine of information on the numerous topics of human interests down to the present day. This is also called the period of sutra literature. Here the preceptors summed up the entire substance of religion in the form of sutras. During Brahmana Upanishad period there was a growth of vast and varied literature, the knowledge became more and more subtle and complex as such there was a need of simplified literature and clear guidance and directions to be imparted in simple language and sutra literature was the result of that necessity. The period of Manu and Panini is in between 600 B.C. to 200 B.C. (Sailendranath 57) their work namely 'Manu smriti' and 'Ashtadhyayi' were still considered to be authoritative. Kautilya's 'Artha shastra' is also the work of this age. The other literature of this period comprises of Dharma sutras, Graha sutras, Upvedas and Vedangas like Sikshsa, chhandas, Vyakarana, Nirukta, Kalpa, Joyostiha etc. complied by various preceptors. On going through the varied literature especially the sutras and smrities, one can have an idea of educational system available in those times. However, even days, timing, places and periods of study were fixed. Receding the days of Upanishads, where a king proclaims "in my kingdom there is no thief, no miser, no drunkard, no man without after in the house and no ignorance person" (Chandoghya Upanishad V 11.5).

2.9.1 Educational Institutions

Vedic Schools run by Acharyas: The normal type of educational institution in those days were, the domestic schools run by the learned Acharyas. The students were admitted

according to the discretion of teachers took special care to see that the aspiring pupil has the right aptitude and the moral fitness for the kind of education i.e., Vedic education was to be imparted to him. Neither any monetary consideration nor any fee was expected from the pupil to grant studentship and to impart education. The progress shown by the student and his conduct and sincerity to undergo strict disciplinary rules and austerity were the factors governing the continuation of studentship under the Acharya. The numbers of students admitted by the Acharyas were also comparatively smaller as the teaching was individual and the teacher had to attend each student separately. The capacity of the teacher's house to accommodate students was also an important consideration for putting a limit to the number of students for admission in the school.

The ancient system of education insisting on the residence of the pupil in the home of his teacher was necessary to meet the demand of the educational method, ie, oral method was followed in those days as a vast quantity of scriptures were required to be memorized with absolute accuracy and accent and pronunciation. As such personal and continuous contact between the student and the teacher was necessary. It was the first and foremost condition to reside with the teachers as his family member.

'Parishads' as existing in those days were not meant to impart instruction in a subject to the admitted students but to give decision which would be binding on the community. In fact, it was an academy of experts of authoritative interpretation of a point concerning to Veda or largely on general conduct. Such institutions or parishads were existing in every educational colony or settlement. The composition of a parishad would usually consist of ten members under according to Manu. Three persons each of whom should know- one of the

three Vedas, One logician. One Mimamsake, One learned man of Nirukta, Three men belonging to first order ie.Brahmacharya, Grihastika, Vanaprasta, One who recites the institute of sacred law. Separate schools for specialized disciplines or 'Vedangas' were conducted by learned 'Rishies' for studies in Vayakarana, Jyotisha, General law- based upon religion. Panini's Vyakarana and his work 'Ashtadhyayi' are the living examples of such schools. Similarly schools of this view is further corroborated by the fact that we hardly know of any grammatical or anthropological work belonging to any of the Vedic schools. Similarly in the case of development of jyotisha which started as an angle of Veda, the famous work on of any Vedic special school can only be the result of its phenomenal development. Special law schools were also run by preceptors and rishis. The original 'dharma sutras' containing the moral duties and detailed rules were the subject of study including the law of partition and inheritance. The schools run by Manu and Yajavalkya producing manuals and secondary smirites are the examples of such institutions.

A child was introduced to education comprising of leaning of Alphabet at the age of five by performing a ceremony called 'Tensur or Vidyarambha'. The occasion was marked by performing worship to 'Hari, Lekshmi and Saraswati' and the family Vidya.

The sutras made it incumbent upon the teacher to take great care to select the students for the study of Vedas. It was considered disastrous to impart knowledge to the undeserved ones. A key note address by Manu reads "Let a Vedic preceptor should die with knowledge than important it to an unworthy recipient". The course of study prescribed for a student of Vedic school was quite comprehensive: As per Manu, the course including Three Vedas, Vedangas, Atharva Veda, Upanisadas and Aryankas, Puranas and Ithihas.

The length of the period of studentship was normally 12 years. The academic session starts on the full moon of the month 'sravan' with the performance of a ceremony called 'Upkarman'. The total length of the session was 5 months in a year. During the period the private study of student was permitted as per regulations. The student was allowed self study of Veda during the last nights of each month while in the dark nights Vasanada comprising of grammar, astronomy etc.

The ceremony marking the conferment of snataka title to a pupil is called 'samavartana' ceremony. It means close of studentship. The ceremony consists of removing of all external marks of Brahmacharya. After the ceremony the student is called 'Snataka' a graduate in modern sense that who has bathed his amounts to conferment of degree. Before a student takes final bath to be designated as 'snataka' and before his studies are formally brought to an end, he should as a gesture of gratefulness give a present to his preceptor according to his capacity. The idea is to to express his gratefulness to his preceptor for the education given and sacred vow fulfilled. This is called guru Dakshina or teachers' honorarium.

Panini is a great grammarian of ancient period is the pioneer of the period of sutra education. In fact this period is supposed to start with Panini's grammatical literature which gives some evidence on the educational system as well as examination system. 'Ashtadhyayi' is one of the famous works of Panini in which the conditions of the period as reflected that grew with the grammer of Panini. The work of Panini has attracted two famous perceptions Katyayana and Pathanjali who complied two famous commentaries.'Vartika'and 'Mahabharata', respectively which are important in the field of education. The method of

evaluation introduced by Panini may be called as a negative marking for very solid reasons. In those days almost a hundred percent accuracy was expected from the students in respect of recitation of texts. In fact during the Vedic and later Vedic period a single error committed by the student in respect of recitation of the Vedic hymn was taken. So seriously that he was disqualified from performing any further ritualistic of Vedas.

2.10 The Epic period

The Epic period which is enclosed with the gathas of Ramayana and Mahabharata discusses human goals, purposes, pleasure, duty, and liberation, attempting to explain this relationship of individual to society and the world and the working of Karma and also explore themes of human existence and the concept of Dharma.

The most common institutions of education in those days were hermitages of Acharyas, Munies, and Kulgurus etc.some of the hermitages which were called Ashramas. The period of Ramayana and Mahabharata is called as the age of Ashrams. In fact every preceptor established his own Ashrama which was got extended and expanded with the passage of time and gained the form of an educational institution with royal support and endowments. Some of Ashramas were as a large of students were like 'Forest Universities' - of ancient India. As per the evidence of Ramayana and Mahabharata, the following Ashramas were mainly functioning during the period are Bhardwaj Ashramam at Preyag, Valmiki Ashrama, Vashisth Ashrama, Kanva Ashrama, and Shounaka Ashrama

2.10.1 Bhagavad Gita & Relevant Themes

The Bhagavat Gita is the most popular religious poem of Sanskrit literature. This is a work of conveying lessons of philosophy religion and ethics. Gita is the source of illumination both to the rich and poor for all people all four – saadhna.. Arjuna seems to be a state of psychological conflict in the battle field.

The message Gita is Universal in its scope. It is an appeal to the torn conscience. The main spirit of Gita is that of the Upanishads. The Gita does not throw over board the authority of the Vedas. Sacrificial acts are to be performed without any expectation of reward.

The following are the four essential margas of the Gita - Janana Marga, Bhakti Marga, Karma Marga. Gita represents a unique synthesis of Action Devotion and knowledge. Man is a complex of intellect, will and emotion, intellect has given rise to the philosophy of knowledge, will to the philosophy of action and emotion to the philosophy of Devotion. Gita tries to build up philosophy of Karma based on jnana and supported by Bhakti in a beautiful manner. This synthesis is called yoga, the union of the individual with Absolute. A yogi is a Stihitaprajna "one firmly rooted in higher reason and unmoved by the pairs of opposites". He attains to the highest state of Brahman, where he is never bewildered and from which he never falls down (C D Sharma, 34). *Yo'ntahsukho'ntararama stathantarjyotireva yah Sa yogi hrahmanirvanam brahmabhuto dhigacchati* (Gita, 2. 23). ie. He who is happy within himself, enjoys within himself the delight of the souls and even so is illumined by the inner light, such a yogi identified with Brahma attain Brahma, who is all peace.

2.10.2 Aim of Education in Gita

The teacher pupil relationship was of the higher order. It was based on freedom and deep love for the teacher. In the Gita, the teacher assumes full responsibility of the pupil's action. There is no escape from one's duty. He shall not inculcate the element of fear in the minds of his pupils. For, the fear leads to the development of the guilt sense in one's students. According to this philosophy, a teacher need not discourage student to doubt and questions. A pupil has every right to put doubt and questions unhesitatingly. For nowhere the Gita stands to curb curiosity, discourage doubt or avoid questions. In fact, all inquiry is to be appreciated that provides the stimulus to the student in the teaching-learning process.

A teacher in the Gita never demands blind following. There appears to be reconciliation between freedom and discipline between doubt and devotion. According to the Gita, the qualities of an ideal pupil are; humility, inquiry service and shraddha. It is the hope that these qualities must be inculcated among the student. Real education was to be imparted to those who deserved it and who are prepared to put it to good use in society. For eg: Arjuna does not oblige Krishna with a share in his kingdom - but by saying that his doubts were removed. The Gita aims to educate those who are willing to receive it. It does not believe in impressing it. For, all types of education are not suitable for pupils at all times. In fact education should cater to the particular needs of the particular pupils. The Gita warns Arjuna, not to disclose the lessons to others unless they deserve it. All the same, Gita emphasises that knowledge must be imparted freely to the deserving candidates.

The aim of educational philosophy is a synthetic approach. Indians do not believe in compartmentalism. The approach of the whole text of the Gita is in such a manner that Sankara found his Advaita, Ramanuja his Dvaita and Bhakti. Tilak found action and aggression. Gandhiji found the elements of truth and non violence. As a matter of fact the Gita remains a source of immense inspiration to the Behaviourism, Naturalism, Freud, Gestaltists and John Dewey for his pragmatism.

Gita may be described as the pupil centred education. Tilak in the Gita Rhasya says "good teachers first ascertain whether or not the disciple has been inspired with the desire for knowledge as if there is no such inspiration they attempt to rouse the desire. The whole science of right action has been expounded in the Gita on this basis" (Bourai 37).

The entire Gita is a grand pedagogical strategy. It gives bread for the hungry, the water for the thirsty, as oxygen for the fainting. In the Gita, the teacher is as much interested in taking it. In a perfect lesson, the teacher and the taught oblige one another.

The concept of recapitulation of the lesson can be traced in Gita the last Adhaya of the Gita is a summary of all preceding Cantos. It is an epitome for the whole lessons. This deepens the meaning, elevates the mind and concludes the lesson at its climax.

The theory of human behaviour in the Gita is unique synthesis. For instances action is not only uncontrollable it is also inescapable. We are always compelled to act or behave according to the quality of nature. The Gita says better to die acting according to one's innate tendency than to resort to inaction because action according to other men's innate tendency is dreadful.

Further, the control of the mind is insisted (38 -39). The Gita is against suppression of instinctive urges and it does away with all sense of guilt and pride which are the worst enemies of an aspirant of higher life. *Nasti buddhirayuktasya na cayuktasya bhavana na cabhavayath santirasantasya kutah sukam (Gita, 2.66)*. He who has not controlled his mind and senses can have no reason: nor can such an undisciplined man think of God. The unthinking man can have no peace; and how can there be happiness for one lacking peace of mind?

Duty towards society is not social, but individual. Moral duty should be done for the sake of duty and not for the sake of achieving results. The best worker is one, who is detached, egoless, and full of patience and indifference towards failure or success. As a matter of fact, the modern concept of educational and vocational guidance is not foreign to the psychology and ethics of the Gita. We must know that the individuals differ in their psychological makeup, their physical capacities, their moral and spiritual growth, their history and heredity, their environment and circumstances. Finally, the Gita is not merely a book of practical ethics, but of spiritual life too. There is no question of duty unless there is a moral within us. Thus, duty is not only external or social but is internal and moral too.

2.11 Concept of Education in Jainism

In the fields of both knowledge and metaphysics, Jaina philosophy is pluralist and relativist. Metaphysics is based on knowledge so it is necessary to understand epistemology as a prelude to understand metaphysics. Consciousness is the essence of the soul. It was a two fold manifestations ie. Philosophy and knowledge.

Education in Jainism is integral and intrinsic to jaina way of life. Education includes knowledge, vision and sound character. This education is means to attain the highest goal of life. To live a Jaina way of life is to educate one's own self and develop the higher quality of soul leading towards perfection and attaining liberation from pain and suffering. Truth is always a truth of one of the aspects of reality – anekananda vada. The object of truth having multi aspects and truth is not about all aspects – syad vada. Truth becomes partial and reflective. Jaina way of life is controlled, disciplined life where one observes the five great vows: Ahimsa, Sathya, Asteya Aparigraha and Brahmacharya. Jaina education insists not only non hurting it also insists on forgiveness and love. No education is complete without these external values. Its non absolutism (anekanara vada) and its theory of manifold aspects of reality (syad vada) reflect a complete system of training or educating a life that fully totally fulfills the ultimate and the highest goal of life.

2.11.1 Aim of Education

Education is a means to live a life more effectively as well as more efficiently. Education aims at a student's physical, mental and moral development. By imparting knowledge and making a child intelligent, it imparts yoga and other physical exercise to make a child physically strong, through its cultural and life skill activities and make character virtuous. With right education one attains right knowledge, right faith, and right conduct.

2.12 Buddhist period

The Era of Buddhist education dominated the Indian scene for several centuries when monasteries. Gautam- the Buddha was born in 567 BC and obtained his Nirvana in 487 BC

(Mahadevan 106). The main theme of Buddhism is characterized by a broad spirit of philosophy and pursuing ·Madhyam Marg (Middle Path) is avoiding the two extremities. It differs from the Hindu philosophy in the following aspects non recognition of Vedas, non-recognition of Brahmanism, Proclamation of equality in respect of castes. The pretentions regarding arbitrary distinction of casts were scattered to wind by the strong logic of the great Buddha.

The scriptures of Buddhism provide guidance to its devotees took its final shape after one or two centuries of Buddha's death and is known as Tripitaka. It comprises of 3 volumes Vinaya Pitaka: This lay down the rules and regulations for the guidance of its devotees and is considered to be most important. Suta-Pitaka: This is also very important work and is a collection of religious discoveries of Buddha. Abhi-Dharma Pitaka: It means higher religion and has been written in the form of question and answer. However the subject matter is the same as dealt with in Suta Pitaka. The vinaya-pitaka has the following parts (a) Sutta Vibhanga (b) Khandhakas (c) Parivala.

The essences of Buddha's preachings are contained in the four noble truths and they form the basis of Buddhism. 'Dukkha" or sufferings Samudaya or the cause of suffering, Nirodha or the extinction of all suffering and margas or eight fold path to eradicate sufferings and experience salvation. The educational thought inherent in four noble truth, according to Buddha if a man awakens to the fact that his deeds beget the result of his suffering or joy, he will not do anything which will be get him suffering later. He will govern his conduct in a manner in all aspects of life-physically, mentally, morally and spiritually - that he will be decorated as an ideal citizen of the society and country and the world.

Lord Buddha says in his second noble truth that ignorance is the cause of suffering mankind. The function of education is to eradicate the ignorance so that man can work toward his spiritual development. In the third noble truth, he has compared this task to attainment of salvation. He says that if desires arising out of ignorance and destroyed or overcome, men will be to conquer over love, desire, enemity and anger. In the form of Fourth noble truth, Buddha prescribed eight fold paths to get rid of all worldly suffering. The noble eightfold path is replete with noble guidance which is capable of purifying the heart, and mind of the men fully. The supreme peace as envisaged, thus we can see that the noble truth has deep educational thought inherent in it.

2.12.1 Philosophy of Buddhist Education

Buddhist Education is purely monastic. The history of Buddhist system of education is practically that of the Buddhist order or Samgha. Buddhist education and learning centred round monastaries as vedic culture centred round the sacrifice. All education, scared as well as secular, was in the hands of monks. The ceremony of initiation into the Buddhist order and the viharas follows closely the lines of the Brahmanical initiation of studentship. Under the Brahmanical system the youth has to find his teacher to whom he has to formally apply for admission to studentsship in the following words. "I come for brahmacharya. I desire to be a Brahmacharin, then the teacher 'ties the girdle round him give him the staff into his hand and explains to him the Brahmacharya by saying 'Thou art a Brahmacharin: drink water perform service: sleep not be day: study the Veda obediently to thy teacher " (Sharma S.R. 136).

There were two kinds of teachers. Upadhya and Acharya. The Upadhya was the highest authority entrusted with the duty of instructing the young Bhikshu in the sacred texts doctrines. He had a standing of ten years. Monks were usually kept in their charge. An Upadhya was expected to be a man of learning, charter and greet standing. The acharya: assumed responsibility for his conduct and was thus called also karmcharya in reference, probably, not merely to his part in the ecclesiastical act but also to his tutorial responsibly as regards discipline. An acharya had six years seniority. A Buddhist teacher was to have the whole hearted devotion of the pupil to his teacher. The primary duties of a teacher were,

He must give the Bhikshu under his charge all possible intellectual and spiritual help and guidance by teaching, by putting questions to him, by exhortation and by instruction. When the people lacked his necessary articles such as an alms bowl or a robe the teacher was expected to supply them out of his own belonging. If the pupil falls ill, the teacher must nurse him as long as his life lasts and wait until he has recovered. A teacher was to be well up in morals, self concentration, wisdom, emancipation and the knowledge and insight thereto. A teacher must be able to train a pupil in the precepts of proper conduct to educate him in the elements of morality, to instruct him in what pertains to Dhamma. A teacher considered it to be his privilege in a sense to receive service from his students. If any student ignored to respect his teacher, he was deemed unfit and consequently was expelled from the order. The teacher too put forth the ideal of high learning, excellent moral character, self possession and spiritualism before his pupils to compel inherent high respect for them. A teacher's task was to teach the student the rules, etiquette and discipline. He had to pay special attention to the vow of chastity, poverty and the abstinence from pleasures. In fact

Intellectual and spiritual discipline was to be maintained at all cost. It is interesting to note that there were regulations as to food and begging for the students.

For a student to serve his teacher was a part of education. For instances the pupil is to rise early from bed and give his teacher teeth-cleaner and water to rinse his mouth with; then preparing a seat for him, serve him rice-milk in rinsed jug and after his drinking it, wash the vessel and sweep the place. Afterwards, he is to equip him for his begging round by giving him fresh undergarment, girdle his two upper garments and his alms bowl; rinsed and filled with water, then is to dress and equip himself, similarly, if he wants to accompany his teacher but must not walk too far or near him. He is not being interrupted his teacher, in speaking even if he makes a mistake.

The relation between the teacher and taught were quite cordial. He was based on the principle of the personal touch whether the sphere of its working lay in the individual house hold of the teacher or in the collective establishment of a monastery. In case of pupils illness, his teacher himself nurses him supplies all medicines needed and pays, attention to him as if he were his child. The entire daily conduct of a student was inspected by his teacher.

The minimum period of studentship was 12 years. Rules and ordination were quite rigid one. The admission of the students was restricted one. The admission to the order was not permitted to youth seeking without the consent of their parents. Restrictions were also imposed upon their suffering from contagious diseases. Serious moral defect was also a bar

to admission and confirmed criminals were kept out. It appears moral, political social and economic obligations were emphasised and recognised by the other.

2.12.2 Methods of teaching

Education in the age of earlier Buddhist texts was not depending upon written literature. The art of writing had developed by that time but the teaching was predominantly oral. The system of oral traditions was as much the characteristic of Buddhist as of Brahmanical education. Even in Fa-hien's time, the oral tradition was still obtaining as the method of instruction even among Buddhists. The Acharya (preceptor) and siddhivithankas (pupils) dwell in the monasteries together. Hence the teacher had recourse of direct method of teaching. He would suggest a lesson of them or their part learnt by heart. The preceptor would proceed further after having ascertained the thorough comprehension and the lesson by the pupil. Senior students worked as Assistant Masters. For example, to manage a school of 500 pupils and undertake their education was not easy task for an individual teacher. He was helped by a staff and Assistant Masters.

Trips and Tours: Education was to be complete with travelling. These trips and tours were undertaken to humanize the native pride or the position held by the students of those times.

An important feature of this system has been that education was made practical. In Buddha Viharas and Monastic schools, Hetu Vidhya or Inductive Method was adopted and the intellect pupils were trained through it. Education was made practical. Nature study was always insisted upon as the best means of awakening a healthy curiosity, a spirit of

observation and inquiry which are indispensable for future. The teacher was at pains to consider what method of instruction would be suitable for that "Veriest dullard of all his pupils". (Bourai 79)

2.12.3 Debates & Discussion

Debating capacity was an important factor, in gradation of scholars. Monastic education devoted special attention to the development in the alumni of their powers of public debate and exposition, which were highly prized and rewarded. The cultivation of such intellectual capacities was systematically stimulated by recognition awarded on the basis of examination. It appears Buddhism was more interested in the cultivation by its leaders, the votaries of the powers of debate by which this religion could spread and win converts from other religions. It is quite evident that the Buddhist education was keen to develop dialectic skill and ability in argumentation among its students and the leaders of the orders.

The curriculum under Buddhist system of education consisted of Arts and science knowledge of the literature of subject had to be followed by its application. 'Nature study' was always insisted upon the best means of awakening a healthy curiosity, a spirit of observation and inquiry, which are indispensible aids to intellectual culture.

Buddhist philosophy had an important place in the scheme of education. But adequate attention was also given to the study of religion and philosophy of the different sets of Hinduism and Jainism. Education was not simply confined to Theology but philosophy and logic, Sanskrit literature, works on law, polity and administration were also taught for the

benefit of the students, to enable them to get Government service or to follow learned profession in society.

Though Buddhism as a religion is almost extinct in India in neighbouring countries such as Srilanka, China, Tibet, Thailand, Burma etc. the majority of population is still the follower of this great religion which has its deep root in Hinduism.

2.12.4 Nalanda University (450 AD to 850 AD)

Nalanda University which comes to flourish as a centre of learning towards the middle of the 5th century A.D is 40 miles to the South west of Patna. The credit to develop Nalanda as the greatest University and Buddhist Monastery goes to Gupta Rulers.

The University comprised of a central college with 7 halls attached to it. The building of Viharas was as high as touching the cloud. There was a compound wall the whole colony with a door on southern side. As per life the gates opened into the great college. The building was having richly adorned towers looking like hill top with their height touching the sky. There were trasluent ponds blossomed with blue lotus and at intervals the amra grove spread over their shade. As per observation of Hiuen Siang there were eight halls and three hundred apartments.

Nalanda had a grand library which was situated in a special area called "Dharma Ganga" and was nine-storeyed high. The library was having a rich collection of rare and sacred books on different subjects. Nalanda owned hundreds of villages yielding rich revenue. As per Hiuen-Siang, lodging, boarding, clothing and medicines were free to the students on account of rich endowments made by the contemporary rulers.

Nalanda was the centre of higher learning in advance studies; the curriculum was not confined to study of the Buddhist religion, philosophy and literature but covered almost the entire circle of knowledge that was available. It included the work belonging to eighteen sets, the Vedas, the Hetu vidya, shebada vidhya, grammar, medicine, Atharva Veda and music etc. The education imparted at Nalanda was free. The boarding, lodging, clothing and medicine were also free. The expenditure on this account was free and was met from the income of estate consisting of hundreds of village endowed by the then ruler. In fact the student had not to worry about their material needs of life and this enabled them to concentrate on their studies whole heartedly. No degree or diploma was awarded to the outgoing student. However the students of Nalanda were looked upon as model all over India. As such the fellowship of Nalanda was considered as an academic degree. For this reason the name of Nalanda which was on degree itself, was stolen to receive honour and respect.

Reference

Achyuthen, Mavelikara. *'Educational practice in Manu, Panini and kautilya.* Thiruvananthapuram: Easwer printers, 1974.

Aggarwal, J. C. *Theory and Principle of Education.* NewDelhi Vikas Publishing House Pvt.

Alterkar, A.S. *Education in India.* Varanasi: Nawal Kishore and Bros. 1957.

Bourai, H, H.A. *Indian Theory of Education.* Delhi: BR Publishing Corporation, 1993.

Ghosh, Suresh Chandra. *The History of Education in Ancient India.* NewDelhi: Munshiram Manoharlal Publishers Pvt. Ltd. 2001.

Goyandka, Jayadayal. *Srimad Bhagavad Gita.* Gorakpur: Govind Bhavan Karyalaya Gita Press, 1995.

Kapoor, Sabodh. (ed) *encyclopedias of Indian Heritage Vol.80.* New Delhi: Cosmo Publications 2002.

Mahadevan, TMP. *Invitation to Indian Philosophy.* New Delhi: Arnold – Heinemann, 1982.

Narain, S. *Examination in Ancient India.* New Delhi: Arya Book Depot, 1993.

Nath Sen, Sailendra. *Ancient Indian Histroy and Civilization.* New Delhi: New Age International (P) Ltd Publishers, 1998.

Pandey, R.S. *Philosophizing Education.* Delhi: Kanishka Publishing House, 1993.

S.R, Sharma. *Philosophy of Educations in India.* New Delhi: Mohit Publications; 1997.

Sharma, Chandrdhar. *A critical survey of Indian Philosophy.* Delhi: Mothilal Banarsidass Publishers, 1988.

Chapter III

Western Perspectives on Education

Education helps man to make a deliberate and conscious effort to live comfortably and happily in his physical and social environment. It enables man to develop his innate potentialities to live a gracious and harmonious life in this world. This is a lifelong process that continues from the beginning of his life till the end. The family, the society and the state are the agencies in the process of education.

In the West educational thinking, like every other branch of knowledge, started in the philosophical deliberation of the ancient Greek philosophers. In the ancient times at the beginning of civilization, there was no provision for education in the schools. A child acquired knowledge by imitating the family, neighbourhood, society and community. A child learnt language, etiquette, social conduct, economic - cultural activities etc while living in family and society. Egypt was a country where western civilization arose. It is said that the beginning of script and writing too began at this place, a script called Hyrogliphian. Egypt's educational history divulges that there was educational system in vogue which was run with the help of temples and royal courts. Thus, education was basically religious, professional and political.

Education has been defined differently by various schools of thoughts like the idealists, the pragmatists, the naturalists and the realist philosophers. However, its meaning has been generally idealistic. Without some sort of idealism there can be no education worth its name. According to Robert R Rusk the aim of education is the enhancement or enrichment

of personality, the differentiating feature of which is the embodiment of universal values. The Western educational philosophers have generally agreed the free growth of the child in the essence of education. According to A.G.Hughes, the essence of discipline is, not forced subordination to the will of hated tyrants, but submission to the example of admired superiors.

Ancient Greece was composed of different groups having different racial origins. There tribes, clans or city state as they were called later on, seemed to have some common traditions, social and cultural goals. "The Greeks are supposed to be the first people who seriously recognized the importance of human values and who dedicated themselves to the pursuit of art, culture and education". (Fowler 35) The foundation of the cultural ideals of western education can be traced back to the principal city states of Greece, the Athens and Sparta represented as the Ionian and Dorian cultural idea respectively.

The aim of Spartan education was to prepare citizens to safeguard the state. They were to obey the laws of the state. In short, the individual was to be trained to be loyal to his country. The young ones were the property of the state. The aim of Athenian education was to provide boys courage and wisdom, but neither of these in excess. Boys were to be prepared both for war and peace. They were to be cultured citizens - broadly educated, refined, sensitive, civic minded and moral beings. The aim was realized by sending boys to different teachers to acquire a wide variety of knowledge expected of an Athenian youth. The Athenian education was learning by doing rather than learning from books. The teacher played an important role and he had to demonstrate, supervise and evaluate the learners. Most of the Athenian education was liberal and contributed to the all round development of

the citizens. It did not, however, consider women equal to men, either for training or for other citizenship duties.

Later Athenian education had undergone remarkable changes after the Persian war, in earlier years the education was mainly concerned with training men, but later on it became more concerned with training boys to become effective and successful in the career. In order to achieve the new goals, the Sophists made their way into Athens (Edward 166).

The sophists were a class of people who could impart quickly every kind of knowledge. Sophists such as Euthydemus, Prodicus and Protagoras were known as 'the wisest' of all and the only professors who contributed for the moral improvement of the people. Development of Greek Philosophy took form with the Sophists who were known as the travelling teachers of wisdom. Yet they lacked many things, their teachings were unsystematic and also limited to a few who could pay them for the tuition. The fact that they accepted payments for their teaching created dislikes and prejudices against them.

Socrates, who took delight in 'pricking bubbles' and who rebelled against traditional ways of thinking. He is the originator of "the Socratic method of teaching" by questioning and examination. Socrates as a moderator held balance between the ultra-conservatives and ultra liberals, an intellectual giant whose ideas and ideals dominated western civilization for two thousand years and continue and to influence even today .Socrates was more committed to know the inner man than the Sophists. He was concerned to find the truth involved about the universal validity of moral laws, which were connected with the chief problem 'Man! Know thyself'. Knowing one's own self meant to Socrates, the analysis of knowledge for

determining the universal validity of moral principles, laws of the state and nature of religions faith. The meaning of education in the West can be traced in the works of Plato. Plato defined education as a lifelong process starting from the early days of childhood lasting to the very end of the life. He used the term education in a wider sense, which makes a man pursue the ideal perfection of citizenship and teaches him how to rule and how to obey. Education not only provides knowledge and skills but also inculcates values, training instincts, fostering right attitudes and habits. In *Republic*, Plato points out that true education, will have the greatest tendency to civilize and humanize people in their relation to one another .This definition of education propounded by Plato is still the most widely accepted concept of education in the West. Education everywhere has been used as a process of inculcating values. Plato said "Now I mean by education that training which is given by suitable habits to the first instincts of virtue in children" (Ramakant 8). These views of Plato have been universally accepted in the West as well as in the East. Reacting against what he perceived as too much of a focus on the immediacy of the physical and sensory world, Plato, described an Utopian society in which "education to body and soul, all the beauty and perfection of which they are capable" (Rawat 54) as an ideal. In his Allegory of the Cave, the shadows of the sensory world must overcome with the light of reason or universal truth. For him, people should concern themselves primarily with the search for truth. Because truth is perfect and eternal, it cannot therefore be found in the world of matter, which is imperfect and constantly changing. The kind of dialectical discussion could not be accomplished by those who argued to win or would not maintain a critical perspective. In *Republic*. Plato proposed the kind of education that would help to bring about a world in which individuals and society are moved

as far as they are capable of moving towards the good. To understand truth, one must pursue knowledge and identify with the absolute mind. Plato also believed that the soul is fully formed prior to birth and is perfect and one with the Universal Being. . For Aristotle education is essential for complete self-realization. To him the supreme good to which all aspire is happiness. A happy man is the one who is educated. A happy man is virtuous, virtue is gained through education. To him the aim of education was the welfare of the individuals so as to bring happiness in their lives.

The 10th and 11th century was the period of great change. The influence of the Church was at its peak. So the Church established schools and monasteries for religious education. There were three chief points of power, religious organization political organization and industrial and commercial organizations. The schools were opened under the influence of religious organizations in which the religious preachers and priests were the teachers. Augustine the founder of Roman Catholic in his work *Confessions* described 'in order to know we must believe'. He patterned his educational philosophy after Platonic traditions. He believed that worldly knowledge gained though the senses was full of error but reason could lead toward understanding and he held that ultimately, it was necessary to transcend reason through faith. Only through faith or intuition can enter the realm of true ideas. The second centers of power were the political organizations which run state - controlled schools. The third powers of center have the freedom to establish their own educational system. Education lived during this period but did not progress. In the middle ages Comenious declared education as a process whereby an individual developed qualities relating to religion, knowledge and morality, and thereby established his claim to be called a human being.

The Greek or Hellenic civilization began towards the end of the 12th Century BC. The poet Homer could be regarded as the first educator of Greek. The aim of education was 'arete' which means 'excellence'. The aim of Homeric education was to enable the leaders to set forth worthy examples that could be imitated by the youth. The brave and the wise became the models for emulation. A Greek teacher was usually an older and experienced man, who accompanied the youth to the court, the market place, and the battle field, and showed them other aspects of social life. The education of the young was ensured through teaching, personal examples and through imitation of all the activities which were practiced by the older people in the club, the gymnasium and the banquets. The Homeric traditions had its influence in the latter periods.

The metaphysical school of thought called scholasticism is largely applied in Roman Catholic schools in the educational philosophy called 'Thomism'. It combines idealist and realist philosophers in a framework that harmonized the idea of Aristotle, the realist, with the idealist notion of Truth. Thomas Aquinas wrote *"Summa Theologica'* formalizing Church doctrine. The Scholastic movement encouraged the logical and philosophical study of the belief of the Church, legitimizing scientific inquiry within a religious framework.

The 14th to 16th centuries are considered to be the period of reawakening in Europe. Many reforms were carried out related to education and religion. Much emphasis was laid on personality development in which humanistic viewpoint was followed. After the period of reawakening in the field of Western education, realistic education restarted, but did not last long. Psychological ideology took birth as a result of the works of Herbart Spencer and Froebel. The effort of Spenser brought about scientific trend in education. Later John has

introduced the pragmatic view in education. Thus, psychology, science, philosophy and sociology came to be included in education which continues even today.

The fundamental principle of education according to Froebel is that instruction and teaching should be passive and protective, not directive and interfering. The principle of liberty has found most eloquent expression in the definition of education given by Rousseau. He says, 'obey the call of Nature'. We shall see that her yoke is easy and that when we give heed to her voice we find the joy in the answer of good conscience. Others have laid emphasis upon the social meaning of education whereby it aims at making an individual fit in the society. A perfect education is one which trains up every human being to fit into the place he or she is to occupy in the social hierarchy, but without, in the process, destroying his or her individuality. All the forgoing definition has stated that education is the process of development. Development means the gradual and continuous progress of mind and body.

3.1 Modernism and Education

The education, according to Descartes, an individual need not accept what was the heard or read without questioning. "Descartes does not purpose that everyone wants to learn this way but insist it is the "correct path". That will help one to gain as much knowledge as possible (Bicknell 33). Descartes defined education as the deliberate act of teaching a new concept or skill to an individual. This form of human interaction seems vital so that each individual may develop the foundational skills that are necessary to engage scientific frame of thinking, to pursue the ultimate destiny. The essence of human nature lies in thought. To find the truth he combined radical skepticism with analytical reasoning. He proved beyond doubt

that human reason is valid in the process of finding pure and certain truth. Descartes in his work *Discourse on Method* explored his 'methodical doubt' where he sought to doubt all things, including his own existence. He was searching for ideas that are indubitable, which are clear and distinct'. He doubted everything but he could still not doubt that he was thinking. Cogito ergo sum, 'I think therefore I am'.

Spinoza's moral theory demonstrates the notion of freedom and self-preservation provides the conceptual core of a coherent philosophy of education. The basic idea of Spinoza's philosophy is monism the idea that all things are one. He identified nature with God – pantheism. Spinoza gives a comprehensive investigation into the educational implications of his moral theory. Moral education is geared at moderating the passion so that we not only recognize but also act on the good overcoming *akrasia* – understanding and empowerment. Leibniz's education means being able to participate in society; it opens up opportunities and promotes social integration. He claimed that monads are the ultimate reality.

Empiricism is a philosophical belief that states knowledge is based on experience. John Locke's view on education is based on the empirical theory of human knowledge. In his famous work 'An Essay Concerning Human Understanding he says that, when born, the mind of the child is like a blank slate – tabula rasa to be filled later with the date derived from sensory experience. To him educations play a crucial role in the moral development and social integration of human being. Education means shaping according to each individual's temperament and skills exercised without force, but in rigorous and pragmatic movement. Berkely in his work '*Principles of Human Knowledge* contended that all existence depends on some mind to know it if no mind exist, then for all intents and purposes nothing would exist

values it perceived by these mind of God, ie; esse-est percipi. There is no existence without perception, but things may exists in the same that they perceived by God. Berkely set out to deny the existence of matter. He postulated that "to be is to be perceived". There is no existence without perception, but things exist in the sense that they are perceived by a Supreme Being. Aim of education is character development because the search for truth depends on personal discipline and steadfast character. The goal of education according to Hume is to base one's beliefs in experience and impression a posteriori. Knowledge is that which we know to concern content, which are universal. All our belief and actions are the product of custom or habit. So he gives importance to learning.

Two important works of Kant *Critique of Pure Reason and Critique of Practical Reason* sought to bring order to the divergent and warring philosophical camps of rationalism and empiricism. According to him knowledge comes him knowledge comes from concentration of thought processes. He worked out a system based on aposteriori and apriori logical judgement that he called synthetic apriori judgement. Both rationalist and empiricist insights gathered together in a unified system. In the *Critique of Practical Reason* he explored the moral and ethical realm. His effort was to arrive at universal postulations concerning what we may call moral ideals, moral imperatives, or moral laws. The primary ingredient of education is that which leads people to think and seek out the good, and the idea of humanity as the destiny of mankind. The essence of education is not simply training but for enlightenment. The education of will means living according to the duties flowing from the categorical imperatives. ie, performance of duties toward oneself and other. Kant's idealism is his concentration on thought processes and the nature of the relation between mind and its

objects on the one hand and universal moral ideals on the other. Education requires bringing talent, ideas to consciousness, introspection, intuition, insight and logic are used to bring to consciousness the forms or concept which are in the mind. So for him the goal of education is to discover and develop each individual's abilities and full moral excellence in order to better serve the society. Kant's approach to education and moral education is based on his moral philosophy. His emphasis on subjectivity is a fundamental principle of education. The idea of education is yard stick for the practice of education. To him good education is itself the source of all that is good in the world. The idea of an education that develops all the natural gifts of man appears to contain the truth.

The theme of Hegel's philosophy is *Bildung*. The term might be transalated as education. It refers to the formative self-development of the mind or spirit. To him the aim of education is upbringing the child to enable to be consciously or for itself, what is already is in itself. So the entire process of *Bildung* is fundamentally an inner or self-directed activity, never merely a process of conditioning the environmental stimulation or the accumulation of information presented by experience. Self-transformation and an acquisition of the power to grasp and articulate the reason for what one believes or knows.

3.2 Marxian Concept of Education

For Marx the source of all life is found in matter. Man is purely a product of nature and not a result of any force outside. A man is purely material being with natural origin and destiny. The development of a good moral character is an essential part of Marxist education. So equality, co-operation and sharing are instilled through education. According to Marxism

the purpose of education is to strengthen the state and building up of a classless society. Love of labour, hard work and respect for elders and respect for property are inculcated through education. In Marxism, truth is not objective or absolute, it is a relative experience. Knowledge gives power. Lenin believed "the only path to truth is science" (Chaube 161) which holds the materialist point of view.

Existentialism emerged as a movement in 20th Century literature and philosophy, foreshadowed most notably by 19th century philosophers like Soren Kierkegaard and Friedrich Nietzsche though it had forerunners like Dostoyevsky. In the 20th Century the German philosophers Martin Heidegger influenced other existentialist philosophers such as Sartre, Simone de Beauvoir, Albert Camus, Fyodor and Franz Kafka.

Beginning with Kierkegaard it has found both theistical and atheistical adherents among European intellectuals, the most well known among these being Jean Paul Sartre, the French man of letters who earned the notable distinction of declining the Nobel Prize for literature. Existentialism is a reaction against the naturalism of the scientists inventing a purely mechanical universe and the idealist lost in reflective contemplation of life. The existentialists hammer home the idea that philosophy is a matter of personal commitment and emotional involvement and not a mere logical construct to be argued coldly. The essence of existentialism is not the possession of truth but the search for truth; therefore it is a matter of personal discovery and has vital relationship to one's whole personality. According to the existentialists one should be a sincere man and not merely a consistent thinker. 'Existence precedes essence'. In the opinion of Sartre, there is neither pre-existent universal pattern for

man according to which one may shape oneself, nor is there a readymade intrinsic human nature according to which one may grow as a fig tree grows figs but 'man simply is'.

Heidegger did not write specifically about education, but his thoughts much promise in helping the educator better understand the intense personal side of existence. The question 'Who am I' is a profound and troubling question, one that most of us face more or less in a blind panic during adolescence and one that is probably never fully answered. We might say that this condition lies at the heart of the identity crisis that each person encounters at various times in his life. Maxine Greene's expression for education is that which "enables learners to become attentive, perceptive or wide awake to possibilities. The educator should develop phenomenological and hermeneutical competence to demystify the condition". (Howard 262)

Related to education, the subject matter of existentialist is that class rooms should be a matter of personal choice. Teachers view the individual as an entity within a social context in which the learner must confront other's view to clarify his or her own. Character development emphasises individual responsibility for decision; real answers come from within the individual, not from outside authority. Examining life through authentic thinking involves students in genuine learning experiences. Existentialists are opposed to thinking about students as objects, to be measured, tracked and standardized. Such educators want the educational experience to focus on creating opportunities for self direction and self actualization. The most important aim in education is the becoming of a human person as one who lives and make decisions about what will do and be Knowing' oneself, is the sense of knowledge of social relationship and biological development, are part of becoming. Human existence and the value related to it is the primary factor in education. Education in the

contemporary, industrial and technological society may will be cleansed and strengthened by emphasis on man for himself. "An uncompromising uniqueness is the message of existentialism for the philosophy of education today". (Kneller 121)

3.3 Language Analysis and Education

Language analysis is relatively a new movement in the history of philosophy and in the field of education. Language analysis is purely a method and a technique to solve the problems of philosophy and not a school of thought representing a metaphysical position about the universe, mind, man or such other phenomena. It is concerned with the correct use of language to describe verifiable facts and ideas. It is also referred to as philosophical analysis or logical analysis. It would prefer to call as the legal approach to education. The concern of language analysts about the correct use of words and phrases and about precise reference is comparable only to legal situation and documentation.

The prominent thinkers of linguistic philosophy are Ludwing Wittgenstein Bertrand Russell and GE Moore. Russell's philosophy of logical atomism, believed that complex problems and ideas can be conceived of or broken up into its minute or atomic forms and can be solved with clarity later. Wittgenstein deviated from Russell and he produced his monumental treatise *'Tractatus Logico Philosophicus'* in 1921. He felt that language of common usage or ordinary language is defective and ineffective in either solving or dissolving philosophical puzzles. So he set an ideal or perfect language of picture theory. According to Hirst ordinary language is an outcome of attempts of groups of people who described objects, experience and interactions. It is a medium of expression which has functional values,

"Ordinary language is a record of connections and distribution that men with predominantly practical purposes have found it important to make. It is, therefore, a valuable guide, but it should never be treated as a repository of unquestionable wisdom". (Hirst 8)

The influence of movement on educational thought and practice is profound and testing. It is felt more unconsciously than one is conscious of it. Any work that begins with operational definition, definition of terms used, and the like, bears the impact of language analysis. The research and writing on action, research and interaction analysis in education may be conceived of as an effect of the movement. An examination of assumption, exposure of logical fallacies, criticism, clarification and interpretation of educational concept has by far helped to clear the debris in educational literature. "Educational literature abounds with slogans and metaphors. An examination of these slogans has brought out the ambiguity and vagueness in them". (Komisar 214) Scheffler has referred to a few such slogans while out lining the role of language analysis in education. He begins with a question and answer in himself thus. "What sort of landscape, and then does education presents to the philosophical analyst. Among its central concepts are such fundamental ideas as knowing, learning, thinking, understanding and explaining which figures prominently not only in the received philosophical literature but in ordinary affairs and in scientific psychology as well. In addition, there are much more specifically educational ideas as mental discipline, achievement, curriculum, character development and maturity which are intimately related to school affairs and are moreover, foci of continuing practical debate". (Scheffler 8-9) Analysis of educational situations has led to serious discussions among professionals in educational circles about the words they use, concepts they teach and facts they pass on. It is due to the

movement that the format of the student's lesson plans in teacher education programmes has undergone and is still undergoing radical change.

3.4 Post Modernism and Education

Pre modernism, modernism and post modernism as philosophical systems are the three very different ways of looking at the world. The difference is represented best in their epistemologies.

In pre modernism, the Church, being the holder and interpreters of revealed knowledge, were the primary authority source. Pre modern period was based upon revealed knowledge from authoritative sources. They believed that ultimate truth could be known and the way to this knowledge is through direct revelation, generally assumed to come from God. As the shift in power moved away from Church, politics took over as primary source of authority. There are two new approaches to knowing that became dominant in the modern period. The first was empiricism which gradually evolved into scientific empiricism or modern science with the development of modernism methodology. The second approach was reason or logic.

According to modernist theory educators ideally should be authoritative transmitters of unbiased knowledge. Traditional modernist believes that educators are legitimate authorities on values and therefore they should train students in universal values. More liberal modernist argues that education should be 'value - neutral'. Teachers help students with value clarification - deciding what values each individual student will hold. The most important

value for them is rationality and progress. Education helps individuals to discover their identities that help the progress of both individual and society.

Post modernism seeks to reconstruct previous authority sources and power. Because power is distrusted, they attempt to set up a less hierarchical approach in which authority and source are more diffused. Post modernism questions the previous approaches to knowing, they advocate an epistemological pluralism which utilizes multiple ways of knowing.

In post modernism education responds as a way of understanding social, cultural and economic trends. It emphasizes the role of language as power relations and motivations in the formation of ideas, beliefs, and attacks the use of sharp binary classification such as male versus female, white versus black etc. To them there is no absolute truth, the world as subjective. Post modernism influences many cultural fields such as religion, literary criticism, sociology, linguistics, architecture history, anthropology, music etc.

Transmission of values and character formation are the core ingredients of a Christian educational philosophy in postmodern era is a renewed concern for ethics and value formation. In the educational context cognitive developmental approach to education focuses on moral, spiritual and civic education. The prominent character of education according to post modernism are high level thinking, research involvement, cooperation in learning, services experience, differentiation of instructions and character education.

Postmodernist theory holds that educationists are unbiased facilitators and 'constructors' of knowledge. Postmodernism thwarts the goal of unifying society which results in domination and exploitation, because unity is always based on dominant culture. Education

should help students to construct diverse personality and useful values in the context of their cultures. Students have no 'true self' or innate essence - because selves are social constructs. Post modern educators believe self -esteem is a pre -conditions for learning. They view education as a type of therapy. They help individuals construct their identities rather than discover them. Individuals and society progress when people are empowered to attain their own chosen goals.

Post modern educational trend seems to be in harmony with an educational philosophy. In synthesis, the dissonance and divergence between reference religious educational philosophy and educational practice which is evident throughout much of the modern era seem to be fading. In their place a cooperative, education can interrelate and jointly provide a postmodern world with a brighter hope for future.

MAJOR SCHOOL OF PHILOSOPHIES OF EDUCATION

3.5 Idealism

According to the idealistic philosophy reality is spiritual; it consists in ideas, purposes, intangible values and internal truths. "Idealism shifts the emphasis from the natural or scientific facts of life to the spiritual aspects of human experiences",(Bhatia 180) Idealism as a school of philosophy is represented by thinkers like Plato, Descartes, Berkeley, Fichte, Hegel, Kant, Shelley, Spinoza, Gentile etc. As a philosophic principle, idealism accepts the significance of thoughts, emotions and ideals and accepts the development of personality and spiritual values as the aim of life, so that unity in diversity is known. The nature of man is spiritual which find expression in intellectual, aesthetic and religious fields. Man can attain

these ideals and values to know the real good and true knowledge and thus develops his personality.

An idealistic philosophy of education is the realization of man as an integral part of universal mind. It assumes that the grandest work of God is man. Hence the foremost aim of education is to 'exalt human personality', which implies the realization of the highest personality of the self in a social and cultural environment. This self realization is not the objective case of a few selected personalities only. Each individual has to be provided with suitable environment and condition that will be conductive to the realization of self. It is to transmit the spiritual heritage of man from generation to generation. Education should help man and direct his efforts towards the attainment of rationality in the universe. "Education must enable mankind through its culture to enter more fully into the spiritual realm" (182). The idealistic philosophy of education is very much akin to Upanisadic thoughts.

According to the idealistic philosophy, reality is spiritual or thought. It consists in ideas purposes, intangible values and internal truth and emphasis on the mental and spiritual qualities of human being. Ultimate reality may be conceived as a self; it may be oneself a community or self or universal self. Hence education becomes primarily concerned with self realization. Following points are the strengths of idealism.

* The high cognitive level of education that idealist promotes.
* The concern for safeguarding and promoting cultural learning and also for morality and character development stress on self-realization and on human and personal side

of life. They provide a comprehensive, systematic and holistic approach towards education.

3.6 Naturalism

Naturalism as a philosophy considers that nature is everything, there is nothing beyond it, they emphasis on causal relationship with power dynamism and natural laws. According to naturalist philosophers "moral instinct, innate conscience, other world miracles, providence, power of prayer, freedom of will are illusions". (Bhatia 17) There is no absolute good or evil in the world. It is a system that depends on the 'regulations of the actual life of the educand'. There are four forms of naturalism: atomism, scientific naturalism, mechanical naturalism and historical naturalism. Atomism was initial naturalism and historical naturalism has no philosophical significance. The scientific naturalism is based on physical science and biology. To them there is no difference between matter and consciousness. John Stuart Mill lays emphasis on causal relationship of physical naturalism. Being a biological naturalist, Darwin holds that to make the child ready for future struggle in life was the primary aim of education. Mechanical naturalism considers the whole universe, including conscious beings as mechanical. It has found support from Herbert Spencer, Laplas, and Ross etc. Aristotle, Comte, Hobbes Bernard Shaw are some of the noted thinkers along these lines.

Naturalism in education aims at self expression, autonomous development of individuality and prepares oneself for the struggle for existence. Bacon and Comenius are associated with naturalism in its beginnings. The latter believed that 'the proper method of imparting knowledge is to follow nature'. Nature, he said, would not lead us astray; the spirit

that is prevalent in various operations of nature ought to be the dominating principle in the art of teaching.

The naturalism of Rousseau is vividly expressed in the slogan 'Back to Nature'. According to Rousseau there are three sources of education, nature, men and things. Education from nature consists in the spontaneous development of student's organs and faculties. The process of education should facilitate the development of child, innate powers and capacities. It should enable the child to live completetely as well ie. man-making education. For him the aim of education is the development of the child in conformity with the nature. Rousseau advocates that "give your scholar no verbal lesson; he should be thought by experience alone" (Bhatia 174). In his work *Emile* he adopt heuristic attitude to apply natural phenomena. Nature is not always the charming and innocent Rousseau might suggest to the impressionable reader. Pierce maintained that the concept of practical effects makes of the whole on concept of an object. The function of education is to enable the child to create his own values and dynamic adaptable mind. To him true knowledge of anything depends on testing our ideas in actual experience. Paedo centric method presents knowledge as a unified whole. Mc. Dougell holds that the purpose of education is to redirect or sublimate the natural impulses for socially desirable ends. Education aims at the transformation, synthesis and sublimation of instincts. Nunn regards the autonomous development of individual as the central aims of education and insisted that an education which aims at fostering individuality in accordance with nature is education. Individuality is identified with self-assertion which means self – realization. He prefers to use education as a means of making the individual capable of developing his own individuality and of contributing to society. Darwinists argue

that education must train the individual to struggle successfully for his own survival and aim of education is to endow the individual with the ability to adapt himself to the surrounding. So the he will be well adjusted, strong and happy being. Lamarck agrees with the concept of biological evolution and to him aim of education is to adapt the environment. Herbert Spencer believed education to be a preparation and training for the complete life. Bernard Shaw believed that education must aim not only for individual development but also at making individual capable of stimulating and sustaining social development.

The naturalist tendency in education leads to the multitudinous experimental studies. Teacher education specializes the study of scientific spirit to evaluate his potentialities and personality. This is entirely a matter of improving performance and practice, of perfecting ways and means. The positive sciences have a generalized method of conducting enquiry and research and carrying out crucial experiments. Naturalism of this second kind of the educationists seek to apply such method, in plenitude of their rigour to the phenomena of education.

3.7 Realism

Realism is a philosophical principle which argues that objects really 'do exist'. Reality exists independent of the human mind. Truth is objective - what can be observed. The realist trend in philosophy can be traced back to Aristotle. To him education is a process which proceeds from matter to form, from imperfection to perfection i.e., it is a process of developing one national powers to the fullest. Another great name of the school is Saint Thomas Aquinas who infused the realist spirit in religion. In his work *Summa Theologica* he

explains that one human mind cannot directly teach other but can communicate indirectly though symbols signes etc. only God can touch the inside the soul directly. For him knowledge can be gained from sense data, it can lead to God. One should proceed from the study of matter to the study of form. He believed that a proper education is one that fully recognizes the spiritual and material nature of the individual. He thought that spiritual side is more important. He is strongly in favour of the education of soul. Both Aristotle and Aquinas held to a dualistic doctrine of reality ie form and matter and the material and spiritual side of human mind. Comenius in his 'Great Didactic' wrote that mind is only a passive recipient reflecting all things around it in a spherical mirror. John Locke put it more vehemently when he said that 'the mind is a 'tabula rasa' and reality is outside the mind. After him philosophers and thinkers like Immanuel Kant, John Herbart and William James affirmed that the external world is a real world. From the historical standpoint there are four forms of realism which are Naïve Realism, Scientific Realism, Neo Realism, and Critical Realism. In naïve realism the existence of an object is independent of the knowledge; it does not influence the object. It is also called common sense realism. Scientific realism holds that knowledge does not influence the object but it can influence the idea of the object. Naive realism states that ideas are as real as objects and that objects are independent of ideas. Critical realism explains that two elements function in knowledge - the mind and the object. It is the re-statement of Locke's representationalism.

Locke's view on education as expressed in *some Thoughts Concerning Education* are not theoretical, they are practical ideas about conduct laziness, reward, and punishments and other generalities in the educational process. A.N. Whitehead argued that education is to

concern with living ideas because to him the important things to be learned are ideas. He warned against learning inert ideas simply because it had been done in the past. This shows his organic orientation that education should enable as to get into the flow of existence, the process – patterns of reality. Dr. Brouely, presents the realist view point in education defines, the common aim of education as a preparation for the 'good life'. To him "the task of the school is to transcribe the good life, the good individual and the good society" (Blau 25) i.e., the principle of self preservation, self determination and self integration.

The contributions of logical positivism on education, is to sharpen our criticism of ideas and to make education scientific. Truth for them is a matter of empirical verifications and metaphysic unverifiable and hence meaningless. Realist puts great emphasis on the practical side of education and their concept of practical includes education for moral and character development. Locke, Herbart and Spencer all held that the chief aim of education should be moral education. Whitehead was close to this position when he said that 'the essence of education is that it be religious. Spencer held that science provides for both moral and intellectual education because the pursuit of science demands integrity, self sacrifice and courage. For Locke good character is superior to intellectual training.

In the sphere of education realism made its appearance as the revolt against theoretical and verbal education. To them education is a cultural necessity. Every individual will have certain congenital potentialities there are also differences in the degree. The realization of these potentialities by a person is called self-realization. It is individualistic and social at the same time. Education enables a person to actualize his potentialities. Self integration refers to the integrated development of an individual. The aim of education is a concrete way to make

life intelligible. Acquisition of knowledge is an important objective of education. It also includes character development and vocational efficiency. The function of educations was to develop the qualities of determinations, reason and intelligence so that one should solve the problems of life.

Realism is a practical philosophy and it preaches one to come to terms with reality. Its emphasis on reality-orientation would help an individual to preserve his mental health. In a vast expanding scientific and technological universe, where knowledge increases exponentially a philosophy that justifies the acquisition of knowledge is worth its place.

3.8 Perennialism

Perennialism is a modified form of realism and is an outgrowth of the thoughts of St. Thomas Aquinas. Many of the principles of Perennialism are still deeply rooted in Aristotle's, tradition of realism. Perennialists believe that there are certain everlasting values to which we must return and which must be brought to the attention of all youth in the schools. John Milton, 17th Century English Poet, in his famous work *Tractate on Education* advocates the study of classified language. To him goal of education is students' intellectual and moral development. The universal in every man is in equal proportion, so that the goal rests fundamentally upon the concept that human nature is universally the same.

According to Hutchins, "the whole doctrine of adjustment to the environment is radically erroneous we are here on earth to change our environment not to adjust it" (B.D. Bhatia 199). The ultimate end of education is the same for all men at all times and everywhere. They are absolute and universal principles.

3.9 Pragmatism

Pragmatism is typical American school of philosophy. It represents the practical mind of people. The chief principle of this philosophy is a man creates his own values; there are no fixed, eternal truths. Truths if any are man-made product. "All systems of ideas are relative to the situation in which they arise and the personalities they satisfy are subject to continuous verification by consequence" (Bhatia 187). They emphasis on man's power to shape his environment to his own need and to create successful solution of problems fairer and better environment for himself. There are three forms of pragmatism, humanistic, experimental and biological. Humanistic pragmatism conceives of the true as that which best satisfies human nature and welfare as a whole. Experimental pragmatism, that which can be experimentally verified. Biological pragmatism stresses the human ability of adaptation to the environment and that of adapting environment to human needs.

To pragmatilist education is not for the pursuit of knowledge for its own sake. The aim of education is to bring about changes in the individual so that he becomes an effective member of society. It may have its intellectual, aesthetic, moral and religious and physical aspects. It is based on activity. These activities want to satisfy and subserve human needs. The function of education according to them is to enable the child to create his own values and to cultivate a dynamic and adaptable mind.

The chief proponents of pragmatism are William James, Schiller, Bacon, Locke C.B. Pearce, and John Dewey. William James described pragmatism as the intermediary stage of idealism and naturalism. It emphasizes on the study of child and his nature as it considers that

the creative attitude of the child develops from nature. It emphasizes to develop creative attitude within society. The purpose of education is to bring such ability in the child through intellectual, emotional; activity based new values and fulfills the social needs. Bacon's influence on pragmatism has been significant. The inductive methods served as the basis for the scientific method. To him aim of education is the wish to apply the scientific method to the problem of humanity to secure a more satisfying life for all.

Auguste Comte is dream was to reform society by the application of science. As a positivist he claims that theology and metaphysics once served a useful function in helping explaining things, the rise and perfection of scientific thinking has surpassed them. Many secrets of human kind and nature can now be unblocked, and we can live in better harmony with ourselves and the natural world. Comte did help establish the application of science more direct to society rather than only to physical needs. His view of social structure and relationships are capable of systematic study and control usher in elements of social theory that are distinct to pragmatism.

In Dewey's scheme education is according to the human environment. Human environment changes from, place to place and time to time, there is nothing quintessential and fixed in his scheme. Dewey's philosophy and programme termed as experimentalism or instrumentalism. It indicates that he emphasized on the dynamic and ever changing character of life. He said that there are no fixed beliefs; utility is the touch stone of every value. So truth is not a fixed eternal thing but something subject to change. To him education is a process of re adjustment. He works out in concrete, terms the implications of this view for the growth of the mind of the learner, the curriculum, the method and objectives. This masterly coverage in

the end leads an education which conforms closely to the existing conditions in a society and emphasizes the success in socially approved and socially conditioned work as the touch stone of its merit. His philosophy of education as a whole is a mere reflects of the human society and if change and mobility are provided in the society to that extent they find a place in his educational scheme. In Dewey's terms action is attended by spontaneous reflection and Dewey's philosophy is concerned only with this. It is primarily a philosophy of spontaneous reflection. The mystery of Dewey regarding philosophy as the theory of education is a kind of abstract sociology of which education is a concrete part. It may indeed be said that if no philosophy we employed to guide education, it would in a society conscious of its nature, purposes and means take the form. What the pragmatist wants to achieve through education is "the cultivation of a dynamic, adaptable mind which will be resourceful and enterprising in all situation - the mind which will have power to create values in an unknown future". (188) Such minds that will reconstruct a society in which the human wants will be fully satisfied through a social medium consisting of co-operative activities.

Pragmatists lay stress on action rather than reflection. They hold that the child learns best only through his activities or his experience. So their method is learning by doing or learning through one's experience. They maintain that one of the chief characteristics of the learning is its integration. They believe that the integration will be possible if knowledge and skill are learnt through activities that are purposeful.

3.10 Essentialism

Essentialists believe that there is a common core of knowledge, the needs to be transmitted to students in a systematic, disciplined way. The emphasis in this conservative perspective is on intellectual and moral standards that schools should teach. The core of the curriculum is essential knowledge and skills and academic rigor. Although this educational philosophy is similar in some ways to perennialism, essentialist accepts the idea that this core curriculum may change. Schooling should be practical, preparing students to become valuable members of society. It should focus on facts - the objective reality out there - and the basics, training students to read, write, speak and compute clearly and logically. Schools should not try to set or influence policies, students should be taught hard work, respect for authority and discipline. Teachers are to help students keep their non-productive instincts in check, such as aggression or mindlessness.

William C Bagley emphasised that the central theme of education is to transmit cultural heritage and to achieve intellectual discipline. Their dictum is 'education for peace'. They are trying to spread this information and try to promote intellectual climate to bring peace to the world.

3.11 Progressivism

Progressivists believe that education should focus on the whole child, rather than on the content of the teacher. This educational philosophy stresses the students should test ideas by active experimentation. Learning is rooted in the questions of learners that arise through experiencing the world. It is active, not passive. The learner is a problem solver and thinker

who make meaning through his or her individual experience in the physical and cultural context. Effective teacher provide experiences so that students can learn by doing. Curriculum content is derived from student's interests and questions. The scientific method is used by progressivist educators so that student can study matter and events systematically The progressive educationist philosophy was established in America from the mid-1920. John Dewey was its foremost proponent. His tenet was to improve the way of life of our citizens through experiencing freedom and democracy, shared decision making, planning of teacher with students, student related topic are all aspects. To them books are tools, rather than authority.

3.12 Behaviourism

Behaviourist theorists believe that behaviour is shaped deliberately by forces in the environment In other words, behaviour is determined by others, rather than by our own free will. By carefully shaping desirable behaviour morality and information is learned. Learners will acquire and remember responses that lead to satisfying after effects. Learning is enhanced, if not, learning is inhibited. Motivation to learn is the after effect or reinforcement behaviorism.

Behavioristic school also known as learning school the chief exponents of this school are Skinner, Watson, Ullman etc. they believe that a child must master the skills of his culture and be able to work with other in order to preserve that culture under changing conditions. The concept like individualization and contingency contracting are their great contribution. The ideas such as self-evaluation and programmed instructions also their goals. They also

emphasize on the idea that the teacher must continually monitor the child's progress and must provide immediate feedback. Therefore they mostly concerned with a strict assessment of behavioral changes in order to evaluate each aspects of child programme, they are more interested in their aspects of teaching that can be quantitatively evaluated.

Behaviourism is linked with empiricism, which stresses scientific information and observation, rather than subjective or metaphysical realities. Behaviourists search for laws that govern human behaviour. Change in behaviour must be observable, internal thought processes are not considered.

Ivan Pavalov's research on using the reinforcement of a bell sound when food was presented to a dog and finding the sound alone would make a dog salivate after several presentations of the conditioned stimulus. Learning occurs as a result of responses to stimuli in the environment that are reinforced by adults and others as well as from feedback from actions on objects. The teacher can help the students learn by conditioning them through identifying the desired behaviours in measurable, observable terms. The organism can act to change its environment and the resulting change reinforces the behavior of the organism in some way.

3.13 Humanism

Humanistic education is also known as person centered education. They tend to focus on the felt concerns and interests of the student intertwine with the intellect. It is a movement which gives importance to man a proper recognition in the universe. To them man is an end not as means. They believe that both feelings and knowledge are important in learning

process. Humanistic education teachers have a wide variety of skills. The basic skills such as reading, writing and computation as well as skill in communicating, thinking, decision making etc. As a humane approach to education it help students to believe in themselves and their potential and encourage that will fosters self respect and respect for others. It also deals with basic human concern such as to pursue knowledge, to grow, to love and to find meaning for one's existence.

The roots of humanism are found in the thinking of Erasmus who attacked the religious teaching and thought prevalent in his time to focus on free inquiry and rediscovery of the classical roots from Greece and Rome. For him character formation as a goal of education. He believed in the essential goodness of children, that humans have free will, moral conscience, and the ability to reason, aesthetic sensibility and religious instinct. He advocated that the young should be treated kindly and that learning should not be forced or rushed, as it proceeds in stages. Humanism was developed as an educational philosophy by Rousseau and Pestalozzi, who emphasized nature and the basic goodness of humans, understanding through the senses, and education as a gradual process in which the development of human character follows the unfolding of nature. Humanists believe that the learner should be in control of his or her own destiny. Since the learner should become a fully autonomous person, personal freedom, choice and responsibility are the focus. The learner is self-motivated to achieve towards the highest level possible. Motivation to learn is intrinsic in humanism. Thus education means both acquisition of knowledge and experience as well as the development of skills, habits and attitude which help a person to full and worthwhile life in this world. It is a process of draw out the best in man. So the goal of education according to

humanist thinkers is that education should be to foster student's derive to learn and teach them how to learn. Students should be self motivated in the studies and desire to learn on their own. It promotes positive self-direction and independence and help to develop the ability to take responsibility for what is learned, creativity etc.

The main exponents of humanist school are Maslow, Carl Rojers etc. They emphasis humanism is the goal of education. Being Humanist educator they hope that the efforts of teacher will contribute to develop. the child a friendly, happy and who will help to find life meaningful. They assist the child to achieve self realization through creativity. They provide stimulation and guide to the child's physical. mental and emotional development including a system of values based on empathy. They gave great importance to learning through play and play way method of teaching. Their major contribution to education is education of child with learning and to adjust problems in life. These children are capable of growing and developing the acceptance of love, empathy. self -discipline, self- direction and individualization. It encourages a spirit of co-operation rather than competition among children. It is based on the satisfaction of child's physical, intellectual and socio-emotional needs.

Reference

Balu, C Joseph, Building a philosophy of education; New Delhi : Prentice Hall, 1965.

Bhatia and Bhatia, *The Philosophical and sociological foundations of education;* Delhi: Dorba House, 1997.

Bhatia Kamala & Bhatia, B D. *Theory and principles of Education.* New Delhi: Dhoha house 1997.

Chaube S.N.A *text book of Educational Philosophy.* New Deli Wisdom Press, 2011.

Edward, Power, *Main Currents in the History of Education;* New York: ML. Grew Hill Co, 1970.

Fowler. W.W, *The Toan Festivals of the period of the Republic;* New York: Macmillan, 1925.

Hirst, P.H and Peter, R.S, *The Logic of Education;* London; ELPS and R&K, 1975.

J. Stabart, *The Grandeur that was Rone;* London: Sidwick & Jackson, 1977.

Jogi Premchand, *History of Educational Philosophy.* Delhi: Crescent Publishing Corporations 2009.

Jogi, Premchand, *Introduction to educational Philosophy;* Delhi: Crescent Publishing Corporation, 2009.

Kneller, *Contempary educational theories in foundation of education;* New York: John Wiley and sons, 1967.

Komisar, B. Pant and Maclellan, James.. *Language and concepts in Education*; Rand McNally & Co. Chicago. 1961.

M S, Talwar & V.A, Banakanal, *Philosophical and Sociological perspective in educations;* New Delhi: Centrum Press, 2009.

Rawat, P.L, *History of Indian Education* (3rd ed); NewDelhi Ram Prasad and sons 1963.

Rawat, Sadhika & Ranga Rajan, Teaching of Education; NewDelhi Pacific Books International 2013.

Scheffler, Israel, *The Language of Education;* New York: Charles C Thomas Illinois, 1960.

Shukla, Ramakant, *Philosophy & Education;* Jaipur; Sublime Publications 2003.

CHAPTER 1V

Educational Philosophy of Swami Vivekananda

Swami Vivekananda was the epitome of fearlessness, courage and righteousness. He was nationality and spirituality personified. Spirituality played a great role in his life. So he based his philosophy of education on Vedanta and Upanishads. He said that the atman or soul was present in every creature; the mission of life of man is to realize it. He believed that all kinds of knowledge or Jnana whether spiritual or general was innate in man. In the educational philosophy of Swami Vivekananda, we can see the glimpse of naturalism, idealism and pragmatism. He acted as a naturalist when he advocated that education can be gained in the natural atmosphere. He became an idealist when he said that the chief aim of education should be spiritual development of the individual, the knowledge which is already present in him. At the same time, he was a great pragmatist when he said that art, industrial and technical education of the Western countries was necessary for national development and emphasised on its utility in India.

Swami Vivekananda is a name, which brings to us the images of a Saint, a prophet, a reformer, a humanist and much more. Translating the teachings of his master Sri Ramakrishna, into philosophy and percept, he shifted the focus of religion from celestial beings to human beings. Human beings became the central focus of spiritual life. He redefined religion and its practice in a manner that encompassed everything to do with our human existence. His goal was to see that all beings could attain the knowledge of their divine nature.

Swami Vivekananda's special contribution to the present age is the deliverance of a universal messages conducive to man's moral and spiritual upliftment and the harmonious living of all human beings, irrespective of difference of colour, creed, sex, age, social rank, cultural standard, political outlook and so forth. Vivekananda's personal experience of East and West, his penetrating insight, his erudition, his boundless compassion, his immaculate life and above all his realization of the ultimate One, the Truth of truths beyond all diversities, made him specially qualified for Divine Commission – the reconstruction of humanity on the spiritual foundation.

Swamiji's chief concern was spiritual elevation of humanity. He saw the human being as inherently endowed with many potentialities and held that common aim of religion, education and work was the development and manifestation of these potentialities. 'Service to man is service to God' was the main principle of his gospel of social service. He founded Ramakrishna Mission primarily with the aim of rendering service in the fields of education public health, rural development, religious harmony and inculcation of moral values.

Swami Vivekananda tried to reconcile human contrast and conflicts and want to establish the universal brotherhood of man. He held out the vision of universal religion which would recognize divinity in every men and women and which help humanity to realize its own nature, ie, Divine nature. He declared that "it is man making religion that we want, it is man making theories that we want, it is man making education all round that we want" *(Complete Works* Vol. V. 224) . He saw the divine in the form of the poor whom he called Daridra Narayan. His mission was the reconstruction of humanity on a spiritual foundation which consists of universal truth that underlie not only all religious but all phases of life. This was

his man making message. It combines man making religion with man making education. In his great message, Swamiji emphasized two values, which considered the central values of Indian Culture and Civilization; they are 'tyagi', (renunciation) and seva (service) renunciation of the little self manifestation of the higher self and its positive expressions of service. Then only can a man establish harmony with his fellow man and with the rest of creativeness. It alone enables a man to cooperate with others and work for general welfare.

Swami Vivekananda was a veritable embodiment of Divine energy. Swamiji's dynamic personality had different kinds of impact on different minds and even common people referred to him as the 'Cyclonic Monk', 'The Hindu Napoleon' and the Warrior Monk', He was a living dynamo who impressed everyone with particular aspects of his blazing personality. He radiated an aura of courage and fearlessness. These attributes, together with his spiritual magnitude, rebust optimism and above all his powerful message, are the external source of living philosophy – declared as 'a tonic of the soul'.

Hindu scriptures evidently are the early influence in his intellectual and emotional make-up. During his early days, he was influenced by two divergent aspects of pious religiosity and an agnostic inclined intellectualism. His mother taught him the Hindu epics, Viz. Ramayana and Mahabharata, his grand father the Upanishads and Vedanta while it was his father who made him an intellectual giant by teaching him Western philosophy and science. Vivekananda's philosophy arises from the awareness of the social, religious and economic conditions of the Indian masses.

The deepest influence upon his thought is 'Ancient Hindu Philosophy' especially of the Upanishads. It can safely be said that to a very great extent. The main body of thought is derived from these Hindu scriptures, from the Upanishads and the Vedanta. He holds that highest truth can be realized by everyone in his very life because it is in every body, only we have to unfold it. He says that "life is a long march towards the highest and best that is hidden in us" (Vivekananda, *Vedanta and the Future of Mankind, 34*). His basic belief is the essential unity of everything that is, in the completely monistic nature of reality owes its origin to Vedanta. Vivekananda always emphasizes the need of interpreting Vedanta in accordance with the demands and needs of the times. Vivekananda is influenced by Buddhist philosophy also. There are at least three ideas in Vivekananda's philosophy for which he remains indebted to Buddhist thought. The first and the foremost is the idea of Mass liberation that Vivekananda envisages; it has a clear similarity with the Buddhistic ideal of Bodhisattva. Secondly he is impressed by the Buddhist assertion that the raft with the help of which one crosses a river in storm should be left for the use of others. Buddha himself, even after attaining enlightenment Nirvana kept on roaming about helping others in their struggle suffering. Vivekananda recognizes the worth of such humanitarian and altruistic work. His missionary zeal for service is influenced by this. Thirdly, some of the Buddhistic ideals, like Samyak karmata and Ajiva have also inspired Vivekananda a great deal.

Along with Indian influences, he also carried on his thought the influence of Christianity. He was impressed by the strength of character, the soul-force that the man of the cross possessed. He could see that it required a supreme spiritual strength to forgive the oppressor in the midst of acute spiritual suffering. He was greatly influenced by the Brahma

Samaj; his association with samaj inculcation it can be a strong feeling against the prevalent orthodox and superstitious believes and to raise his voice against these practices. He reality the Gita, which advocates service and renunciation, was a source of constant inspiration for Vivekananda.

The profoundest influence was that of his master, Sri. Ramakrishna Paramahamsa. It was Sri. Ramakrishn who makes the spiritual transformation in the personality and mental make-up of Vivekananda. Ramakrishna himself a great humanist, framed Vivekananda in the very same mould. His master led him to 'Nirvikalpa Samadhi and opened the eyes of the disciple to renounce all egoistic desire including that for his own salvation, and convinced that the mission of life is to the service of mankind.

4.1 Philosophy of Education

"Education is the manifestation of the perfection already in man" *(Complete Works* Vol. IV 358). What we say a man 'knows' should in strict psychological language, be what he 'discovers' or 'unveils'. What a man 'learns' is really what he 'discovers' by taking the cover off his own soul, which is a mine of infinite knowledge. "We say Newton discovered gravitation was it sitting anywhere in a corner waiting for him? It was in his own mind; the time came and he found it out. All knowledge that the world has ever received comes from the mind; the infinite library of the universe is in your own mind. The external world is simply the suggestion, the occasion, which sets you to study your own mind. The falling of an apple gave the suggestion to Newton, and he studied his own mind. He rearranged all the previous links of thought in his mind and discovered a new link among them, which we called the law of

gravitation. It was not in the apple or in anything in the centre of the earth" *(Complete Works* Vol. 1 28).

According to Vivekananda all knowledge therefore secular or spiritual is in the human mind. In many cases it is not discovered, but it remains covered, and when the covering is being slowly taken off, we say 'We are learning' and the advance of knowledge is made by the advance of this process of uncovering. The man from whom this veil is being lifted is the more knowing man; the man upon whom it lies thick is ignorant, and the man from whom it has entirely gone is all – knowing, omniscient. Like fire in a piece of flint, knowledge exists in the mind; suggestion is the friction which brings it out, all knowledge and all power are within. "What we call powers, secrets of nature, and force are all within. All knowledge comes from the human soul. Man manifests knowledge, discovers it within himself, which is pre existing through eternity" *(Complete Works* Vol. 1. 422).

No one was ever really taught by another each of us has to teach himself. The external teacher offers only the suggestion which arouses the internal teacher to understand things. Then things will be made clearer to us by our own power of perception and thought, and we shall realize them in our own souls. The whole of the big banyan tree which covers acres of ground was in the little seed which was perhaps no bigger than one – eighth of mustard seed. All that mass of energy was there confined. The gigantic intellect, we know, lies coiled up in the proto plasmatic cell. It may seem like a paradox, but it is true. Each one of us has come out of one protoplasmic cell and all the powers we possess were coiled up there. We cannot say they came from food, for us you heap up food Mountains high, what power comes out of it? The energy was there, potentially no doubt, but still there. So is infinite power in these

souls of man whether he knows it or not. Its manifestation is only a question of being conscious of it. The Divine light within is obscured in most people. It is like a lamp in a cask of iron. No gleam of light can shine through. Gradually, by purity and unselfishness, we can make the obscuring medium less and less dense, until at last it becomes as transparent as glass. "Sri Ramakrishna was like the iron cask transformed into a glass cask through which can be seen the inner light as it is" *(Complete Works* Vol. VII 21).

"You cannot teach a child any more than you can grow a plant. The plant develops its own nature" *(Complete Works* Vol. V.410). "Loosen the soil a little, so that it may come out easily. Put a hedge round it see that it is not killed by anything" *(Complete Works* Vol. IV. 55). "You can supply the growing seed with the materials for the making up of its body, bringing to it's the earth, the water, the air that it wants. And there your work stops. It will take all that it wants by its own nature. So with the education of child 'A child educates itself'. Within man is all knowledge and it requires only an awakening, and that much is the work of the teacher. We have only to do so much for the boys that they may learn to apply their own intellect to the proper use of their hands, legs, ears and eyes" (*Complete Works* Vol. V. 366).

"In every one there are infinite tendencies which require proper scope for satisfaction". (*Complete Works* Vol. VII 269). Freedom is the first condition of growth. Vivekananda encourages the free will and self training of children. The thinking principle was reckoned higher than the subject of thinking. The training of the mind is a prerequisite for knowledge acquisition. The pupil had to educate himself and had to achieve his mental growth with the help of the teacher. Forceful guidance and compulsion in teaching bring about negative effect. In the words sister Nivedita, Swamiji's most favourite disciple the whole of

education is complete if we once waken in a child the thirst for knowledge. For that, the first need of the teacher is to enter into the consciousness of the taught to understand where he is and towards what he is progressing. Without this there can be no lesson. All that we can do is to stimulate him to help himself and remove from his path and takes him to achieve real nature. Violent attempts to reform always end by retarding reform. "If we do not allow one to become a lion, then one will become a fox" (*Complete works* Vol.VII 22).

We should give positive ideas. Negative thoughts only weaken men. "Do you not find what where parents are constantly taxing their sons to read and write, telling them that they will never learn anything the latter do actually turn out to be so in many cases? If you speak kind words to them and encourage them, they are bound to improve in time. If you can give them positive ideas, people will grow up to be men and learn to stand on their own legs. In language and literature, in poetry and arts, in everything we must point out not the mistakes that people are making in their thoughts and actions, but the way in which they will be able to do these things better" *(Complete Works* Vol. VII.170) . The teaching must be modified according to the needs of the taught. Past lives have moulded our tendencies and so give to the pupil according to his tendencies. Take everyone where he stands and push him forward *(Complete Works* Vol. VI.246). Service as Worship. Vivekananda says "Education is not the amount of information that is put into your brain and runs riot there, undigested all your life. We must have life building, man making, character – making, assimilation of ideas. If you have assimilated five ideas and made them your life and character, you have more education than any man who has got by heart a whole library. If education were identical with

information, the libraries would be the greatest sages in the world and encyclopedias the rishis" (302).

Getting by heart the thoughts of others in a foreign language and stuffing your brain with them and taking some university degrees, you consider yourself educated. In this education "What is the goal of your education? Either a clerkship or being, a lawyer or at the most of a Deputy Magistrate, which is another form of clerkship isn't that all? What good will it do you or to the country at large? Open your eyes and see what a piteous cry for food is rising in the land of Bharata, proverbial for its food. Will your education fulfill this want"? *(Complete Works* Vol. VII, 182). The education that does not help the common mass of people to equip themselves for the struggle for life, which does not bring out strength of character, a spirit of Philanthropy and the courage of a lion, is it worth the name? "We want that education by which character is formed, strength of mind is increased, the intellect is expanded and by which one can stand on one's own feet" *(Complete Works* Vol. V.342). What we need is to study, independent of foreign control, different branches of knowledge that is our own, and with it the English language and Western science; we need technical education and all else that will develop industries.

The end of all education, all training should be man making. The end and aim of all training is to make the man grow. The training, by which the current and expression of will are brought under control and become fruitful, is called education. It is man – making religion that want. It is man making theories that we want. It is man making education all round that we want. Neither parrot like book learning nor borrowed ideas will ever lead to the process of self unfoldment, to attain the realization of the infinite power within. An education that does

not enable one to stand on one's our legs is not worth having. A system that promotes mere parroting of facts and makes us overly dependent on external aids only enslaves our intellects even further. Swamiji advocated a mode of education that endorsed an integrated development of the human personality. Such an integrated model takes care of the physical, mental, intellectual and spiritual growth of the student. He firmly believed that a true balance achieved between these four factors of the individuals development would create a strong, independent and a compassionate human being thriving for the absolute truth" (T.V Avinashalingam 12).

The teachers are not the masters and they should not assume that they knew everything. Teaching is a service and takes it as privilege given by the almighty to serve the children. The first and foremost condition is to give freedom for growth. Service is worship. The teachers are specially blessed as they were assigned the divine task of teaching. Do it only as worship.

Vivekananda is also a proponent of the Vedic or Upanisads concept on education or the Indian ideal of education. That education is to understand the knower and the known which enable the knower to know the absolute that is Paravidhya that which is not aparavidhya or avidhya. Apara Vidhya is the secular knowledge, the understanding of the phenomenal world which is centered on the curriculum. The ultimate aim of education is to find out the 'Truth'. The student is starting from a point of avidya, traverse through the aparavidhya removing all the obstacles to reach the paravidhya.

4.2 Means of Education

The best means of education, according to Vivekananda is love. Education should be based upon love. Love is the best inspiration in character building. The child should be taught through love. This love for men, for human being, the only motive in imparting education should be love for the educand, for the man in him. That is why Vivekananda's philosophy of education is known as man – making. The teacher's aim should be neither money making nor attainment of fame but only bestowing human love. The spiritual force works through love. This love within the educator is the real source of his influence upon the educand. This may be amply clear by the example of the relationship of Vivekananda with his Guru Ramakrishna. It was the force of spiritual love in Ramakrishna which helped Vivekananda to God realization. It is this which makes the educator to take the educand from untruth to truth, darkness to light, and death to immortality. The task of the educator is to help the educand in manifesting and expressing his abilities and capacities. Education should help the individual to recognize his cultural heritage and to use it in his struggle of life. The educator can guide the educand because he himself has the experience of treading on this path and knows how to face the difficulties. Vivekananda has not only presented high ideals of education but also developed a sound system by which these ideals may be achieved.

Education is not a bed of roses. Every educand has to face problems peculiar to his own. He solves them by his own efforts and with the guidance of the teacher. The skilled teacher guides the pupil through these difficulties and takes him forward. This requires a sufficient knowledge of human psychology because most of our problems are psychological in nature. The teacher should teach the educand to concentrate his attention, only then can the

problems be solved. The greater attention the more the effort effective. Concentration, according to ancient thought, is the key to true knowledge. Therefore Vivekananda has placed much emphasis upon focusing of attention. It is only after years of concentration that a man becomes a scholar and great scientist. The educand should be distinguished according to their abilities; every one of them has to develop concentration. Again while teaching concentration; the educator should keep in mind the varying abilities of concentration possessed by the educants. While for some persons concentration is spontaneous and easy, for other it is difficult and requires long training. Hence, the educator must organize his teaching in such a way that he may be helpful to teach educand separately. He should attend to every one's difficulties and try to solve them as much as possible. Thus Vivekananda supported the ancient Indian means of achieving concentration through Yoga.

Again according to ancient Indian thinkers, Brahmacharya or abstinence is the first means of achieving concentration. It gives mental and spiritual powers of the highest kind. It transforms sex drive into spiritual force. Brahmacharya implies purity of thought, deed and action. It helps to improve and sharpen various psychological processes such as learning and memorizing, thinking. It helps in achieving power of memory and improves the powers of the mind. Vivekananda therefore, strongly emphasized the need for the students to observe Brahmacharya. This leads to both mental and physical advantages. Firstly it takes effective care of all distractions. Secondly it improves the body and the mind so that they may become effective means of knowledge.

In addition to concentration, the other means of education are discussion and contemplation. It is only through these that the educand may remove his difficulties.

Discussion should be carried out in an informal atmosphere. Contemplation should be practiced in a calm and quiet atmosphere with the mind fully alive. In the end, the educational process requires faith and reverence of the educand in the teacher and his teachings. Without faith and no true knowledge can be achieved. It is faith and reverence which are the sound foundations for all character development and self-education. This faith and reverence, however, depend not only upon the educand but also upon the high examples presented by the teacher. In the educational process, therefore, the teacher occupies a very high place.

4.2.1 Freedom in Education

Vivekananda was a strong supporter of freedom in education because he believed that it was the first pre-requisite of development. Hence no teacher should exert any kind of pressure on his pupils. It is foolish to think them one can improve another person or child. Only the child himself can solve his own problems. All that the teacher can do is to help him. Vivekananda stressed up on educators that their attitude to teaching should be that of a worshipper. Like other contemporary philosophers of education he too, believed that education is as important to the realization of God. For him education is also a means to establishing brotherhood in all mankind.

4.2.2 Vivekananda's Concept of Curriculum

According to Vivekananda, the very essence of education is concentration of mind, not collecting facts. He did not prescribe any typical curriculum to be followed rigidly. He emphasized a curriculum based on the concept of all round development of the child personality. One side he recommended the study of Vedanta, Religion, Philosophy and

Technology and on the other side, he favoured Western Sciences engineering and other modern subjects. He wanted to synthesis these two trends, which was the burning need of the day.

Vivekananda had a comprehensive view of education and its contents. He recommended the study of language, especially regional language, Sanskrit, link language and English. He also stressed on the importance of subjects like, history, geography, economics and other social sciences. Even home sciences and psychology were recommended by him. Vivekananda wanted to make education self supporting in all respects. Economic independence should be important aspects of education. For this reason, he favoured agriculture, technical education and physical education. Physical education and health education has important role in man's progress. He was concerned about the proper care of body health development of one's physique.

Vivekananda was in favour of replacing the ideal of utility by an ideal of beauty. Art, science and religion are three different way of expressing single truth. Besides the provision of science and Vedanta he considered art is an indispensable part of the curriculum. Education in science must be supplemented by training in art. According to him, while Asians specialized in Art, the West developed science and both are necessary for modern man. The ideal of utility should be substituted by the ideal of duty through the teaching of art.

Vivekananda welcomed the impact of western science and technology and at the same time he cautioned his countrymen against being dazzled by its materialist success and going in for a slavish imitation of its customs and way of life. He advocated "What we want are

western science coupled with Vedanta, Brahmacharya as the guiding motto and also shradda in one self " *(Complete Works,* Vol. V, 366) . He placed great emphasis on the inclusion of subjects on the cultural heritage of Indian in the school curriculum and at the same time insisted on the learning of western technology. Manjumder wrote "He represented the modern spirit of freedom and equality, manliness and energy of action and he demonstrated in his own life the basis unity of manliness and goodness. He was in other words, the personification of the harmony of all human energy". (Majumder 216-217) Tagore said: "Not only that he sought to build a bridge between east and west but he was the perfect example of such a synthesis". (Tagore 48). Tagore in his Rabindra Rachanavali greeted Vivekananda "as the meeting point of east and west" (48).

4.2.3 Medium of Education

In teaching language Vivekananda laid particular stress upon teaching through the mother tongue. Here he is supported by all other contemporary Indian philosophers of education. Besides mother tongue, there should be a common language which is necessary to keep the country united. This may be taught in addition to these regional languages. The teaching of Sanskrit forms an important part of the curriculum envisaged by Vivekananda. Sanskrit is the source of all Indian language and repository of all inherited knowledge. It is therefore, absolutely necessary that every Indian should know Sanskrit. Vivekananda appreciated the greatness of Sanskrit in eloquent words when he said that this language granted power, ability and prestige to the nation and that our awareness of our cultural heritage and past greatness depends very much upon our knowledge of this language. He felt that in the absence of this knowledge, it will be impossible to protect Indian culture. If the

society has to develop and progress, it is necessary that men and women should know the language which is the store house of ancient heritage, besides the knowledge of the mother tongue. Vivekananda elaborately discussed the teaching methods in physical, moral and religious education.

4.2.4 Physical Education

Vivekananda laid particular stress on the value of physical education. He said that a person who is physically strong can realize the self. He stated "make your nerve strong, what we want is muscles of iron and nerves of steel. We have wept long enough. No more weeping but stand on your feet and be a man" *(Complete Works* Vol. III. 224) . He said you will be nearer to heaven through football than through the study of Gita. You will understand Gita better by your biceps, your muscles a little stronger *(Complete works,* Vol. II 242). You will understand the Upanishads better and the glory of the Atman. When your body stands firm on your feet you feel yourself a man: Self- realization or character building is impossible in the absence of physical education. One must know the secret of making the body strong through physical education, for a complete education, it is necessary to develop both mind and body. Vivekananda himself took physical exercise every day. He glorified power and opposed weakness in any form. Power is life and weakness is death. He emphasizes that power is happiness and weakness a never ending burden.

4.2.5 Moral and Religious Education

Laying emphasis upon religious education Vivekananda said "Religion is the inner most core of education. (Complete Works Vol. V.231). Religion is as the rice and everything

else, like the curries. Taking only curries causes indigestion, and so is the case with taking rice alone'. Therefore, religious education is a vital part of a sound curriculum. This religious education is necessary in order to counter effect the evil influences of modern materialism. It is only by a synthesis of religion and science that man may reap the advantage of both. As has been already pointed out, religious education in itself is not sufficient. It should not be the whole of curriculum but only a part of it. This religion, again, is not of any particular dogma or sectarian philosophy, in fact; it is what Tagore called religion of man. Hence Vivekananda did not distinguish between secular and religious education. Besides courage, Vivekananda highlighted service and renounciation (Tyaga or seva) in religious education. Then alone religious education may be useful to the nation. Religion creates total man. It encourages all type of qualities, soft as well as virile.

Moral and religious education will develop self – confidence among young men and women. Self confidence according to Vivekananda is the real religion. It includes universal brotherhood and love of humanity, because a person having self confidence sees his self-everywhere. Thus Vivekananda's religion was humanistic. Religion is the source of all that are good. Thus for Vivekananda, ethics and religion are one and the same. God is always on the side of goodness. To fight for goodness is service to God. Weakness is the source of all evils. It is the root of all violence, hatred and enemity. If a man sees his own self everywhere, he needs not fear any one. Fearlessness and power are eternal truth, the real nature of the self, Thus, Vivekananda pleaded for the realization of Truth through religious practices. Gandhi also identified Truth with God. The seeker after truth should search for it in every aspects of life. Truth is power, untruth is weakness. Knowledge is truth ignorance is untruth. Thus Truth

increases power, courage and energy. It is therefore, necessary for the individual as well as collective welfare.

Vivekananda worshipped power. This power was not physical or biological but spiritual power. Rising high in the tradition of Vedanta, Vivekananda never allowed his feet to leave the solid ground. His teachings influenced the west where materialism was rampant. This was due to the reason that his teachings were based on universal truths. Modern man is not prepared to leave the world. He wants to enjoy it. Vivekananda therefore gave a practical garb to his religion. India in his time was groning under slavery. Vivekananda therefore, asked Indian men and women to shed all types of weakness and to march forward courageously. According to him, we have to speak less and work more, achieve power first than anything else. According to Vivekananda, 'first of all our young men must be strong. Religion will come afterwards'.

In the curriculum for religious education, Vivekananda considered Gita, Upanishads and the Vedas as the most important. The study of these scriptures will fill young men and women with courage. These are the eternal sources of the life force of Indian culture. These are the bases of our spiritual education. Vivekananda however was not in favour of preaching any particular religious dogmas. Religion for him was self-realization. Temples, mosques, churches and synagogues do not make religion. Religion is divinization. He considered all religions to be equal. A true religion cannot be limited to a particular place or time. Their ancient forms are worshipped and their modern forms are respected.

4.2.6 Teaching and Learning

Vivekananda was in favour of Indian system of educational organization which was based on the criteria of learning by sitting at the feet of the Acharya, Guru or the teacher through a close contact. The success of education according to Vivekananda, depend upon the initiative taken by the teacher in enthusing the child to forward the study, inculcate self – confidence, self realization and self reliance.

Vivekananda's idea of education is Guru Griha vasa, "Without the personal life of the teacher there would be no education" *(Complete Works.* Vol. V.224) . For Vivekananda one should live from his very boyhood with one whose character is a blazing fire and should have before him a living example of the highest teaching. In our country the imparting of knowledge has always been through men of renunciation. "The charge of imparting knowledge should again fall upon the shoulders of Tyagis" *(Complete Works* Vol. V. 369).

There are certain qualities necessary for the taught and also for the teacher. The conditions necessary for the taught are a real thirst for knowledge and preseverance. Purity in thought, speech and act is absolutely necessary. There must be a continuous struggle, a constant fight, an unremitting grappling with our lower nature, till the higher want is actively felt and victory is achieved. The student who sets out with such a spirit of perseverance will surely find success at last.

A student is a seeker of truth with certain conditions. The student if he wants to know the truth must give up all desire for gain. What we see is not truth as long as any desire creeps into our minds. So long as there is in the heart the least desire for the world, truth will not

come. Vivekananda describes the qualities of a teacher. He says "We must see that he knows the spirit of the scriptures. The whole world reads Bible, Vedas and Qurans; but they are all only words, syntax, etymology, philology the dry bones of religion. The teacher who deals too much in words and allows the mind to be carried away by the force of world loses the spirit. It is the knowledge of spirit of the scriptures alone that constitute the true teacher " *(Complete Works,* Vol. III .48-49). The second condition necessary for the teacher is sinlessness. The question is often asked: "Why should we look into the character and personality of teacher? This is not right. The sine qua non of acquiring truth for oneself or for imparting to others is purity of heart and soul. "He must be perfectly pure and then only comes the value of his words " *(Complete Works* Vol. 111 50). The function of the teacher indeed, is an affair of the transference of something and not one of mere stimulation of existing intellectual or other faculties in the taught. Something real and appreciable as an influence comes from the teacher and goes to the taught. Therefore, the teacher must be pure. The third condition is in regard to the motive. The teacher must not teach with any ulterior selfish motive, for money, name or fame. His work must be simply out of love, out of pure love for mankind at large. "The only medium through which spiritual force can be transmitted is love. Any selfish motive such as the desire for gain or name will immediately destroy the conveying medium" (Complete Works vol. III. 51) . Self restraint is a manifestation of greater power than all outgoing action. All outgoing energy following a selfish motive is frittered away: it will not cause power to return anybody; but if restrained it will result in development of power. This self control will tend to produce a mighty will, a character which makes a Christ or a Buddha.

A student must be able to control the internal and external senses. By hard practice he had to arrive the stage where he can assert his mind against the commands of nature. He should able to say to his mind 'you are mine; I order you, do not see or hear anything'. Next the mind must be made to quiet down. It is rushing about. Just as I sit down to mediate, all the vilest subjects in the world come up. The whole thing is nauseating. Why should the mind think thoughts I do not want it to think? I am as if were a slave to the mind. No spiritual knowledge is possible so long as the mind is restless and out of control. The disciple has to learn to control the mind. The disciple must have great power of endurance. Life seems comfortable and find the mind behave well when everything is going well with you. But if something goes wrong, mind loses its balance. That is not good. Bear all evil and misery without one murmur or hurt, without one thought of unhappiness, resistance, remedy or retaliation. That is true endurance.

To find out the ultimate truth the student has is to conceive an extreme desire to be free. In general no one desires anything beyond the body. For them the world but a combination of stomach and six Millions of men and women are living for their bodily satisfaction. if take these away from them they will find their life empty, meaningless and intolerable. Our mind is continuously hankering for ways and means to satisfy the hunger for the stomach and sex. These desires of the body bring only momentary satisfaction and endless suffering. It is like drinking a cup of which the surface layer is nectar, while underneath all is poison. Renunciation of the senses and desires is the only way out of this misery. If one want to be spiritual must renounce this. This is the real test. Give up the world – this nonsense of the senses. There is only one real desire, to know what is true, to be spiritual. No more

materialism, no more egoism. Our sole concern should be to know the highest truth. Let us worship the spirit in spirit, standing on spirit, let the foundation be spirit, the middle spirit, the culmination spirit. That is the goal.

The relationship between the teacher and the disciple is the same as that between an ancestor and his descendent. Without faith, humility, submission and veneration in our heart towards the teacher, there cannot be any growth in us. "In those countries which have neglected to keep up this kind of relation, the teacher has become a mere lecturer, the teacher expecting his five dollars and the person taught expecting his brain to be filled with the teacher words and each going his own way after this much is done " *(Complete Works* Vol. III. 52). Too much faith in personality has a tendency to produce weakness and idolatry. "Worship your Guru as God, but do not obey him blindly. Love him all you will, but think for yourself " *(Complete Works* Vol. VII. 85-86).

4.3 Synthesis of Science and Vedanta

With the aim of education as man –making, Vivekananda developed a curriculum which could lead multisided and all round development of the educand. He tried to synthesis science and Vedanta, modern and ancient knowledge, so that the curriculum may include whatever is best in these. He realized that the curriculum must be able to achieve the development of every aspects of the child's personality. In science matter is nothing but energy in the form of wave function. Similar is the nature of spirit; which is beyond limitation of name, form and action. Hence there should be a synthesis between vedanta, which advocates spirit as truth and science, which advocates matter as Truth. According to him, what

is really needed in India is a synthesis of Western Science and Indian Vedanta which would lead to a harmonious world of beautiful co-existence if this is not done, it may lead to improper use of science which would bring destruction and calamities.

4.4 Concentration: The Essence of Education

There is only one method to attain knowledge, that which is called concentration. The very essence of education is concentration of mind. From the lowest man to the highest yogi, all have to use the same method to attain knowledge. *Prasantamanasam hyenam yoginam sukhamuttamam. Upaiti Santarajasam brahmabhutamakalmasam* (Gita 6.27) . The Yogi whose mind in perfectly serene who is sinless, whose passion is sub dued and who is identified with Brahma, the embodiment of truth knowledge and bliss, supreme happiness comes as a matter of course.

The more the power of concentration the greater the knowledge is acquired. Even the lowest shoe black, if he gives more concentration, will black shoes better. The cook with concentration will cook a meal all the better. In making money, or in worshipping God, or in doing anything, the stronger the power of concentration, the better will that thing be done. This is one call the one knock, which opens the gates of Nature, and lets out floods of light. This is the power of concentration, is the only Treasure – house of knowledge *(Complete Works.* Vol. II 390-91). Ninety percent of thought-force is wasted by ordinary human being and therefore he is constantly committing blunders.' The trained man or mind never makes a mistake'. The main difference between men and the animals is the difference in their power of concentration. An animal has very little powers of concentration. Those who have trained

animals find much difficulty in the fact that the animal is constantly forgetting what is told him. He cannot concentrate his mind upon anything for a long time. Here is the difference between man and animals. This difference in their power of concentration also constitutes the difference between man and man. Compare the lowest with the highest man. The difference is in the degree of concentration.

All success in any line of work is the result of this. High achievements in art, music, etc are the result of concentration. When the mind is concentrated and turned back on itself, all within us will be our servants, not our masters. The Greeks applied their concentration to the external world and the result was perfection in art, literature etc. The Hindu concentrated on the internal world, upon the unseen realms in the self and developed the science of yoga. The world is ready to give up its secrets if we only know how to knock, how to give the necessary blow. The strength and force of the blow come through concentration.

The power of concentration is the only key to the treasure-house of knowledge. "In the present state of our body we are much distracted, and the mind is frittering away its energies upon a hundred things. As soon as I try to call on my thoughts and concentrate my mind upon any one object of knowledge, thousands of undesired impulses rush into the brain; thousands of thoughts rush into the mind and disturb it. How to check it and brings the mind under control is the whole subject of study in 'Raja yoga'. The practice of meditation leads to mental concentration" *(Complete Works* Vol. VI. 38-39).

According to Vivekananda the very essence of education is concentration of mind and the collection of facts. "If I had to do my education once again, I would not study facts at all.

I would develop the power of concentration and detachment, and then with a perfect instrument, collect facts at will" *(Complete Works* Vol .VII. 67). Power comes to him who observes unbroken Brahmacharya for a period of twelve years. "Complete continence gives great intellectual and spiritual power" *(Complete Works* Vol. V. 369). A controlled desire leads to the highest results. Controlled desires can transform the sexual energy into spiritual energy. The stronger this force, the more can be done with it. "Only a powerful current of water can do hydraulic mining'. It owes to want of continence that everything is on the brink of ruin in our country. By observance of strict Brahmacharya all learning can be mastered in a very short time; one acquires an unfailing memory of what one hears or knows but once. The chaste brain has tremendous energy and gigantic will power. Without chastity there can be no spiritual strength. Continence gives wonderful control over mankind. The spiritual leaders of men have been very continent and this is what give them power" *(Complete Works,* Vol. 1 263).

Every boy should be trained to practice absolute Brahmacharya and then alone faith and shradda will come. Chastity in thought, word, and deed always and in all conditions is what is called Brahmacharya. Unchaste imagination is as bad as unchaste action. The Brahmacharin must possess the characteristic like, be pure in thought, word and deed. The idea of true shraddha must be brought back once more tous. The faith in our own selves must be reawakened and then only all the problems which face our country will gradually be solved by ourselves. What we want is this shraddha. What makes the difference between man and man is the difference in shraddha and nothing else. What make one man great and another weak and low is this shraddha. "My master used to say: he who thinks himself weak will

become weak; and that is true. This shraddha must enter into you whatever of material power you see manifested by the western races, is the outcome of the shraddha, because they believe in their muscles; and if you believe in the spirit how much more will it work" *(Complete Works* Vol. III.319). No good comes out of man who day and night thinks he is nobody. If a man day and night thinks that he is miserable, low and nothing, nothing he becomes. "If you say, 'I am, I am 'so shall you be. That is the great fact you ought to remember. We are children of the Almighty; we are sparks of the infinite, divine fire. How can we be nothing? We are everything, ready to do everything; we can do everything. This faith in themselves was in the heart of our ancestors; this faith in themselves was the motive power that pushed them forward in the march of civilization. If there has been degeneration; if there had been defect, you will find that degeneration to have started on the day our people lost this faith in themselves" *(Complete Works* Vol. III. 376).

To preach the doctrine of shraddha or genuine faith is the mission of Vivekananda's life. This faith is one of the most potent factors of humanity. "First have faith in yourselves. Know that though one may be a little bubble and another may be a mountain-high wave, yet behind both the bubble and the wave there is the infinite ocean" *(Complete Works* Vol. III. 444). "The infinite ocean is the back ground of me as well as you. Mine also is that infinite ocean of life, of power, of spirituality as well as yours. Therefore, my brethren, teach this life saving, great, ennobling grand doctrine of your children even from their very birth" *(Complete Works* Vol. III. 376) .

4.5 Aim of Education

Swamiji believes that the final goal of education is the realization of the self. This goal cannot be realized without material welfare of an individual. It does not mean that the individual should give up all material welfare to attain this goal. The material well being is a part of the education. His famous quotation 'a sound body contains a sound soul' reassures the need of empirical knowledge. His aims of education can be classified into two heads, proximate and ultimate.

4.5.1 Proximate Aims of Education

Swamiji advocates that physical development leads towards spiritual upliftment. In his words "strength is goodness, weakness is sin.. Bodily activities and strength could be achieved through the right kind of food and proper physical exercise. All sin and all evil can be summed up in one word 'weaknesses. First of all our young man must be strong. Religion will come afterwards. You will be nearer to heaven through football than through the study of Gita. You will understand Gita better with your biceps, your muscles a little stronger" (Complete Works Vol. III.242). Swamiji emphasized the need of mental training and development along with the enhancement of physical capabilities. Swamiji believes that mental or intellectual development is not the highest good. Morality and spirituality are the things for which we strive. but mental development through confidence and concentration (Sraddha and Jagrat) would enable the individual to attain knowledge leading yoga and finally to the realization of self. Mental Development taken into consideration the training of individual's powers of thinking willing and feeling. Swamiji advocates that character is the

strength of man. It is the greatest treasure that student can acquire in the school or at home. 'Mata, pita, guru, and daiva' is the sequence in the teaching learning process. The preschool education at home by the parents after vidyarambha or upanayana is the basis of man making character building education envisaged by ancient Indian education. The learning process is lifelong and it begins at home. In the words of Swamiji education is training by which the expression of will is brought under control and becomes fruitful by the practice of Brahma change. Self – sufficiency in education is another aim as has been advocated by Swamiji. Education should develop the capacity within the child to earn his own bread and salt and lead a comfortable life. Children should be trained in agriculture, industry and technical works. The education must be based on moral, ethical and spiritual principles. It is the combination of body, mind and intelligence. The development full potentialities all these are the aim of education.

4.5.2 Ultimate Aims of Education

Swamiji believes that there are certain objective values like truth, beauty and goodness. Pursuit of these values will lead one to the manifestation of his own self. Education is a misnomer unless it trains the mind of man. Therefore the ultimate aim of education is to develop the mind of man, which will lead towards self-realizations.

According to Vedanta, only a pure moral man has the power to control his will. Such a pure moral man who throws his imagination upon his fellow being has nothing to fear, he is a dynamo of power and can do anything and everything in a calm way. Following the doctrines of the Vedanta, Swamiji advocates that strength and fearlessness are the two major characteristic of human personality. The greatest ideal of education is to develop such human

personalities, which will lead toward self realization. Swamiji believes that faith in one's own self must be created through education. Education should develop awareness among the students that they have their latent powers, which are always quite potent to make one's life sublime and divine. Education should teach every student, the mantram of the KathaUpanisad 'Arise, awake and stop not till the goal is reached'.

One of the important ethical questions in the Gita is whether man should renounce action or whether they should perform them even after realization of supreme knowledge. Following the doctrine of the Gita, Swamiji says that man should perform his duties with a total sense of detachment. Thus he can become a Karma Yogi. He propagates the message of the Gita. *'Karmanya Vadhikarasthe Ma Phaleshu Kadachana'* you have right to work, but not the fruit. Such Karma or work will lead one towards self – realization. Swamiji advocates that education should teach individual that Atman (soul) is the same in all from the ant to the perfect man, the difference being, only in its manifestation. An ideal system of education is one which imparts universal brotherhood. A student should realize that from the highest creation to the meanest grass the same power is present in all. whether manifested or not. Swamiji advocates that introduction of Yoga in education helps "a child to realize the harmony, the layers of gross mind and penetrates deeply into realms of the mind and gets deeper knowledge. which leads towards self realization. The term spirituality centers on some inner experience of a man and it is often used by those who write about the inner aspects of religious life" (Chatterjee 3). The knowledge is acquired through the training of mind. Ancient Indian education developed special methodology to. control and train the mind. To start with the controlling of the mind one has to adopt and follow certain norms

from the early childhood itself. He advocates Ashtanga yoga (Eight fold path) prescribed by Patanjali in his book yoga sutra to tame the mind and to concentrate upon to develop the power of meditation. The eight steps are called Yama, Niyama, Asana, Pranayana, Pratyahara Dharana, Dhyana and Samadhi. The first two steps are dos and don't's to elevate self, body and mind to positive frame work. The third and fourth steps are intrinisic extrinsic energy the faith to internalize and focus the mind. The final steps are the levels of concentration which is contemplated upon the Absolute Truth.

Avidya is ignorance and vidya is knowledge. Education means removal of ignorance and revival of knowledge. Vivekananda in his Neo Vedanta combines Jnana, karma, bhakti and yoga. What he wants is a religion that will be equally acceptable to all minds and it must be equally philosophic, emotional and equally conducive to action. This ideal can be attained only by yoga. To the worker it is the union between men and the whole humanity, to the mystic between this lower and higher self, to the lover union between himself and God of love and to the philosophic it is the union of all existence.

4.6 Education for Character Formation

The character of any man is but the aggregate of his tendencies, the sum total of the bent of his mind. "Character is the solid foundation for self development". *(Complete Works* Vol. I. 27) The aim of education is character building. This depends upon the ideals cherished by the individual. The educator should present high ideals before the educands. The best way to develop a character is the personal example of high character set by the teachers. Laying emphasis upon this point Vivekananda said. without the personal life of the teacher there

would be no education. One would live from his very boyhood with one whose character is like a blazing fire and should have before him a living example of the highest teaching. 'In ancient Indian system of education the teachers used to present high ideals before the pupils, who in their turn imitated those ideals according to their capacities.

Character formation according to Vivekananda requires hard work. This is not possible by those who have a wish for all types of enjoyments. Struggle is the best teacher in character building. Activity and purushartha are the signs of life. Inactivity shows the absence of vitality while living in all types of comforts and escaping from all types of labour no one can build up high character. Besides hard work, character formation requires traits such as purity, thirst for knowledge, preservance, faith, humility, submission and veneration etc. These qualities may be developed by the teacher's example and the pupils efforts. According to Vivekananda without faith, humility, submission and veneration in our hearts towards the teacher, there cannot be any growth in us. The true teacher is he who can immediately come down to the level of the student, and transfer his soul to the student's soul and see through and understand through his mind. Such a relationship between the teacher and the taught is possible only in a Gurukula system of education. Therefore Vivekananda favoured the ancient Indian Gurukula system of education. In these Gurukuls, the pupils served the teacher, who in his turn helped the pupils everywhere to achieve knowledge. There was hardly any economic relationship between the teacher and taught, which is the curse of the present system of education.

Character is intimately connected with habits. Habits express character. A good habit makes for good character. While the contemporary psychologist admits the value of habits in

one's life, Vivekananda has pointed out the value of habits not only in this life but in lives to come. A bad habit may be broken by developing the opposite good habits. If a man constantly thinks, that he will be courageous and progressive, he may develop confidence for breaking bad habits. It is not the teacher or guardian who may reform the habits of a person but only he himself. Man is caught in the net of his own karmas from which he alone can get out no one else can directly help him. Our own self in us is our best guide in the struggle that is life. The child should be allowed to commit mistakes in the process of character formation. He will learn much by his mistakes. Errors are the stepping stones to our progress in character. The progress requires courage and strong will. Strong will is the sign of great character and will make men great. Vivekananda himself was an ideal teacher. His words worked like magic upon men and women. This is only in the case of a teacher who has himself risen high. Presenting his own example Vivekananda asked the people to build up their character and manifest their real nature which is effulgent, the resplendent, the ever pure.

4.7. Fulfilment of Svadharma

Vivekananda supported the idea of Svadharma in education. Everyone has to grow like himself. No one has to imitate the other, hence he condemned the imposition of foreign educationTo him, "Getting the thought of others in a foreign language and stuffing in brain with them and taking some University degree, one can pride one self as educated. Is this education?". True improvement is self-inspired. There should be no external pressure of any type on the child. External pressure only creates destructive reactions leading to obstinacy and indiscipline. In an atmosphere of freedom love and sympathy alone, the child will develop courage and self-reliance. He should not be unnecessarily checked in his activities.

Such negative directions tend to blunt his intelligence and mental development. He should be talked to stand on his own to be himself.

He is a staunch champion of freedom in education. Freedom is the first requirement for self-development. The child should be given freedom to grow, according to his own nature. In the words of Vivekananda "you cannot teach a child any more than you can grow a plant. All you can do is on the negative side- you can only help. You can take away the obstacles, but knowledge comes out of its own nature" *(Complete Works* Vol. V. 410). Loosen the soil a little, so that it may come out easily. Put a hedge around it see that it is not killed by anything, and there your work stops. You cannot do anything else. The rest is a manifestation from within its own nature. The teacher should not exert any type of pressure on the child. The child should be helped in solving his problem himself. The teachers should have an attitude of service workshop. Education ultimately aims at realization. It is meant to be the establishment of fraternity of mankind.

4.8 Education of Self Development

In contrast to the contemporary system of education, Vivekananda advocated education for self development. What we want are western science coupled with Vedanta, Brahmacharya, as guiding motto, and also shraddha and faith in one's own self. Education according to most of the Western educationist aims at man's adjustment with the environment. According to the Indian philosophical tradition, on the other hand, education is the realization of the knowledge inherent in man. True knowledge does not come from outside, it is discovered within the individual, in the self which is the source of all knowledge.

All knowledge that the world has ever received comes from the mind, the infinite library of the universe is in our mind. External world is simple. The falling of an apple gave the suggestion to Newton, and he studied his own mind. He rearranged all precious links of thought in his mind and discovered a new link among them, which we call the law of gravitation. Thus according to Vivekananda, the function of education is the uncovering of the knowledge hidden in our own mind. A person's education is not judged by the number of books he has read but by the thickness of the cover of ignorance of his mind. The thicker is this cover, the greater is the ignorance. As the light of knowledge dawns, this cover of ignorance gradually shatters. The teacher's job is to uncover knowledge by his guidance. His guidance makes the mind active and the educand himself unveils the knowledge lying within him.

4.9 Education for Realization

Vivekananda considers realisation as the chief aim of life. He advocates Yoga as the most ideal method for self realization. Four yogas Karma Yoga, Bhakti Yoga, Jnana yoga, Raja Yoga.

The scope of all these yogas are one and the same – removal of ignorance and enabling the soul to restore its original nature. Although Vivekananda describes four yogas differently, he says that they are different ways for realization of the same goal. It is quite possible that a particular person incapable of following the marga jnana can follow path of devotion .i.e. One can choose the path he likes. These paths are not completely exclusive of each other, in certain respect they over lap. It is not that the man of Devotions has nothing to

do with the way of knowledge; he also performs certain acts of self-sacrifice. Therefore they are not divided in to water – light- compartments. Vivekananda gives perfect liberty to the individual for choosing and pursuing the course that he likes best. The only thing is that there must be a very strong and intense sincerity and a sense of purpose. Vivekananda asserts that realization requires a very radical regeneration of the individual. He must be transformed morally, religiously and spiritually. An individual, who has realized the soul, can have absolute control over his mind. He is free from fetters. Peace of mind, training of mind and universal love will help a person to realize the self.

4.10. Education of Women

For education, Vivekananda strongly believed that there is no gender discrimination. As the manifestation of the same innate perfection or divinity, men and women are equally disposed to understand and practice any type of knowledge. It is very difficult to understand why in this country so much difference is made between men and women, whereas the Vedanta declares that one and the same self in all beings. Writing down smrities and binding them by hard rules, the men have turned the women into more manufacturing machine. In the period of degradation, when the priests made the other castes incompetent to study the Vedas, they deprived the women also of all their rights, "You will find in the Vedic and Upanishadic age Maitreyi, Gargi and other ladies of revered memory have taken the place of Rishis. In assembly of a thousand Brahmanas who were all erudite in the Vedas. Gargi boldly challenged Yrjnavalkya in a discussion about Brahman" *(Complete Works,* Vol. VII 214-15).

Women have many and grave problems, but none that cannot be solved by the magic word education. Manu says, "Where women are respected, there the Gods delight and where they are not, there all work and effort come to naught. There is no hope of rise for that family or country where they live in sadness" (Complete Works Vol. II. 391). Daughters should be supported and educated with as much care and attention as the sons. As sons should be married after observing Brahmacharya up to the thirtieth year, so daughters also should observe Brahmacharya and be educated by their parents. But what are we actually doing. They have all the time been trained in helplessness and servile dependence on others; and so they are good only to weep their eyes out at the approach of the slightest mishap or danger. Women must be put in a position to solve their own problems in their own way. Our Indian women are as capable of doing it as any in the world. His great confidence in women was evident from his utterance with five hundred men, the conquest of India might take fifty years with as many women not more than a few weeks" (Dasgupta 351). The children of such mothers will make further progress in the virtues that distinguish themselves. It is only in the virtues that distinguish themselves. It is only in the homes of educated and pious mothers that great men are born" (Complete Works Vol. VI .489).

4.11 Education of the Masses

In a vast country like India where a large number of children are deprived of education at the school level. Vivekananda supported mass education at least. He believed that a country can progress only through mass education. "My heart aches to think of the condition of the poor, the low in India, they sink lower and lower every day. They feel the blow showered upon them by a cruel society, but they do not know whence the blow comes. They

have forgotten that they too are men" (*Complete Works* Vol. V 14). Control of education by a class of people is the cause of India's ruin. This is a national sin to neglect mass education. "My heart is too full to express my feeling so long as the millions live in hunger and ignorance, I hold every man a traitor who, having been educated at their expense, pays not the least heed to them" (*Complete Works* Vol. V. 58) . Our great national sin is the neglect of the masses and that is the cause of our downfall. To Vivekananda "no amount of politics would be of any avail until the masses in India are once more well educated, well-fed and well cared for" *(Complete Works* Vol. V. 222-223). A nation is advanced in proportion as education and intelligence spread among the masses. The chief cause of India's ruin has been the monopolizing of the whole education and intelligence of the land among a handful of men. If we are to rise again we shall have to do it by spreading education among the masses. The only service to be done for our lower classes is to give them education to develop their individuality. They are to be given ideas. Their eyes are to be opened to what is going on in the world around them, and then they will work out their own salvation. Every nation, every man and every woman must work out their own salvation. Give them ideas that are the only help they require and them the rest must follow as affect. "Ours is to put the chemicals together, the crystallization comes in the law of nature" *(Complete Works* Vol. V. 362).

Teach the masses in the vernaculars, give them ideas, they will get information, but something more will be necessary. Give them, culture, until there can be no permanence in the raised condition of the masses. At the same time Sanskrit education must go along with it, because the very sound of Sanskrit words gives a prestige a power and strength to the race. Even the great Buddha made once false step when he stopped the Sanskrit language from

being studied by the masses. He wanted rapid and immediate results; and translated and preached in the language of the day-Pali. That was grand he spoke the language of the people and the people understood him. It spreads the idea quickly and made them reach far and wide. But along with that Sanskrit ought to have been spread. Knowledge came but prestige was not there. Until you give them that, there will be another caste created, having the advantage of the Sanskrit language, which will quickly get above the rest.

Swami Vivekananda was the first person in India who advocated the need of distant education or to provide education at the door step of the people who are deprived of the institutionalized education. He claimed, "Remember that the nation lives in cottage" *(Complete Works* Vol. V. 29). Our duty at present is to go from one part of the country to another, from village to village and make the people understand that mere sitting about idealy won't do any more. "Make them understand their real condition and say "O ye Brothers all arise! Awake! How much longer would you remain asleep" *(Complete Works* Vol. V. 381). He further advocates that go and advise them how to improve their own conditions and make them comprehend the sublime truths of the Shastra's, by presenting them in a lucid and popular way. Impress upon their mind that they have the same right to religion as the Brahmanas. Initiate, even down to the Chandalas in their fiery mantras. Also instruct them in simple words about the necessities of life, and in trade, commerce, agriculture etc. "They cannot find light or education that will bring the light to them – who will travel from door to door bringing education to them? Let these people be your God-think of them, work for them, pray for them incessantly – the Lord will show you the way" *(Complete Works* Vol .V .57-58). According to Vivekananda the one thing that is at the root of all evils in India is the

conditions of the poor. Suppose open a free school in every village, still it would do no good for the poverty in India is such that the poor boys would rather go to help their fathers in the fields or otherwise try to make a living then come to the school. He says if the mountain does not come to Mohammed, Mohammed must go to the mountain. 'If the poor boy cannot come to education, education must go to him. There are thousands of single minded, self-sacrificing Sannyasins in our own country going from village to village, teaching religion. If some of them can be organised as teachers of secular things also, they will go from place to place, from door to door, not only preaching but teaching also. Suppose two of these men go to a village in the evening with a camera, a globe, some maps etc., they can teach a great deal of astronomy and geography to the ignorant. By telling stories about different nations, they can give the poor a hundred times more information through the ear than they can get in a lifetime through books'. Kindle their knowledge with the help of modern science. "Teach them History, Geography, Science, literature and along with these the profound truths if religion through these " (Complete works Vol. IV. 362-63).

In our culturally plural society education should foster universal and eternal values oriented towards the unity and integration of our people. Education as such should be made a forceful tool for the cultivation of social and moral values. The cultivation of values is possible with a sound system of education. The whole scheme of education, in the context of perfection of human personality, is based on the absolute values of truth towards self realization. Vivekananda emphasized the need for a complete reorientation of human values to fight against hedonism and commercial fetishes. He suggested that education should not be for stuffing some facts into the brain, it should aim at reforming the human mind. Education

must be able to produce a man of integrity, dedicated administrator, socially conscious citizens with good manners.

The central ethical purpose of Vivekananda educational system is to train up the pupil to develop good inner character resulting in good actions. The primary aim of education should be to help the individual to realize his best self. It should cultivate values of life like honesty, love, sympathy, non-violence, self - restraint, cooperativeness, sacrifice and finally faith in man and God. Religion is a synthesis of values and an integration of experiences. It stands for the entire personality of man. He always says 'education is the perfection that has always in man'. The perfection is the absolute and absolute the divine. He says man is potentially divine. Since divinity and perfection are one and the same there can be no antithesis between religion and education.

Education is a continuous process. It should cover all aspects of life, physical, material, intellectual, emotional, moral and spiritual and all the stages of life from birth to death. Practicing yoga, student can develop his innate qualities life fearlessness, love, sympathy and also equip him to lead an ideal life. It always brings about culture of human heart The virtues to be developed in the students are purity, real thirst for knowledge and perseverance, faith, humility, submission and veneration towards the teacher. The sense of humility is the basis of a man's character, the true mark of a balanced personality. The ideal of every educated man should be perfect unselfishness. Along with the spirit of independence the spirit of obedience is equally important.

India's mission to the world is to instill in the minds of the people the spirit of tolerance and love and this can be possible only with the resurrection of values of human life based on vedantic ideals which existed an ancient time. As a widely travelled teacher throughout India and a large part of the world Vivekananda could gain first hand knowledge and experience about the miseries of the masses and the deterioration of values of human life. Vivekananda found a difference in the attitude of the people of the East and West. He found that in spite of the material advancement of the West they had to learn lot from the East, spiritually.

Vivekananda synthesized spiritual and material values. He felt that India needed an educational system which must be based on the ancient Vedanta tradition, but which at the same time, must also prepare the individual to earn his livelihood, so that every man and woman in the country may progress in his or her own profession. No profession is bad, because even the lowest kind of work done with a feeling of service and self sacrifice become as valuable as the greatest work. It is therefore necessary to spread the message of education to every household in the country. Its absence is responsible for the degraded condition of the country. Education should not be confined only to the schools but should spread to factories, houses, playing grounds, agricultural fields etc. This kind of arrangement can be seen in the traditional Indian system of vanaprastha and sanyasa. He suggests that two or three educators should team up and collecting all the paraphernalia of educations, should go to village, collect all the children at one place and impart education to them. He asked educator to reach every village and every hutment so that whole country may awake from ignorance. In this manner these children can be educated far more rapidly than through education in the classroom.

Vivekananda has favoured the spread of education among all sections of society, the poorest and the best. He pleaded for universal, compulsory and free education. His concept of educational pattern conformed to the philosophical and spiritual tradition of India, because he favoured originality in India rather than the blind imitation of the West.

On the one hand he advocated adoption of western scientific temper, while on the other he insisted abstinence and spirituality, in keeping with the traditional ideals. In determining a curriculum for the education of young men and women, he paid special attention to the need for developing qualities like courage, self confidence, concentration, a high moral character, etc. He advised the educators to adopt a missionary attitude to teaching rather than a professional one. He would not have been welcomed in the West as he was. In fact he was willing to borrow new ideas from the West, but he insisted that anything borrowed must be harmonized with Indian culture in such a way that it should not offend the national feeling of the people, and he never departed from the ideal of Swadeshi or the indigenous. Even though he was an idealist, his ideas on education are practical and realistic, because the pattern of education he suggested was specially designed according to the needs of the country.

Reference

Chattergee, Majaret. *The Concept of spirituality.* Calcutta: Allied Publishers pvt. 1987.

Dasgupta, R K (ed). *Swami Vivekananda, A hundred years since Chicago.* Culcutta: Ramakrishna Mission 1994.

Goyandka, Jayadayal.*Srimad Bhagavad Gita.* Gorakpur: Givind Bhavan Karyalaya. Gita Press, 1995.

Jyothirmayandna, *Swami Vivekananda: His Gospel of man kind.* Madras: Sakthi, 1986.

Majumdar, R.C. (ed), *Swami Vivekananda Centenary memorial volume.* Calcutta: Ramakrishna Mission 1963.

Vivekananda, Swami. *Practical Vedanta. Calcutta:* AdvaitasAshrama, 1958.

Tagore, Rabindranath. *'Rabindra Rachanavali XIII cited in Swami Ranganathanada Swami Vivekananda and Human excellence.* Calcutta: Advaita Ashrama 1995.

TV, Avinashalingam. *'complied from the speeches and writing of Swami Vivekananda* .Mylapore: Ramakrishna Math 1943.

V.S. Avinahalingam. *Thoughts of Power; Compiled from the Speeches and Writings of Swami Vivekananda.* Calcutta: Advaita Ashrama 1943.

Vivekananda, Swami .*Complete Works of Swami Vivekananda.* Vol. III. Calcutta: Advaita Ashram, 1964.

-------------, --------------. *Complete Works of Swami Vivekananda.* Vol. V. Calcutta: Advaita Ashram, 1964.

------------, -------------- Complete *Works of Swami Vivekananda* Vol. II. Calcutta: Advaita Ashram, 1964.

-----------, --------------. *Complete Works of Swami Vivekananda.* Vol. I. Calcutta: Advaita Ashram, 1964.

-----------, --------------. *Complete Works of Swami Vivekananda.* Vol. IV. Calcutta: Advaita Ashram, 1964.

----------, ---------- *Vedanta and the Future of Mankind.* Calcutta: Advaita Ashrma 1993.

----------, ---------- *Complete Works of Swami Vivekananda.* Vol. VI Calcutta: Advaita Ashram, 1964.

----------, ----------. *Complete Works of Swami Vivekananda.* Vol. VII. Calcutta: Advaita Ashram, 1964.

----------, ----------. *In Defence of Hinduism.* Calcutta: Advaita Ashrama, 1946.

CHAPTER V

Educational philosophy of Rabindranath Tagore

Rabindranath Tagore is one of those few iconic personalities whom, the people of India hold very close to their heart. A literary genius and a humanist, he did not leave any facet of life untouched until it bloomed into an unforgetable creation of supreme beauty and charm. A people's bard, his heart never stopped wrenching at the sight of human misery. For this he would compose and stage drama and stretch out a helping hand to bring succour to the needy. A thorough nationalist, he would not brook any narrow sentimentalism coming in the way of universal human values. An uncompromising lover of freedom, he would resolute in raising his voice against trifle attempts at its shifting. He was the muse who could transfix the garrulous currents of padma in a note book sitting on its bank. He remains as yet a game of a man to be surpassed in whatever he did. Not surprisingly, the greatest tribute to him came from none else than the Mahatma, in his own life time, who called him 'Gurudev'.

In India, philosophy is called 'Darsana' which means 'vision' – Vision of the real. Rabindranath takes this meaning of the term 'philosophy' rather literally. That is why in his thought there is a very great emphasis on 'personal realization'. In *Religion of Man* he says "I have already made the confession that my religion is a poet's religion. All that I feel about it is from vision and not from knowledge. Frankly, I acknowledge that I cannot satisfactorily answer any questions about evil or about what happens after death. He is trained to read the thoughts of a thinker in terms of certain accepted epithets and concepts. But it may not be

possible for him to apply his traditional philosophical models to the personal realization of a seer of truth" (Tagore, Religion 67).

In the galaxy of modern educational thinkers the name of Rabindranath Tagore is famous not only in his country for his contribution; but all over the world. His philosophy of education aims at developing a system of education for human regeneration. Man is in the centre of all his thinking, his philosophy, religion, literature, poetry, social activities and educational programmes. He is a humanist but an integral humanist in the Indian tradition. He is not a rationalist but believes in something higher then reason in man. He does not think science alone to be capable of delivering the human goods but wants to synthesise it with Vedanta. He is a nationalist and at the same time, an internationalist. To him the ultimate God is the Universal Man and the only aim of all the man's activities was the realization of his God. Human regeneration is his sole aim and ideal. His educational system is a means to achieve this aim.

Tagore's philosophy is a peculiar and yet a religious synthesis of Abstract Monism and Theism. Reality according to him is one. He identifies this reality with personal God 'The man of his heart' – 'Jivan Devata'. Tagore can rightly be called an idealist or spiritualist; he can again be described both as a monist and a theist. His philosophy oscillates between Sankara's Vedanta and Vaisnavism. His educational system is based on essential human virtues such as freedom, purity, sympathy, perfection and world brotherhood.

Before discussing and analyzing the educational ideas and ideals of Tagore, we must find out what are the sources which ultimately influenced his educational philosophy.

The influence which moulded up Tagore's philosophy is especially humanism. In his philosophy undoubtedly the name of Upanishad comes first. All his philosophical discourses in 'Santiniketan','Sadhana', *'The Religion of man', 'Personality' 'Man', 'Manuser dharma'* and *'Sanchaya'* are deeply influenced by the Upanishadic teachings. At many places he has quoted the slokas of Upanishads to support his opinion. Tagore grew up in an atmosphere pulsating with truths of the Upanisads. He himself wrote in preface to 'sadhana'. The writer has been brought up in a family where texts of Upanishads are used in daily worship. And again, "to me the verse of the Upanishads and the teachings of Buddha have ever been things of the spirit, and therefore endowed with boundless vital growth, and I have used them both in my own life and in my preaching, as being instinct with special meaning for me" (Tagore, *Sadhana* 7). His father Maharshi Debendranath Tagore was a pioneer of Brahmodharma, a new religion based on the truths of the Upanishads. Apart from family tradition, he himself made special study of Upanishads, he was fascinated by Upanishadic teaching, but it should be admitted that though Tagore was much influenced by Upanishadic teaching we should not say that we find in Tagore's philosophy the echo of Upanishadic thinkers and there is nothing new in Tagore's philosophy. Dr. S.B. Dasgupta one of the famous critiques of Tagore, mentioned that "there is similarity between the mental makeup of Tagore and Upanishadic thinkers. If Tagore would have never read Upanishad then also we would find the similarity between the philosophy of Upanishads and that of Rabindranath" (Dasgupta 4).

Though he was influenced by Upanishads, his humanism is mostly his own. Tagore's ideas of man, nature and the relation of them with God are similar to the ideas of Upanishadic ideology. The concept of dualism of self has also been derived from the Upanishads. Finite

self in human beings which confines to the boundaries of human limitations and divine soul existing within them. The individual divine soul is the manifestation of 'Jivan Devata'.

What differentiates Tagore from the Upanishads is his three fold conception of reality against the Upanishads, Advaita Vedanta and Dvaita. Tagore attaches equal importance to humanity, world and God. There is no doubt that he is influenced by the Upanishads, but he has a free integral and independent way of thinking. The Upanishadic principles explain how human beings can transcend themselves and get a glimpse to the infinite.

Tagore's philosophy of life was influenced by the teaching of Gita. He received ideas about Nishkama Karma and a personal God from the Gita, borrowing the ideas from Gita. Tagore believed that the true endeavour of man is the search of truth or of dharma, which does not mean renunciation of action. Soul cannot be liberated if it remains inaction. But Tagore says that when man lives in his 'aham' he is not conscious of the world outside it, compared to his 'self' the whole world is unreal, but when he makes himself free from his personal desired he can truly work for others. But one can work in the way only when he thinks the world as real and his own 'aham' as false. Tagore himself also takes of one's lower self, which is most selfish and 'true self' which realizes the whole world in it. The nature of this 'self' is to expand gradually the consciousness of one's unity with all. Thus the humanistic ideas of Gita influenced Tagore.

The educational philosophy of Tagore is grounded in the supreme ideal of ancient Indian religion, philosophy and art. The Supreme ideal manifests itself in Supreme Truth, Supreme Good and Supreme Beauty corresponding to the intellect, will and sentiment in the

human individual. Since Tagore was influenced by the ancient Indian scriptures like the Upanishads and the Gita his philosophy is idealistic in nature. Thus his idealism is a true child of India's own past and his philosophy is thoroughly Indian both in origin and development.

Experience of the spiritual world, religion as the right centre of life's activities and the unity of thought and truth are the keynote of Tagore's philosophy of life. He advocated that there should be spiritual relationships between man and man. His individualism therefore is compatible with the growth of social groups on the basis of the individual's spiritual worth. The essential unity of the universe is evident to him true, that he advocates internationalism, but not from the economic or political point of view. He realizes and stresses the spiritual bondage of the universe. Having an explicit faith in the fundamental unity of mankind, he preached human brotherhood.

Tagore, like most of the ancient sages and seers, believes that man should live for the ultimate truth. He wants men to "have access to life that goes beyond death and rises above all 'circumstances' (Tagore, *Sadhana* 51). He says: 'let us find our God, let us live for the ultimate truth which emancipates us from the bondage of the dust and gives us the wealth, not of things but of inner light, not of power but of love" (Tagore, *Religion* 107) . The revivalism of his age found expression in Brahma Samaj, led by Raja Ram Mohan Roy, and Arya Samaj founded by Swami Dayanand Saraswati and also in devotional mysticism of Ramakrishna Paramhamsa. It exercised a deep influence on him.

5.1 Literary Movement

Tagore was a prolific writer. He emerged as a great literacy figure in Bengal and raised Bengali to a literary language appreciated both in India and the world. He composed more than two thousand poems which were published in different forms. He wrote drama in prose and verse, essays, short stories and novels. Thus Tagore considered writing as a Sadhana, a spiritual discipline, which was unique in Indian tradition. His literary activities were a sign of his self-realization and a process of education. Tagore's poetic works may be divided into three categories devotional, dialogical and intuitive. These works include love poems, poem of nature, religio – mystical, legendary, historical and social.

Tagore wrote about fifteen books of philosophical lectures and essays about one hundred books of verse (mostly in Bengali and partly translated by himself from his own Bengali version in to English) and about forty works of fiction. His main writings of philosophical interests are, *Sadhana, The Realisation of life* (1913) *Personality* (1917) *Creative unity* 1922, and *The Religion of Man* (1931) all published in London and New York and Man (1937) published in Madras. His best known poems appear in *Gitanjal*i (1910), *Gitimalya* and *Gitali* in 1914. Tagore was recognized in the world as a famous poet, when he was awarded Nobel Prize in 1913.

5.2 Tagore's Philosophy of Education

Tagore's Philosophy of education cannot be understood without understanding the metaphysical theory. In the metaphysical theory of Rabindranath, the most important idea is the concept of universal man. This universal man is known by the individual not through

reason or logic but through direct realization. It may be pointed out that Tagore's idea of man is a comprehensive development of his thoughts and ideas in a manner to focus the process of unity or harmony in the human life, among people, countries and cultures of the world. To emphasize common elements of all these ideas for the development of a comprehensive idea representing a perspective for mankind as whole where the universal absolutistic idea of Vedas, Upanishads, Vedanta, Brahmanism and the ideals of love, service and sacrifice of Sufis, Vaishnavas, Bauls, Buddha, christ and of their thoughts can find. The world flow into one another and thinkers of the world their meeting and exchange buildup a process of the idea of man, which man his to share commonly and communicate as a colossal family, losing their receptiveness.

The essence of man is his soul consciousness. The inherent nature of the soul is eternal and real. The selfhood of man is the wholeness of men. Tagore's concept of man is purified transcendentalism. There is an intense hearing of the heart for the divine, which is in man. "God has many strings on his sitar some are made of iron, others of copper and yet others are made of gold. Humanity is the golden string of God's flute" (Tagore, *Address to Shantiniketan*, 1931). Every man has Divine in him which tends to harmonize every other object in nature. Even the animal in the savage has been transformed into higher stages in the civilized man. According to Tagore there are two methods through which the savage is transformed into a higher life of men. The one is adaption ie, by eliminating the old and acquiring new characters. The other is grouping of character, the progress of man through education.

The first question that may be asked is what urged Tagore to take up education; he had spent most of his time in literary pursuits till he was forty or more. He had never any desire to take part in practical work. It is a historical fact as well as a truth, that he finished going to school even while he was thirteen. So long as he was forced to go to school, he felt its tortures unbearable. He often used to count the years that must pass before he could find his freedom. He even wished that by some magic spell he could cross the intervening fifteen or twenty years and suddenly become a grown-up man. He afterwards used to realize that what then weighed heavily on his mind was the unnatural pressure of the system of education, which prevailed everywhere. Tagore's philosophy of education is therefore, a result of the memory of his school days, the school which resembled an education factory lifeless, colorless, and dissociated from the context of the universe, within bare white walls staring like the eyeballs of the dead.

In the school days of his time, boys were not allowed freedom to take delight activities; they were fettered and imprisoned, stilled by a force discipline, which in turn killed the sensitiveness of the childs mind, the mind, which is always on the alert, restless and eager to receive first –hand knowledge from Mother Nature. He disliked the idea of children, sitting inert, like dead specimens of some museum, while lessons are being pelted at them from like hailstones on flowers.

The great feature of Tagore's educational philosophy is naturalism which pervades throughout. Tagore recognized a kinship between man and nature. He says "when a man does not realize his kinship with the world of nature he lives in a prison – home whose walls are alien to him" (Tagore, *Sadhana* 8). For Tagore man and nature are indispensible elements of

reality. Both man and nature need each other in the same way as God and man need each other. "Whatever nature possesses is not only a store house of powers but habitations of mens spirit as well" (Tagore, *Creative* 27) . He is always against the artificial methods of teaching and learning. He is a great naturalist to the core in education. It can be summed up in one word 'Harmony'. Harmony with nature and man fundamental unity of creation in Tagore's language, "I believe that in a little flower there is a living power hidden in beauty which is more potent than a Maxim gun. I believe that in the bird's notes nature expresses herself with a force which is greater than that revealed in the deafening roar of the cannonade". (Dash 48) Tagore had modeled his school after the ancient pattern of the gurukula. He established his school in the name of santam, sivam, and advaitam. He also stuck two fundamental notes for his ashram; one of the universe and the other of the soul of man. His shrine is situated at the confluence of the streams of these two notes.

The very fact that Tagore selected a forest retreat for his school is in itself one of the first evidence of a behaviour pattern that gradually made the people of India identify him in their minds with the 'Guru' of the past.

According to Tagore nature is the greatest teacher. It is not hostile to man, but it is the form of 'Mother nature'. Nature is kind, benevolent and generous. To him education divorced from nature has brought untold harm to young children. Just as a man develops his relation with his fellowmen; he should develop his relation with the nature. God is found in the midst of nature. God revealed himself through different colors, forms and rhythms of nature God therefore, desires that there must be close relationship between man, God and nature. In

Gitanjali Tagore describes "God and man as two separate realities floating at will" (Tagore, *Gitanjali* poem no. 84)

Being a naturalist he is keenly aware of children's sensitivity to the influence of the great world in which they have been born. He knows that their subconscious mind is active, always imbibing some lessons and with it realizing the joy of knowledge. He further believed that the extra ordinary sensitiveness of the children's mind would make easy their introduction to the great world of reality and also make it joyful. Like the Gestalt psychologist, he believes that children imbibe their lesson with the aid of their whole body and mind, with all the sense fully active and eager. Therefore, he deprecates the school, where in the doors of natural information are closed to the children – children missing the perpetual stream of ideas which come straight from the heart of nature. Tagore believed that children should be surrounded with natural things which have their own natural value. According to Tagore, the minds of children should be allowed to stumble on and be surprised at everything that happens in the day to day life. In this respect, he is a great educational philosopher like, John Dewey: Just like Rousseau, he does not want purposefulness, which belongs to the adult –mind, to be forced upon the children in school, when once purposefulness is introduced, it becomes a torture to the child, because it goes against nature's purpose. In his view, nature is the greatest of all teachers for the child and therefore, there should be a little of interference as possible at every step by the human teacher in the matter of, and in the process of the child's learning. The reason why he distrusts very much the human teacher is because he felt education more in machine – made lessons than in lessons of life, so that the whole growth of the child's mind is not only hurt but forcibly spoilt. Therefore, he had great faith in the educational values of

natural objects. It was his conviction that the new tomorrow would stimulate the attention of the children with new facts of life and hence it would be the best method for the child.

He hates the idea of a dull routine in a school – that every day at the same hour, the same book is brought and poured out for the child. He wants the attention of children to be hit by chances of surprise of nature – the coming of morning, heralded by music and flowers and beautiful sunset, leaving deep marks on the children's minds.

Tagore believed that children had the natural gift of learning things very easily, which the adults completely ignore. He thought that with children every new fact or event would come to a mind that was always open, with abundant hospitality; and through such exuberant, in different acceptance that they learnt innumerable facts within a very short time, perhaps even amazing when compared with the slowness, with which the adults learnt. Since he had a great faith in the child's natural way of learning, he would not insist on forced mental feeding as a result of which lessons became a form of torture. He considers artificial feeding of the mind to be a man's most cruel and most wasteful mistakes.

Tagore wants children to have their own freedom to grow, which according to him, is the greatest possible gift for the child life. In his educational institution, Tagore also aimed at another kind of freedom – the freedom of sympathy with all humanity, a freedom from all racial and national prejudices. He tried to save the children from such vicious method of alienating their minds and also from other prejudices fostered through book, histories, geographies and lessons full of national prejudices. He sought by his methods of education to free the minds of children, usually shut inside prison – houses, so that they might become

capable of understanding, other people with different languages and customs. In his opinion, the worst of fellers come only when children lose their freedom of mind.

Tagore wanted to develop and give form to some ideal of education, so that the children might be brought up in an atmosphere of a higher life. Tagore wanted the ideal of the age to find a place in the centre of all education. The ideal of the age is racial unity which was to be brought about by living relationship of the people. Tagore included the ideal of unity in the activities of his institution – educational, aesthetic and social service activities. This in turn engendered in the students, love of humanity at large. They had their own freedom to grow freedom of sympathy with all humanity, freedom from all kinds of racial and national prejudices. Thus the freedom of mind becomes the greatest ideal of education for Tagore.

Rabindranath had faith in ideals, which was creative. Great ideal which creates great societies of men; Tagore's ideal is realization of truth, the supreme reality and true enjoyment in his view lies in the realization of perfection.

Tagore's ideal in education is a comprehensive one. It has for its field of activity the whole of human nature from its depth to its height. Its fundamental aspect is unity. The ideal of society which he wanted to bring about should have dance in its steps, music in its voice, beauty in its limbs, metaphor in stars and flowers, maintaining its harmony with God's creation. He does not want living society to become, under the tyranny of a prolific greed like an over – laden market cart, jolting and creaking on the road, that leads from things to nothing, tearing ugly ruts across the green life till it breaks down, under the burden of vulgarity, on the wayside, reaching nowhere. His ideal in education was the establishment of

the spiritual relationship between people. He believed in the bringing of different human races close together in bond of love and cooperation that brings a spiritual unity of man. The ideals are to be achieved not through the mechanical method of organization but through a spirit of true sympathy. He wanted to rescue man from the organized power of machine by that living power of the spirit which grows into strength, not through mere addition, but through organic assimilation.

True idealism in the educational philosophy of Rabindranath Tagore is to be found reflected in the following lines when he says that 'an ideal school' "must be an ashram where men have gathered for the highest end of life, in the peace of nature; were life is not merely meditative, but fully awake in its activities, where boy's mind are not being perpetually drilled into believing that the ideal of the self –idolatry of the nation is the truest ideal for them to accept; where they are hidden to realize man's world as God's kingdom to whose citizenship they have to aspire; Tagore regards self as an independent. "Where the sunrise and sunset and the silent glory of stars are not daily ignored; where nature's festivities of flowers and fruits have their joyous recognition from man; and where the young and the old the teachers and the students, sit at the same table to partake of their daily food and the food of their eternal life" (Tagore, *My School* 10) .Tagore's philosophy of education is based on the ideal of the spiritual unity of all races.

It was his belief that it was co-operation and love, mutual trust and mutual aid which made for strength and real progress in civilization, and not mere science or its advancement. He wanted a new spiritual and moral power to be continually developed in order to enable men to assimilate their scientific gains, to control their new weapons and machines; otherwise

he thought, they would dominate, enslave and slay men. According to Rabindranath, the world of mere science is not a world of reality, but an abstract impersonal world of force. Having been a witness to the first and second world war, he saw its disastrous consequences and therefore he began to distrust the modern civilization of vast power in which men have been losing freedom, humanity and lives in order to fit themselves for vast mechanical organizations – scientific, political, economic and military.

Tagore combined Eastern Idealism with Western Realism in a remarkable fashion. He not only tried to revive the traditional culture of India but also sought a higher unity between Eastern ideals and Western Science. According to Tagore the best point of education should be in full touch with our complete life, economical, intellectual, aesthetic, social and spiritual our educational institutions should be in the very heart of society, connected with it by the living bond of varied co-operation.

The object Tagore had when he started the Surull Farm, the Institute of Rural Reconstruction and the Siksha – Satra was to combine idealism and make education as realistic and as practical as possible . An insight into his realism can be obtained when he observed that Our centre of culture should not be the centre of the intellectual life of India but the centre of her economic life also. It must cultivate land, breed cattle to feed itself and provide needs of students, it must produce all necessaries, devising the best means and using the best materials calling science to its aid. Its very existence should depend upon the success of its industrial ventures carried out on the cooperative principle which will unite the teachers and students in a living and active bond of necessity.

Viswa – Bharati, the ideal of human brotherhood, a healing of the world –wide bridge between the rich and the poor, the scholar and the labouer, the learned and unlearned, as well as a solution of the conflict and divisions which have taken place both in the creeds and among the races of mankind. In his realism there is no rank materialism or pure pragmatism. In his educational philosophy, he always emphasized the principal characteristics of the Eastern mind, namely – not setting too high a price upon success through gaining advantage but upon self-realization through fulfilling the dharma or the ideals. His aim in education was not only simply to imitate the West, but to try to appreciate and assimilate the best in them and make it their own. He contended that if the East ever tried to duplicate Western life, the duplicate was bound to be a forgery.

Tagore wanted to make his children as happy as possible and give them as much freedom as he could in his institution. When children found themselves in an atmosphere of freedom and trust they never gave him any trouble. From the first, he trusted them and they always responded to his trust. His main aim was to find his own freedom in a larger world of men and things. He did not want his school to be just something more than ordinary in the sense that it was more free and happy than other schools, but it was how broader aim that it should represent further and wider ideals, embracing humanity itself. It was his idea that it should be a centre of culture, representing the best in both East and West.

In his centre of culture, scholars and teachers from all the parts of world were to live together in a spirit of mutual understanding. sympathy and love and learn the best in each other culture and teach what they have to contribute to others. They lived in an atmosphere of ideas, of living aspirations and worked together in a common pursuit of knowledge. Tagore

made an attempt on his institution to give educational training to the scholar not only in their own culture but also in the culture of others. Initiative and originality of mind were developed and freedom of thought was inspired the routine method of teaching were not to be accepted in his institutions. The scholars were rather expected to carry own their own work. Study with the help and facility given to them in the form of good Library, ample leisure and ready help of teachers. Between the teachers and the students there was a close contact and intimacy of relationship and it sought to establish a living relation between them.

The ideal always before Tagore has been to realize, in and through education the essential unity of man. The way in which he sought to achieve that unity gave him an insight into the object of education and its problems. Naturally, his various educational experiments Bholpur School, the Rural farm, the institute of rural reconstruction and Sikshas – shatra and his Viswa Bharati which represent all, crystallize his various aims and object of education which in turn had a wonderful philosophy of education, on which foundation, the super structures have been built. In fact, the various methods adopt by Tagore in the different branches of Viswa Bharati only show the different ways in which he sought to achieve the cherished aim and make his educational philosophy to practical success.

In the west Tagore is recognized not only as a poet but also one of the foremost thinkers; and one of the most outstanding educators of the present age. This is not because of any of the books on the philosophy of education that he had written although one can find some of the most modern theories of education in some of his writings, but because of school which he has founded and because of his principle of education which he had tried to work out and which are recognized by all the leading educators.

Tagore's philosophy and his principles of education have not been the outcome of any special training he had received at a training college or University. His Philosophy was the Philosophy of an artist and of a poet genius. Being an artist and a poet, he realized and appreciated sensitiveness in others especially in children.

The role of music and art in education the minds of children has been strongly recognized by Tagore. It is chiefly through music that both the student and teachings at shantiniketan – have understood the poetry of Tagore just as they have also understood his ideas by acting his plays. It is according to Tagore's own philosophy of education, that people learn best through the sub conscious mind – while acting in a play the actor subconsciously assimilate the ideas underlying the plot. Similarly, most of the students have learned Tagore's poetry by heart through music.

In fact, Shentiniketan looks much like and Asian hermitage and yet is thoroughly modern. All the modern educational principles are been practiced here – learning by doing. Social activities and an all round development of whole man not omitting the idea of service to one's fellow man. Shantiniketan is one large family, the members are from different religions, castes and creeds from different parts of India, from Europe and the far East and yet they seems to fit in which the atmosphere, all working for a common cause and perfect harmony with one another.

Rabindranath's approach to education is humanistic. "Living ideals can never be set into clock-work arrangement, giving accurate account of it every second, and those who have faith in their ideas have to test its truth in discords and failure that are sure to come to tempt

them from their path. I for my part believe in the principle of life, in the soul of man, more than in methods. I believe that the object of education is the freedom of mind which can only be achieved though the path of freedom, though freedom has its risk and responsibility of life itself has" (Tagore, *Lectures & Address*, P. 40 – 41). Tagore wants to establish harmony of relationship through humanism in education. According to him, only fullness of expression would signify full life and therefore, he observes: "our childhood should be given its full measures of life draught, for which it has an endless thirst. The young mind should be saturated with the idea that it has been born in a human world which is in harmony with the world around it. And this is what our regular type of school ignore with an air of superior wisdom, serve and disdainful. It forcibly snatches children away from a world full of the mystery of God's own hand – work full of the suggestiveness of personality" (19).

Tagore's early education has given him knowledge of the wrong from which children of man suffer. He considers children to be Gods own creations. Education of sympathy is far more important to him than mere knowledge. "We have come to this world to accept it, not merely to know it. We may become powerful by knowledge, but we attain fullness by sympathy. The highest education is that which does not merely give us information, but makes our life in harmony with all existence. But we find that this education of sympathy is not only systematically ignored in schools, but it is severely repressed" (21). Then Tagore goes on describing the unnatural way in which education is being given in schools. "From our very childhood habits are formed and knowledge is imparted in such a manner that our life is weaned away from nature, and our mind and the world are set in opposition from the beginning of out days" (21). Thus the greatest of education for which we came prepared is

neglected and made to lose out world to find a bagful of information instead. Tagore accepts the idea of degree in truth and reality. For example, to him both mind and nature are real. He says: "The flower that has failed to bloom, the river that has lost its course in the deserts, even these are not all together devoid of meaning" (Tagore, *Gitanjali*. Poem No. 147).

True humanism which is one of the most important characteristics in Tagore's approach to problems of education is quite evident when he says "we have obstacles in human nature and in our circumstances. Some of us have a feeble faith in boy's minds as living organisms and some have the natural propensity of doing good by force. On the other hand, the boys have their different degrees of receptivity and there are a good number of inevitable failures. Delinquencies make their appearance unexpectedly making us suspicious as to the efficiency of our own ideals" (Tagore, *My school* 9-10).

5.3 Aim of Education

Being a great visionary and a man of spiritual wisdom, his object to education is the emancipation of man from all kinds of bondages. He aims at a perfection, not only that of body or mind but also that of soul. In order to achieve that aim in his endeavour he makes education as broad as possible. That become evident when he says "But for us to maintain self respect which we owe to ourselves and to our creator, we must make the purpose of our education nothing short of the highest purpose of man, the fullest growth and freedom of soul" (Tagore, *my school*, pamphlet 5). At the same time he condemns the modern view of education which aims at only economic self sufficiency, thereby making a slave to for and money, ignoring the nobler aspects of life.

He expresses that when he says "it is pitiable to scramble for small pittance of fortune. Only let us have access to the life that gives beyond death and rises above all circumstances, let us find our God, let us live for the ultimate truth which emancipate us from the bondage of the dust and gives us the wealth not of things, but of inner light, not of power, but of inner love" (Tagore, *My school* 5). Tagore's object of education was to bring about the perfection of man by dispelling the darkness of ignorance and the ushering in of the light of knowledge. For Tagore knowledge does not mean mere pedantry but true wisdom which will be expressed in action through sympathy and love. In this connection Tagore observes "we have to keep in mind the fact that love and action are the only mediums through which perfect knowledge can be obtained, for the object of knowledge is not pedantry but wisdom" (Tagore, *Poets school*, 19).

According to Tagore, true freedom is not possible unless it is expressed in action. By developing a breadth of outlook through education an individual can express himself fully – in many ways, through which perfect freedom of body mind and soul is possible. To put it his own words: "Apathy and ignorance are the worst forms of bondage of man; they are the invisible walls of confinement that we carry round us when we are in their grip" (13). By creating an atmosphere of ideas in his institution by making provision for the growth of mind through many creative activities, by making teaching life-inspired and life-centered and by making education a joyous adventure of intellectual exploration and discoveries, the freedom aimed at is to be achieved according to Tagore.

Another object to education, according to Tagore, was the highest one that of giving mans the unity of truth. That unity of truth can be obtained only when there is no separation of

relationship between the intellect, the physical and spiritual aspects education but a harmony prevails. Tagore rightly observes that the highest education is that which does not merely give one, information but makes one's life in harmony with all existence. While aiming at such a harmony, he deplores people devoting their whole attention to giving children information, not knowing that by this emphasis they are accentuating a break between the intellectual physical and spiritual life.

Tagore attached for more significance to moral values in education than for mere results of science which produced a system and physical power. He aptly observes:" That we should borrow science from the west is right, we have a great things to accept from the people of west – their treasure of the intellect which is immense and whose superiority we must acknowledge. But it would be a great degradation on our part it we forget our own moral wealth of wisdom, which is of far greater value than a system that produces endless materials and physical power that is always on the war – path" (Tagore, *Talks* 67). Having witnessed the disasters that the first world war produced he began to distrust the evil purpose for which men's intellect has been utilized and therefore, he observe, "I came to the conclusion that what was needed was to develop and give form to some ideal of education so that we might bring up our children in the atmosphere of a higher life" (67).

Rabindranath keenly felt the need for idealism in education which was greatly lacking in the western education. In trying to restore the factor that was seriously lacking, he wanted to bring about a harmony between the West and East. While so doing, he did not distrust completely any culture, simply because of its foreign character. In his 'creative unity' he observes: "Then again, let us admit that modern science is Europe's great gift to humanity for

all times to come. We in India, must claim it from our hands, and gratefully accept it in order to be saved from the curse of futility by lagging behind. We shall fail to reap the harvest of the present age if we delay" (Tagore, *Creative* 193). In fact, what he objects is the artificial arrangement by which foreign education tends to occupy all the space of our national mind, and thus kills, or hampers, the great opportunity for the creation of a new thought power by a new combination of truths. It is this which makes him urge that all the elements in our culture, but truly to accept and assimilate it; to use it for our sustenance, not as our burden; to get mastery over our culture, and not to live on its outskirts as the hewers of texts and drawers of book learning. Thus, Tagore does not want education to be merely informative but desires that it should be creative also. "The great use of education is not merely to collect facts, but also to know man and to make oneself known to man" (Tagore, *Creative* 197).

5.3.1 Integral Development

According to Tagore the fundamental purpose of education is not merely enrich ourselves through the fullness of knowledge, but to establish bond of love and friendship between man and man. This is the humanistic aim of education in Tagore's philosophy. His approach to ultimate reality is integral. He believes in an inner harmony between man nature and God. The trinity man, nature and god are in fact the three aspects of same reality. In man the physical, mental and spiritual aspects are equally important and internally related. Therefore like Sri Aurobindo, Tagore believes in a multi – sided education with physical, intellectual, moral and religious aims. These are the faculties which enable man to grow into his real potentialities. efforts should be taken for man to develop these faculties at childhood and knowledge be attained directly from living with the nature.

5.3.2 Physical and Mental aim

Tagore gave equal importance of physical and intellectual development of this study. He thought that there was an inseparable bond between physical and mental faculties of man. He said "even if they learnt nothing, they would have had ample time for play, climbing trees, diving into ponds, plucking and tearing flowers perpetrating thousand and one mischief on Mother Nature, they would have obtained the nourishment of the body, happiness of mind and satisfaction of the natural impulses of childhood" (19). Living in closer contact with nature in early stages of education. It is thus with the end of physical fitness in view that Tagore wanted children to be in closer contact with nature in their early childhood. He recommends education through nature not only for children but for adults also. He thinks that such education would free them from false sense of shame and purify their outlook by making it easy and natural.

Along with physical aim of education, Tagore equally lays emphasis upon the mental aim of education. Like Vivekananda he is critical of the prevalent system of education which laid sole emphasis upon bookish learning. He said that one can touch the world not with our books and it is deplorable. Intellectualism takes us away from nature and creates a gulf between man and man. According to Tagore the intellectual aim of education is the development of the intellectual faculties such as logical thinking, critical appraisal and assimilation. Two mental faculties which should be developed through educations they are the power of thinking and the power of imaginations. Both are necessary for real manhood. Tagore believed that power of thinking and power of imagination are undoubtedly two faculties very essential for adult life. So "if one is to grow into real manhood, these two

factors cannot be eliminated from life" (Shri Gajarani 20). He criticizes the present system of education which put too much stress on memory and too little on imagination and thinking. He suggests that ever since childhood, instead of putting the entire burden on the memory, the power of thinking and the power of imagination should also be given opportunities for free exercise.

Tagore holds that education should facilitate an individual's cultural assimilations with his society and its knowledge and also promote the concept of universal culture. Education as a mere academic exercise and it alienates people from the society and prevent individual's cultural assimilation with the society which promote the concept of universal outlook and vision.

5.3.3 Moral and spiritual Aim

Like Vivekananda Tagore was also very much religious in his approach. In his opinion "real moral training consists not in fostering moral teaching like external decorations, but in making religion and morality an intimate part of life" (Tagore, *Creative* 22). For him religion could not be a part of life but it is its whole.

One of the important aims of education is discipline. Religion too is a disciplining force. In Siksa Samasya, we find an indirect exposition of Brahmacharya as a means of real education in early years. Tagore was a great admirer of Tapasya and Sadhana. He believed that austere living and self sacrifice could lead to nobility. He declared that "Nothing great and noble can be achieved except through severe suffering and sacrifice" (23). Another important value envisaged by Tagore was peace and tranquility. Both Vivekananda and

Tagore emphasized the importance of Brahmacharya, or celibacy during studentship. In ancient education Brahmacharya is synonym for the student.

- Education should create a sense of harmony with all throughout the world. The The Bharatiya concept of 'Visva Bandhhutva' or 'vasudaiva kudumbakom' could be attained through education the love of mankind and fellow feeling for all. In this modern era the Scientific developments had rendered this world small. The propensity of extended contacts provided and resulted in extended cultural contact. Thus the multicultural world was moving towards one culture world. In a seamless or borderless unification of the world harmonious co-existence could be attained by education. So according to Tagore, "the greatest education today is the education of mankind to give us national pride and conceit became the history of tomorrow will begin the chapter of international co-operation" (24).

5.3.4 General Aim

According to Tagore, the broad inclusive aim of education is the development of all the potential faculties of an individual leading to an all-round harmonious development of his personality. 'Man's education' he points out, 'aims at keeping alive to the last moment of life that infinite aspiration which is necessary for developing into full manhood. To attain full manhood is the ultimate end of education; everything else is subordinate it" (Tagore, 1326, B.S (a). In an article titled Siksa Shestra, he wrote, "lying of the foundation of human personality as a whole to be the aim of education" (Tagore, 1351, B.S. 51). He mainly emphasized that the aim of education 'is completed personality growth' which is very well correlated to Vivekananda's famous rhetoric *"fullest expression of our own self"*. He wanted the system of

education to be freed from the power of memory and to exercise his power of thinking and imagination"(12).

Two important questions that crop up with regard to education are; where is the end of education? And what after education? One such problem is that of the end of education. The important question is what after education. Is education always for educations' sake? The reply is a big 'NO'. In a utilitarian perspective after education one has to earn his livelihood. In modern contact purpose call it relevant education. Tagore did not fully agree with the utilitarian aim of education, because it fulfills only part of the objective. He stated "knowledge has two departments: On is pure knowledge the other utilitarian knowledge. Whatever is worth knowledge is knowledge. It should be known equally by man and women not for practical utility, but for the sake of knowing" (Tagore, *Creative* 25).

In order to make education practical he had definite plans. Tagore believed that the orientation of education should be both social and individualistic. It is both complementary and supplementary and hence made a synthesis of the two. In his opinion education is the freedom of the mind which can only be achieved though the path of freedom. The aspiration of man for an ever expanding fullness has two aspects that are inter-related, one is individual fullness and the other is social fullness, Tagore visualized "One of the main aims of education is to prepare the individual for the service of the country" (25). The Bharatiya concept of social work is based on tyaga and seva, renunciation and service because social work or samaja seva is a divine endeavour.

5.3.5 Harmony with Environment

Another aim of education according to Tagore is the harmony of the educand with the environment. The educand should know his environment and create harmony with it. One should imbibe his cultural heritage through his interaction with environment. According to him neither the education of the sense nor the education of the intellect, but the education of the feeling should receive the place of honour in our schools. True education is possible only in the forest, through intimate contact with nature and purifying austere pursuits.

5.3.6 Education of the Whole Man

According to Tagore, the education that is primarily necessary for fullness of the individual is manhood training for his holistic development. This type of education teaches every learner to conquer his own little self and herald his higher self – the self that by no means betrays his development of personality, considering the fact that self-reliance and self understanding act as the most precious qualities of personality. This type of education that emboldens "one's spirit also teaches one how to ride petty selfishness how to be liberal but not unusually and unduly uncompromising to every affair of life and experience and how to feel the pulse of oneness of humanity" (Mohit Chakrabarthi 7). It also allows one to be imbued with the spirit of truth that sustains and glorifies the human mind. The education that widens one's outlook and broadens the spirit of unstinted devotion to service to humanity. Patriotism fires one with the untiring zeal for tearing off the shackles of all temptations and giving all ears to the call of the indomitable, the endless and the most thrilling adventure of

life. True education always stands for advancement of erudition of the whole man and progress of world civilization.

Education of the whole man incorporates the idea of universalism whereby the whole world is transformed into a world of true humanity. Each country tries to reach the highest point of excellence in every affair of life. Education allows one to inculcate the spirit of excellence of oneself in homogeneity even under the threats of a heterogeneous atmosphere of life. The sooner one succeeds as a learner in utilizing one's own power of excellence the better is the possibility of coming out of the wolf of typical human aggressions tearing off the entrails of the spirit of unified sense of oneness.

5.3.7 Education for Individuality

True education aims at the emancipation of true individuality is the epitome of Tagore's educational thoughts and experiments. He highlights the spirit of individuality in moulding the overall development of personality. He criticises the contemporary process of education where the development of one's individuality is sandwitched in the commercial approach to impart education with a view to earning one's bread and never to have an access to the wide world of exercise of individual intellectual excellences.

Society aggravates where mechanized education mars the role of the individual; Tagore highlights the spirit of individuality and gives top most priority to growth and development of an individual learner through uninterrupted pursuit of learning. He also reiterated the fact that in the process of development of individuality, a balance between within and without, between the artificial, narrow, drab and mechanized elements of worldly

affair and the real, wide, wonderful and unique world of one's own in order to find the true meaning of life by means of untiring endeavour must be the objective of education.

5.3.8 Education for Freedom

Freedom is necessary for union of self with God. It is because of this freedom then the human self has purpose and greatness. In the highest stage of realization the self must remain distinct from God. The difference between Atman and Brahman is always there just like the difference between being and becoming "God is the infinite ideal of perfection and man the eternal process of self realization" (Tagore, *Creative* 15). With a view to ensuring the individual learner to find out the best in himself to exercise his own individual potentialities under favourable atmosphere and to be critical and creative makes room for wider avenues of freedom. Rabindranath deeply feels that in education freedom of an individual is the first criterion of creation of consciousness – the consciousness of what one is and that one should be. As an exponent of advancement of learning through one's own language, so that the learner might not encounter unusual impediments in the infinite domain of learning and experience, he also states the importance of knowing, receiving and utilizing the best thoughts, best ideas, best expressions of the alien world by moulding in one's own fashion and enriching with critical and creative contribution. Education is thus raised to the position of identifying, analyzing and incorporating freedom of right from an individual up to a society. The medium of expression and freedom of spontaneity are the crying needs of education in the true sense of the term. When education wails in suppression of feelings and imagination, individuality suffers most, and when individuality is imprisoned civilization mocks at humanity. "The fundamental aspect of education is the pursuit to express in words of thought

and ideas of the mind. It is the symptom of the healthy mind to make the very synchronization of the give- and – take process inwardly and outwardly. If the foreign language becomes the principle medium of cultivation of expression, it turns out as it like a habit of expression of ideas through mask (Tagore, *Siksha* 242).

5.3.9 Education for Aesthetic and Creative Development

"In Tagore's work, philosophy, religion and poetry fuse together beautifully in a common spiritual vision" (V.S.Naravane 37). In the fibre of Indian thought art tends to be ignored, without art life cannot be a comprehensive one. Plato contended that art should be directed towards attainment of moral value. Aristotle differed and advanced the conception 'art for arts sake'. There are modern critics who are guided by this conception. Marxian principle emphatically declares that art should be directed towards the attainment of social ends. In Tagore we find harmonious blending of the two. Rabindranath accepts the concept of evolution that matter, life mind and the spirit are the products of evolutionary process. In his words "Man has a fond of emotional energy which is not all occupied with his self-preservation. This surplus seeks its outlet in the relation of art, for man's civilization is build upon his surplus. This is the creative energy of man and source of evolution from physical nature to spirit" (Tagore, *Personality* 11). Rabindranath wants an uncompromising break through, a radical switch- over from all kinds of passivities. Cultivation of the service of goodness, adoration of the truth, good and beautiful in one's life, preparation of a better life through observance of simple, unassuming, natural facts of life like decorating the house with flowers and foliages, boutique work all endearing effects of performing arts, dance, drama etc. that mould the passionate urge of humanity in an objective manner. Education remains

incomplete in the absence of exercise of aesthetics and creativity "art evokes in our mind the deep and rich sense of reality" (Tagore, *Religion* 141). The relation between the teacher and the taught is based on the pre-supposition that there must be a creative and dynamic interchange of ideas and thoughts, of experience and innovations, of facts and imagination.

5.3.10 Education for Social Awareness and National Integration

Education for social awareness and national integration is in essence the education for human relationship. Tagore takes it a challenge for introducing a new system of mass education. Apathy and ignorance are, the worst forms of bondage. Humanity must be made free from this bondage. Tagore had the endearing heart to feel the pulse of the poor and the distressed whose life blood has strengthened the stream of livelihood of so called intellectual urbanites.

Dissatisfied with imperialistic, commercial parochial patch work type of education, Tagore introduces a new system that is rooted to the soil of the country and the world in the broad sense of the term. He gives stress on Yatra, Kathakata, the songs of the Ramayana, the Kavigaan and shows the avenue of reviving the spirit of rural unity. With emphasise on learning through the mother tongue which he considers to be equivalent to the breast milk of the mother, he opens out a new hope of regeneration of social and creative awareness.

Social service was one of the important objectives of Tagore's theory of education. To him it is a bond which knitted the human beings into communities and communities into nations and so on. Educations bring about a synthesis between individual and society. His concept of society was an international society based on universalism. Tagore himself breaks

a new ground by introducing people's education council for advancement of education of the adults and deprived. In his own 'The Poets school' experiments on education through imparting practical assignments for boys and girls coming from near by rural areas, working all day long sowing seeds, planting saplings seedlings, weaving clothes, using tools ploughing fields, pave newer avenues of the joy of learning by doing and learning by living. Self-reliance and self activity are the two very important weapons that Tagore wonderfully introduces through the the institutions of rural reconstruction of Sriniketan. Through analysis and evaluation of activities pertaining to social advancements by means of social and cultural activities sponsored by the said institute mark a new dimension of Tagore as a social and reformer.

5.4 Means of Education

Tagore said that there should be harmony between man and nature. The present predicament lies in the separation of man and nature. Society, i.e, family, neighborhood, play group, school and others should provide healthy condition for the development of the children. Gandhiji introduced craft work in Wardha scheme. Tagore's view is akin to Gandhiji. But both differ in the distinct attitudes towards life. Gandhiji laid emphasis on action; action was the keynote of character building. Tagore centers his view on the joy of life. Eternal Ananda of realization and expression is the core view of Tagore's educational system. Tagore presents an all encompassing system. "The scheme envisaged by Tagore and Gandhiji has no inherent contradiction and it is perfectly possible to include the Gandhian elements within the Tagore scheme, thereby making the latter more vigorous in its directive

influence on social life and saving it from the risk of social consequence" (Sunil Chandra Sarkar 98-99).

Some educationist holds social efficiency as the centre of education, which make education child centric. "Tagore makes 'life' the centre, not the life of this child or that, not even a particular aspect of human life in preference to some other, but life as a whole" (100). Tagore established his educational philosophy on the following Pillars.

One has to control the senses, conquer lust, anger, greed etc. and to dispel egoistic ignorance. After this one has to purify the inner most being. To establish rapport with the universe. To see God in one's own self and everything in God.

5.5 Mass Education

The fact that social awakening of the masses need a enlightened seat of advancement of learning can be hardly ignored. Tagore wants every educational institution to play vital role of bringing about social consciousness, so that the union between thought and action, experimentation and contemplation pave a avenues of emancipation of individuality. Education turned into reverence for what is just, pure, serene. Simple this changes the whole of socially distressed people's thought and activities and plays a vital role in orienting peoples behavioural bankruptcies. Therefore Tagore emphasizes on rethinking on character – crisis which is at the root of crisis of civilization. Not mere utilitarianism but fullness in education alone can bring desirable social change. As a matter of fact Tagore comes nearer to Gandhi who wants to bring about social change though mass awakening of consciousness on the

concept of Sarvodaya. Sarvodaya is the lesson of moral and ethical purity of perfection that can contribute to the welfare of global society.

Freedom for fullness of education as Tagore emphasizes is both mandatory and purposeful for social orientation. An individual becomes truly educated when he whole heartedly involves himself towards greater cause of the society.

Education allows everyone in the society to be true to each other in all respects and in all directions of the society. Education creates an ardent atmosphere of mental harmony and understanding between man and man and man and the society. The role of mass education is the upbringing of the society. Involvement in social changes is through education must primarily be germinated in the granary of genuine love for society.

5.6 Harmony and Love between Man and Nature

Tagore feels a need for harmony between man and nature. This relation between man and nature is that of personal love and not that of Mechanical law of Causation (Tagore, *Personality*, 13). Tagore finds that nature plays the role of mother just as the mother nurtures the child. Similarly in nature one may find complete nourishment for both the body and for the soul. The individual finds the emotional, moral and spiritual nourishment from the world. Thus the relationship between man and the world around him is characterized by law.

Tagore's spiritual world belongs to this world of ours. "With the breath we draw we must always feel this truth we are living in God. (Tagore, *Personality* 187). Thus Tagore finds spiritual significance in natural elements". If man penetrates deep beyond the natural phenomena he will have spiritual vision. In this way man will realize the eternal spirit in all

objects and will ultimately find the perfect truth. So the man must find himself in the closest relation with all the things around him and he should regard "the sun, the moon, water, earth as the manifestation of this same living truth that holds them together" (Tagore, *Sadhana* 8-9).

5.7 Freedom of Mind and World Peace

The human surplus according to Tagore results in constant longing for freedom and fulfillment. The same he want to implement in the field of education. He explained freedom in three categorized ways i.e, freedom of heart, freedom of intellect and freedom of will. Tagore meanings of freedom of mind, peace and universal love of fullness of life and human loyalty, held to lead a better world. For Tagore love is the supreme path. Tagore calls love as "integrated essence" (Tagore, *Religion* 30). 'Love is a unique state of being, it realizes both unity and difference. Tagore use the same word for joy and love. "this joy, whose other name is love must by its very nature have duality for its realization. The lover seeks his own other self in his beloved. It is the joy that creates this separation, in order to realize through obstacles of union". (30-31) To Tagore peace could be achieved only when diverse races and nation were free to evolve into their distinct characteristic. All would be attached to the stem of humanity through the bondage of love. He ardently believed that world peace could be achieved only through love and freedom. East and West met on a common ground and on terms of equal fellowships. Where knowledge from the flows in two streams from the East and from West and in their unity to perceived the oneness of Truth that pervades and sustains the entire universe.

"Where the mind is without fear and the head is held high; Where knowledge is free; Where the world has not been broken up into fragments by narrow domestic walls; Where words came out from the depth of truth; Where litreless striving stretches its arms towards perfection; Where the clear stream of reason has not lost its way into the dreary disert and of dead habit; Where the mind is led forward by these into ever widening thought and action – into that heaven of freedom, my Father, Let my country awake" (Tagore, *Gitanjali* poem No. 35).

5.8 Educational Trinity

Santhiniketan, Viswa Bharati and Sriniketan, together constitute Tagore educational trinity. The three institutions displayed a discernible pattern of growth and expansion, illustrating their underlying creative unity.

5.8.1 Santhiniketan

The most important trinity is Santhinikethan. It is a living movement to Tagore's electic genius as philosopher – educationist who believed in the principle of harmony in all human relations and achievements.

While starting his school, Rabindranath had in his mind, the Tapovana, the forest hermitages of ancient India where the teachers and the pupils would be seekers of truth, and would live the life of truth far away from the din and excitement of crowds amidst the natural beauties of the forest. In such an atmosphere, the scholars and students were expected to live in a very simple manner, to learn, to think truth as more important than riches, to love nature and to respect all life. Rabindranath firmly believed that India's work was to teach the world

this love of outward simplicity and inward truth. In fact, Tagore wanted Santhinikethan to be rather the first new forest school of India, but at the same time, he did not want it to be just a replica of the old type. He hoped that it would have the same spirit of the ancient forest school but at the same time, a different outward from suiting the times. His Primary object was not teaching but living "life in god. The traditional forest colonies of great teachers fascinated Tagore and he wanted to recapture its spirit in his institution. Tagore's admiration for the ashram was due to the fact that "they consisted of homes where, with their families' lived men whose object was to see the world in God and to realize their own life in them. Though they lived outside society, yet they were to society what the sun is to the planets, the centre from which it received its life and light. And here boys grew up in an intimate vision of external life before they were thought fit to enter the state of the house holder" (Tagore, *My School* 5).

The school of Tagore arose in a natural way from little beginnings. It was while residing there in the year 1901 the idea of reviving the ashram occurred to the mind of Tagore and it was an experiment in the direction that in the year 1901, he began to keep a little school with only four or five pupils in all of whom one was his own son and most of them happened to be problem children who were supposed to be incorrigible. But slowly the school grew and in a few years there was a hundred and fifty boys living together there, all in residence. Now there are many girls also with a separate hostel, but they share all the classes and the activities with the boys. Santhinikethan is a garden school. Here the classes are held in the open air-the whole life of the school goes on out of doors. The various classes meet under different trees in the grounds and each boy where there is writing to be done, will take his own mat, ink-pot, paper and pen. Since it was a poet's school, it was full of music and poetry. In fact

Rabindranath once called the school itself a poem-a poem that was written on life and not on paper, the boys in the school began and ended with music, he himself composed most of the songs and hymns and he taught the boys to sing them every morning before sunrise. Every morning a group of student sings would so go round the ashram and wake up the boys before sunrise by singing some of the songs of Tagore which signified joy and praise to God for morning and evening, for the flowers of spring and the harvest of autumn for the heat and dew for the days of storm and rain and for the quiet moon nights.

The system that Tagore built up in his school was not a rigid one since he himself despised the more idea of size or organization as such. He was not afraid of the small beginning it had: he cared more for the rich ideas and the true spirit with which it worked than for anything else. Even when he started his school he openly declared his underlying motive as such. "For the idea is not like a fixed foundation upon which a building is erected it is more like a seed which cannot be separated and pointed and directly it begins to grow in to a plants" (Tagore, *Letters and Address* 18).

The growth of his school was the growth of his life and not the mere carrying out of his doctrines. The ideals of santiniketan changed with his maturity like a ripening fruit that not only grows in its size and deepens in its colour but undergoes change in the very quality of its inner pulp. The idea with which Tagore started the school was a very noble one and he worked very hard with a missionary zeal making a huge sacrifice of his all money energy and time. He was himself little convinced with the smallness of it results but at the same time he was not disheartened.

The secret of success becomes a great revelation when he gives out that "thus when I turn back from the struggle to achieve results from ambitions of doing benefit to others and came to my own innermost need; when I felt that living one's own life is truth is living the life of all the world, the unquiet atmosphere of the outward struggle cleared up and the power of spontaneous creation found its way through the centre of all things" (Tagore, *My school* 7). Tagore upbringing was in an atmosphere of ideas free from all conventions he was fearless in his freedom of mind and it emboldened him to try experiments undaunted by failures.

At Shantiniketan ,Tagore tried to create an atmosphere of ideas and in the teaching system of his school, he tried to carry out his theory of education which was based on his experience of children mind .He had more faith in the sub-conscious mind of children that in their conscious intelligence . He was also sure that what were needed was breadth of culture and no formal method of teaching. He wanted to develop and give form to some ideal of education so that children might be brought up in an atmosphere of higher life. He emphasized the need for idealism in education, so that an inner standard of perfection may be attained and self emancipation obtained .He wanted to make learning a joyous adventure - learning by exploring and activity. .In his school there was no prescription, regarding the learning of lessons at set hours. The boys were given complete liberty to learn songs, not at set hours, but when they felt like it ; to read for hours together the treasures which they had treasured for themselves and to go exploring and live like Robinson Crusoe. To put it in a nut-shell, the children of his school learnt by exploring and experimenting by activity, by music, and drama and by making a noise. The naturalism of Roussau finds its echo in his school. Tagore taught his children that nature was their best friend and not an enemy and therefore,

they should learn by living and working with nature. Life was lived in its fullness, in communion with nature, realizing the unity of all mankind.

His ideal of education was not book learning but learning through love and action, the true medium through which perfect knowledge could be obtained .His object of knowledge was not pedantry but wisdom. Therefore, he introduced in his school a number of culture and creative activities, and active vigour of work, and joyous of exercise of inventive and constructive energies that help to build up character. He believed in children making their own experiments and improvisation in order to give opportunities for exploring once capacity through surprises of achievements. Rabindranath did not want the path of knowledge to be very smooth and completely free from all obstacles .He recognizes that "Life's fulfillment finds constant contradictions in its path but these are necessary for the sake of its advance" (Tagore, *Poet's School* 7).

The active healthy life in Shantiniketan, brought out all that was good in the boys and he accumulated rubbish of impurities was swept off. They daily life brought before them moral problems, in the concrete shape of difficulties and claimed solutions for them. The logic of facts showed to them the reality of moral principal in life .To the children of Shantiniketan, studies were never a task, since they were permeated by a holiday spirit, taking shape in activities, Tagore did not believed in the religious method of teaching which seemed dull and unappealing to him in his boyhood days. He boldly declared that people were not to expect in his institution the ordinary routine method of class teaching.

Naturalness was developed in the children through their daily, constant and intimate relationship with their human surroundings, through several media such as their associating themselves with the various festivals, dramatic, performances, music, picture making, study of literature and other activities, which were the true expressions of life. The students were given opportunity to find their freedom in nature by being able to love it. It was helpful in developing in them a sensitiveness of soul in their relationship-not only with men and things but also with nature. Briefly speaking, Tagore believed in an education which took account of the organic wholeness of human individuality. For the healthy growth of such an individuality would be needed a general stimulation of all its faculties both bodily and mental. Tagore found from his experience in Santiniketan, that the minds of children actively engaged in vigorous constructive work, quickly developed energies which sought eager outlets in the *pursuit of other kinds.*

At Shantiniketan, under the environment of Ashram, the pupil found the best opportunity for their physical, intellectual and spiritual development. There was no distinction between the teachers and pupil. Life was lived in harmony with nature, realizing the unity of mankind in all spheres of life. Ernest Rhys has rightly observed "To know how education can be made musical both in the old way and the new, we would turn to the school of Peace at Santiniketan" (Ernest 133). At Santiniketan, the beauty of nature and the noblest pursuits of man were all in a 'Pleasant harmony'.

5.8.2 Viswa - Bharathi

Viswa-Bharati is Rabindranath Tagore's international University at Santiniketan. The term 'Viswa - Bharati' signifies a place of Universal knowledge and world culture. Viswa Bharati grew out of Santiniketan Ashram founded by the poet's father, Maharshi Devendranath in 1863. The Ashram was meant originally to be a retreat where seekers after truth might come and meditate in peace and seclusion. In 1901 an experimental school was started at Santiniketan by Rabindranath with the object of providing for an education that would not be divorced from nature and pupils feels freedom, mutual trust and joy. Since 1921 Santiniketan has been the seat of Viswa-Bharati, an international University seeking to develop a basis on which the culture of the East and West may meet in common fellowship. To him institution, which he called Viswa-Bharati, where indeed the whole world find its one single nest, he first invited scholars, teachers and friends from different parts of India representing its different cultures. This helped Tagore in his work, its spirit widened and gradually, Tagore thought of opening its doors wide. He wanted his institution to represent further and wide ideals embracing humanity itself.

Rabindranath's scheme of education at Viswa-Bharati was to be distinctly national, patriotic, and absolutely Indian, of the very soil of Bengal. But yet it was to be infused with and aided by the highest, noblest and most intelligent thought and method of which the human spirit had hitherto made it master. In his attempt at bringing about a true integration of the East and the West, he refused to recognise any barrier between them, since he believed in the Unity of all cultures. Tagore thought that both the East and the West were ever in search of

each other as the right hand would need the help of the left. Therefore, the Poet- educationist felt that

According to Tagore, the first step in the realization of such a unity was to create opportunities for revealing the different people to one another. A meeting ground was to be found out, where there could be no question of conflicting interests. One such place will be the University, "Where we can work together in a common Pursuit of truth, share together our Common heritage, and realize that artists in all parts of the world have created forms of beauty, Scientists discovered secrets of the Universe, Philosophers solved the problem of existences, saints made the truth of the spiritual world organic in their own lives, not merely for some particular race to which they belonged but for all mankind" (Tagore, *Creative* 172). The difference in man which are natural did not disturb his peace of mind, because he knew the fundamental principle of life, that is unity and therefore that mind of man is one and it works through many differences which would be absolutely essential for the achievement of fundamental Unity. The achievement of fundamental unity was the primary aim of Tagore at Viswa-Bharati. And therefore, he realized too well that the perfection of such a unity would be not in dead uniformity, but in harmony of relationship. The aim of Viswa-Bharati was life-giving; it was to achieve unity in diversity. The function of Viswa-Bharati is best explained by Tagore himself as thus: "Being strongly impressed with the need and the responsibility, which every individual today must realize according to his power, I have formed the nucleus of an International University in India, as one of the best means of promoting mutual understanding between the East and West. This institution, according to plan I have in mind, will invite students from the west to study the different systems of Indian philosophy, literature, art and

music in their proper environment, encouraging them to carry on research work in collaboration with the scholars already engaged in the task" (Tagore, *Creative* 172-73).

The primary object of Viswa-Bharati would be to reveal the Eastern mind of the world; he wanted to synthesis of all the different cultures which Asia possessed. Since knowledge is universal, it has to be shared equally by all. Such a sharing would enable good appreciation of the distinct contribution of each country and at the same time, would not ignore the individuality of each and her specific power to exist. He did not want India to be merely receptive or imitative but wanted her to be conscious of her own rich individuality and the priceless treasures of wisdom that she has to offer to the enlightment of the world. He wants everyone not to forget that India had her own mind which was not something of a dead past but living, and that it thought, it felt, it expressed itself and it was receptive as well as productive.

Viswa-Bharati was formally opened on December 22, 1921, twenty years after. the founding of the Santiniketan School. According to Tagore, Viswa-Bharati would have two main aspects, One would be for the East to know its own mind in the same way that the West has done, owing to its concentration of culture and the use of it vernaculars. Secondly, Tagore sought at Viswa-Bharati to have a living relationship established between the Eastern and Western People. In accordance with the poet's thought, the work of Viswa-Bharati can be thought of as growing up in three concentric circles. The innermost circle is the circle of India. It represented the rich treasures of India contained in her literature, social traditions, art and music. Provision was made at Viswa-Bharati for the study of different Indian languages, different systems of music, dance and religion as well; for Rabindranath clearly recognised

that it was not enough to know one's own province language or religion only. Therefore, Tagore welcomed students from all parts of India to Viswa- Bharati. The second circle is the Circle of Asia. Viswa-Bharati maintained its links with other parts of Asia through the various departments of studies. Students from Persia, Ceylon, Burma, Malaya, Tibet, China and Japan were enrolled in one or other department of Viswa-Bharati and thus the students were helped to realize that no country could afford to be completely independent of other countries either in its thought or art of civilization. The third circle is the world circle which includes along with Asia the civilizations of the West of Europe and America. Rabindranath opened the doors of Viswa-Bharati to Western teachers and students who helped a good deal to make Viswa-Bharati a real university.

At Viswa-Bharati, Tagore tried to develop initiative and originality of mind in the students. Since he knew the defects of Western education, principally foreign and European, imitative and not constructive he wanted to infuse and new spirit into it by introducing an inspiring atmosphere of creative activity, by making education in natural atmosphere. In Viswa-Bharati should be, in it, no barriers of caste or creed and no test of religious belief imposed on the students. Within the precincts of the Ashram, no image should be made the object of worship, no word of religious controversy spoken and no injury to be done to the life of bird or beast. Members of all communities were equally welcome and in the hostels and dining-halls, students lived a corporate life. Tagore made ample provision for the study of different religious cultures of mankind and they received due recognition within the borders of Viswa-Bharati.

Life was lived by all in vital harmony with all creation. In Viswa-Bharati, the education given is not merely a matter books and classrooms and black-boards and written examination papers. It is an education received and imparted within the lap of nature herself, beneath the shade of over-hanging trees and under the open sky, at the festival of the full moon and through the music that ushers in the coming of the rain. On every side and by every means the teaching given in Ashram is kept in union with God's marvellous creations.

Tagore's regard for nature which is deep finds expression in the matter of sex education at Viswa-Bharati. He agrees with the modern educationists that there shall be no artificial educational barriers created between man and woman. In the international university of Rabindranath, both man and woman share equally in the education given and both are equally represented in the constitution. Rabindranath's conception of future civilization is based on spiritual ideals of reciprocity between man and women and not upon economic ideals of mere efficiency; upon worldwide social cooperation and not upon economic and political competition or exploitation. And therefore, he would not ignore the equal claims of the superiority of a woman on any account.

In order to prove his faith in human values and to give effect to his philosophy that men and women are equal. Tagore has tried to maintain intact the family life at Viswa-Bharati as far as possible.

The Viswa-Bharati maintains the following academic Institutions or Bhavans which are all co-educational and residential they are Patha Bhavana (school section), Siksha Bhavana (Higher Secondary), Vidhya Bhavana (College for under graduate & post graduate

studies and research), Vinaya Bhavana (College of teaching), Kala Bhavana (College of fine arts & crafts), Sangit Bhavan (College of music and dance), Cheena Bhavana, Indo Tibetan Institute, Hindi Bhavana (Which organise teaching and research in Chinese, Tibet and Hindi respectively.)

5.8.3 Sriniketan

On February 6, 1922 only a few weeks after the formal opening of Viswa-Bharati, Tagore opened a new centre at Surul with the name of 'Sriniketan'. The word 'Sri' contains the idea of prosperity, of welfare resulting from activity and growing into healthy beauty. The name Sriniketan, therefore, reveals Rabindranath's hopes and ideals. He wished to make the village centre "a home of welfare and beauty" (Tagore, *Sykes* 88).

Starting the institute of Rural reconstruction, the thoughts that were upper most in the mind of Tagore were to arouse the feeling of self confidence in the villagers and imbibe them with a spirit of self help, train them in the principles of co-operation and lastly to urge them to rely on their collective strength for a solution of their numerous problems. That was why training formed an important part of the activities of Sriniketan in the sphere of rural reconstruction.

The basis of Sriniketan was laid on co-operation. Tagore believed that his educational institution should not only instruct but live; not only think, but also produce. He wanted his centre of culture, not only to be a centre of intellectual life of India, but also the centre of her economic life. According to him, true education is to realise, at every step, how the training and knowledge gained his organic connection with one's surroundings. Therefore, it was his

ambition, that education to be true, should be in full touch with complete life - economical, intellectual, aesthetic, social and spiritual.

Aims and Objective of the Institute of rural Reconstruction are the Following

(1) To win the friendship and affection of the villages by taking a real interest in all that concerns their life and welfare and by making a lively effort to assist them in solving their most pressing problems.

(2 To take the problems of the village and the field to the classroom for study and discussion and to the experimental form for solution.

(3) To carry the knowledge and experience gained in the class room to the villagers to improve their sanitation and health, to teach better methods of growing crops and vegetables and of keeping livestock to encourage them to learn and practice art and crafts, and to bring home to them the benefits of associated life mutual aid and common endeavour.

(4) To encourage in the staff and students of the department itself a spirit of sincere service

(5) To train the students to a due sense of their own intrinsic worth, physical and moral and in particular to teach them to do with their own hands everything, which a village householder or a cultivator does or should do for a living if possible, more efficiently.

(6) To put the students in the way of acquiring practical experience in cultivation, dairying, animal husbandry, Poultry keeping carpentry, smithing, weaving and tanning, practical sanitation work and in the art and spirit of cooperation.

(7) To give the students elementary instruction in the sciences connected with their practical work to train them to think and observe accurately, and to express and record the knowledge

Industrial training formed an important part of Sriniketan. Older boys were given training in the silpe-Bhavana, the schools of crafts, so that it might help them to earn their living in the future. Training in crafts was wider in its scopes since a number of courses were thrown open to them in the carpentry section, Weaving section, book binding section and pottery section etc. The main object of the department of industries had been to revive the local industries and introduce such others as might be profitable to the village people. "It was by Wanton exploitations of nature that material achievements had been made. It had destroyed the peace and harmony of cosmic life (Tagore, *Rabindra Rachanabali* vol. 13. 42).

There were always a few vacancies for students who wished to come and earn their board and lodging and in return to learn self-support and be of service in the village. There would also be accommodation for a few research students in rural reconstruction work. Surul students were able to attend lectures at Santiniketan on certain evening in the week and a taste for art and literature was being maintained and developed by close contact with Santiniketan itself.

The village-welfare department has been acting as the extension Department for the institute, carrying all its activities into the villages and coordinating the work of different departments was the goal Rural Reconstruction.

The success of Tagore's experiment in rural reconstruction was the test of real happiness that he had brought to the villagers around Sriniketan. Tagore tried by his

experiments at Surul, to bring to the villages not only more money, but also greater interest in life and hence more happiness and enjoyment. He comes around to the view that "Plain living and high thinking was the only solution for men to live in harmony with nature" (Tagore, *Rabindra Rachanabali;* Vol 2, 223). The course of training that he offered at Sriniketan has enabled the People to become independent and self-reliant without which there could no real freedom or happiness for the villagers. For that we want to make every village in India a Sriniketan a home of welfare and beauty.

5.8.4 Siksha-Satra

An Experimental in rural Education at Sriniketan Siksha-Satra was a new school which Tagore founded in 1924. He began his experiment in rural education with a few boys who were too poor. One of the inspiring factors for starting the Siksha-Satra was to give a practical basis of education by giving fuller, opportunities to the students to enter into intimate relationship with the natural and social environment. Secondly, Tagore wanted them to take upon themselves greater measure of responsibility in meeting the day today requirements of individual and community life. Thirdly, he wanted the greatest emphasis to be laid on learning through creative occupations and at the same time, he wanted that knowledge of formal subject should be co-related, to the basic activities.

Besides . the poet, the two people who were most directly responsible for the starting of the experiment in rural education were Mr. L K Elmhirst, and Mr. Santhosh Chandra Majumdar both received their agricultural training in the Unites States, but neither of them

had any professional training in teaching. They would naturally play a leading part in the reconstruction of their home villages and thus make for a renaissance for rural life in India.

The aim of Tagore in founding the Siksha-Satra was to have school that would equip boys for a full civic life. The boys must have their intellect developed, as well as their aesthetic imagination; they must imbibe an espirit-de-crops, or team spirit on which to build a harmonious social life in their home villages. The primary object of an institution of this kind he said ' "should be to educate one's limbs and mind not merely to be in readiness for all emergencies, but also to be in perfect tune in the symphony of response between life and the world" (Bulletin No.2). Through Siksha-Satra one can experience in dealing with the overflowing abundance of child life, its charm and simplicity to provide the liberty for the joy and play.

The experiment was started with only half a dozen boys. The whole emphasis was laid upon education by experience. Only a limited number were admitted at the initial stages. They were either orphans or their parents were too destitute to send them to any school. No particular method was employed in the matter of selection of these boys. Being a residential school, there was no distinction of caste or creed among the inmates all the students and teachers, kin by feeling of community, as one social group. The student had plenty of opportunity for fully developing their talents and capacities under the guidance. Tagore's goal was to organise for the boys, a life of vigorous self-expression and creative enterprise. At Siksha-Sastra , each boy was allowed to read any book he liked and progress at his own rate, with the guidance and help of the right teacher at the right time being always assured. The students learnt gardening through growing vegetables, regular marketing by the students

themselves gave them knowledge of arithmetic, and their occasional samples across the undulating country resulted in knowledge and geography and from their observation of several living beings, both within and outside the campus, sprang their knowledge of natural sciences. One day in the week was given over to an excursion which was usually in the form of a picnic. During their excursion they would study local geography as well as the history of the district. As they pass through the fields they would notice the different kinds of soils in various places, observe the irrigation tanks, collect all kinds of stones and fossils, analysis herbal specimens and study medical and economic values of the herbs etc. From the psychological point of view such excursions were very valuable, in less than Six months the boys of Siksha-Sastra would learn a good many lesson of self-help, personal hygiene and sanitation, and above all they used to learn the dignity of labour.

The nature of the course at Siksha-Satra aimed at leading the students to discover things for themselves, to encourage spontaneous curiosity in Nature and love of work and creation through work. In the long run, such training was expected to equip them properly so that they might earn their living by some crafts, agricultural sciences, or business methods and at the same time develop the body by physical culture. Sufficient care was taken to see that each one of the student maintained good health. In Siksha-Satra all teaching was life-inspired and life centred. Tagore capitalized on the subjective experiences of the students and the methods adopted were largely based on the intelligent and imaginative observation of the boy's environment and background. He himself never punished the students. anybody misbehaved;

Tagore's experiment in Rural education has proved a great success, he had the heartening response of the villagers themselves who were unsophisticated and not job-minded and since the boys who were enrolled in his institution never thought of education merely as a means of passing examinations, just to find comfortable jobs in cities. In the view of the efforts that are being made today to re-orient the educational system to meet the needs of the people of free India, it is indeed curious to think Rabindranath, nearly a quarter of a century back anticipated the most progressive educational thoughts and principles yet discovered and gave them a concrete shape in the small modest -looking institution, Siksha-Sastra.

As a great social synthesizer, Tagore makes an ardent appeal to the finer sensibilities of mankind – the sensibilities of the heart – to bring about a certain form of social cohension in the part of emotion. He does not want that one pupil should have a fractional knowledge and experience of the history of world – a history that is alienated from the main socio cultural stream of people living far or near. Tagore visualized sad consequences of the so called modern civilization in his unique introspective pattern of thought and wanted to revitalize the universal spirit of brotherhood of mankind, which finally took shape in his idea of foundation of Viswabharathi. It is indeed, the idea of fullness in education through which a transvaluation of social norms and values can be significantly brought out. With this definite idea in view Tagore shows in his educational thoughts and experiments at Viswabharathi that not from the ivory tower of alienation but from the platform of common social day to day pattern of life all social in consistencies need a change – a thrilling and pulsating change of course. In his own Viswabharathi whose motto is as, he firmly declare '*Yatra visvam bhaktiyekanidam*' an unparalled excerpt from the Upanisad. Where the world makes its home

in a single nest, the social evolution of mankind has been considered from the grass root levels of human consciousness. And whatever educational principles and procedures, methods and strategies are innovated and practiced in performance are all in the pipeline of the total social welfare and humanity.

In Tagore's view education was not intellectual development alone. It also develop a student's aesthetic nature and creativity. The quest for knowledge and physical activity in an agreable environment were integral parts of the process. Freedom and creativity are linked in Tagore's thought, one conditioning the other. The more people go beyond the limitation of their animal nature, the closer they come to humanism, freedom and unity and are then able to develop their creativity. This quest alone gives a meaning of life and education is an effort to make life meaningful. Here the aim of individual and those of the community have become almost one. Tagore did not neglect the lesser aims of life and education. In the colonial system of education that existed at that time the whole focus of education was on employment, and neglects the higher aims of life. His intension was to correct this wrong emphasis, without ignoring science, technology and agricultural sciences, as well as training in village crafts. Without these, it was not possible to revive the derelict life of rural India. Both categories of aims should thus be considered the objective of education. It was necessary, Tagore felt to make the younger generation aware of their national cultural heritage and to grasp its significance for them. If the same time education should bring children face to face with the cultures of other countries and persuade them to learn from them. Tagore put great emphasis on the use of a national language as the vehicle of education at all stages. He wanted Indian universities to integrate themselves with society and make an effort to educate

people living in the countryside. He did not want education to remain confined to the cities and to particular classes of society. He was very much concerned with women's education. His educational and the number of female students is conspicuously large at Santiniketan. He wanted women and men to be offered similar theoretical course with separate practical courses for women, since their roles in life differ from those of men. Tagore considered teachers to be very important aim in any scheme of education. He wanted teachers to help young children to grow on their own as a gardener helps the young plants to grow.

From the above discussion we can sketch out that Tagore did not write a central educational treatise, this ideas must be assembled through his various writing and educational experiments like that at Santiniketan should be implement collectively and universally. In general he envisioned an education that was intensely rooted in one's immediate surrounding but connected to the cultures of the wider world, upon agreeable learning and individualized to the personality of the child. He felt that a curriculum should orbit organically around nature with classes held in the open air under the trees to provide for a spontaneous appreciation of the variability of the plant and animal kingdoms and seasonal changes.

The present system of education is instrumental in the advancement in science and technology has brought physical comforts to a few but it has failed to bring the peace and joy. That is the defects in our educational system. Our information-centered, non-creative educational system had failed to generate self employment, develop a proper value system or device a mechanism for reducing tension and discontent its consequences are alarming. Unemployment, corruption, dishonesty, terrorism, disrespect for women and elders and adult tension are the result of present educational system in some extent. The final result in lack of

peace and joy we have no choice but to change our educational system. Tagore's model of education is the best experiment model in hand. Its relevance must be assessed before it is adopted. The aim of Tagore's model is harmonious development of individual faculties. In present day conditions, its relevance can be established from psychological, intellectual, spiritual and social factors. Only harmonious development ensures proper development and leads to eternal joy. It helps generate self-employment, develop proper value systems which can kill social evils like dishonesty, corruption and terrorism. The present educational system has failed to produce desirable results. The time had come to switch to Tagore's alternative model which is based on well established principles of child and social psychology. It is not the panacea but has immense potential for producing a new social order. So if, the state and central governments and intellectuals come forward to make an honest attempt to fulfill Tagore's dream, it will be the highest tribute the country can pay to the poet in the centenary year of that experiment. Otherwise we may have to wait till a foreign country adopts this model and put its own stamp on it. We will then have to borrow it as a 'Foreign product'.

Reference

Chakrabarthi, Mohit. *Rabindranath Tagore Diverse Dimensions.* New Delhi: Atlantic Publishers and Distributors 1990.

Dasgupta. *Upanishader Patobhukikya Rabindra manaas.* Calcutta: A Mukherjee 2 Co. 1968.

Dash, B.N. *Thoughts and Theories of Indian Educational Thinker.* New Delhi: Dominents publishers, 2009.

Gajarani, Shri. *Rabindranath Tagore.* New Delhi: Common Wealth Publications, 2006.

Madhusoodhen Sreekala. *Indain Education*: Genesis, Growth Development and Decline, Chennai: Vivekananda Kendra Prakashan Trust, 2014.

Naravane, V.S. *Introduction to Rabindranath Tagore,* Allahabad: South Asian Books 1978.

Rabindranath Tagore *Lectures and Address;* London: Macmillan & Co. Ltd. 1950.

Rhys, Ernest. *Rabindranath Tagore & Biographical study.* New York: Macmillan and Co- 1968.

Sarkar, Sunil Chandra. Tagore *Educational Philosophy and Experiment,* Viswabharathi: 1961)

Siksha Shatra, *An Experiment in rural education in Sriniketan;* Viswabhati: Bulletin No. 21 January, 1949.

Tagore *Rabindranath. personality.* London: Macmillan & Co. Ltd 1st edition, 1961.

-----------, -----------. *Kalvidya Santhiniketan:* 1926 BS (a).

-----------, -----------. *Rabindra Rachanabali* Vol II British Centenary edition. West Bengal; 1961.

-----------, -----------. *Rabindra Rachanabali.* Vol 13 British Centenary edition, West Bengal; 1961.

-----------, -----------. Calcutta: Viswa bharathi, 1351 BS.

-----------, -----------. *'Siksha Swangikaran' siksha.* Viswa Bharathi 1973.

-----------, -----------. *'Marjirie sykens Longmans.* Green & Co 1974.

----------, ------------. *My school.* Viswa Bharati. Pamphlet, no. 1 1946.

----------, ------------. *The Religion of man.* New Delhi. An imprint of Harper Collins Publishers India Pvt. Ltd, 1993.

----------, ------------. *'A poets school* (Bulletin No. 9). Calcutta: Viswabharati; 1946.

----------, ------------. *Creative unity.* London: Macmillan and co, 1995.

----------, ------------.. *Gitanjali,* London: Macmillan & col. Ltd. 1956.

----------, ------------. *Sadhana – The Realization of life.* London: Macmillan and co, 1954.

----------, ------------.. *Talks in china.* Viswabharati: Book shop.

CHAPTER VI

Conclusion

The Indian concept of education unravels the secret of secular and spiritual knowledge, the apara vidya and para vidya. It has been a story of unity and synthesis, of reconciliation and development of a perfect fusion of old and new values. Today this appears to be the missing spirit in education. Our tradition respects the spiritual view of man as well as the biological view. So the purpose of value education in the Indian context is not to discover new value but to activate and energize the spiritual, psychic and physical value sources already present in everyone and to direct the emotions and life energies towards illumination and perfection. In the opinion of Mukherji "Ancient Indian Education is also to be understood as being ultimately the outcome of Indian theory of knowledge and a part of the corresponding scheme of life and values. That scheme takes full account of the fact that life includes death and the two form the whole truth. This gives a particular angle of vision, a sense of perspective and proportion in which material and the moral, the physical and spiritual, the perishable and permanent interests and values of life are clearly defined and strictly differentiated" (Mookherji. Vol. 1, p.xxii. prologue).

Thus Indian knowledge system takes care not only the life-long material existence in this planet but also prompt the ethereal existence even beyond the corporeal existence of man. The apara vidya or the knowledge acquisition of the objective world is only a part of the education, the complete education, paravidya must aid in the self fulfillment of the individual for he is potentially Divine. "*Vijnate sarvamidam vijnatam bhavatiti*. Paravidya is the higher

knowledge, which is supreme rational knowledge. It does not negate rationality, it transcends rationality. The mind is a brilliant and multi faced instrument for rational thinking. However it is limited by its very structure. There are ranges of knowledge and experiences which do not come within the ambit of so called rational thinking. At some point our consciousness, the mind has to be transcended, to attain the higher knowledge, this supra rational realization which comes not by intellectual gymnastics but by spiritual realization.

According to Indian traditional theory, education must know how to liberate the individual consciousness from various kinds of bondage and tyranny to enable him to develop an integrated personality and live in harmony with nature. Our ancient and modern seers and thinkers have had a clear perception of a valid theory and rationale for an educational system. Swami Vivekananda, Sri Aurobindo, Tagore and Gandhiji have presented the framework of an integrated system of education based on the firm foundation of a deeper law of universal brotherhood.

Hence the new system of education will have to be open ended, multi leveled, and multi faceted, experimental and innovative. Therefore our education should cut a cross the artificial barriers which divide humanity into races, religions and castes. In fact, the new educational system should strive to create a climate of opinion in favour of oneness, that support and sustains the sacred spirit of 'Vasudhavkutumb' taken i.e., the entire world is one family.

Describing Vivekananda's contribution to education Gore noted that Vivekananda examined education very critically and gave ancient knowledge a new interpretation, more

related to what the modern mind needed" (Gore 271). According to Lakshmi kumari through the definition of education as "manifestation of the perfection already in man', Swami Vivekananda has conveyed all that is to be conveyed about the Indian ideal of education. In her opinion this perfection is to be understood as the spark of the infinite power which resides in everything. True education should therefore, teach one how to achieve this goal of life through training, pursuit of knowledge and above all through relentless self – effort. If the cardinal theme is understood, any type of knowledge, be it art, architecture, music, medicine, sciences to or literature it will bloom in a unique way to the pinnacle of perfection and realization" (Lekshmi kumari 81).

Vivekananda advocated the method of Yoga, the science of science and the art of art of the upanishadic knowledge system to be emulated in the modern education. Yoga is defined as chitta- vrithi nirodha. The system of education in ancient India is a reflection of the material and spiritual values of the people of that time. These values of Indians of Vedic period are enshrined in their ancient literature. The system of education aimed at leading the individual from darkness of ignorance to the light of knowledge, 'asatoma sadgamaya – thamasoma jyothir gamaya'. It was believed that each individual is unique and it is futile to expect every individual to be developed into the same type. In Gurukula life students were inspired to utilize their moral and spiritual powers for the development of their racial culture. A learned man was respected more than the kings. The king was respected only within his kingdom, while a learned man was respected everywhere.

Ancient Indian education aimed at the all round development of the student. Each student must be given chance to develop his innate qualities. Education should enable a

person to develop a strong moral character, spirit of service, love of knowledge, ability to live in harmony with all and ability to seek higher spiritual goals. In this student centered education the quality of the child decided the type of education to be given to him. The Guru began to impart instruction only after determining his level of understanding, his ability to understand and his aptitude.

The aim of education was lofty. It aimed at providing full opportunity for the development of human traits to enable the student to get full opportunity to develop themselves. Education was not merely a means for successful worldly life limiting to certain stage of life, but a means to embrace the entire course of life consisting the four successive ashrams Brahmacharya, Garhastyam, Vanaprastha and Sanyasam that ultimately lead to self realization. Upanishadic education aims at the holistic development of an individual for a successful career in the material worldly life, but also a means to reach the ultimate goal of human life, the realization of the knowledge of the Absolute Truth, the Brahman.

Socrates, Plato and Aristotle the famous Greek trio, laid stress on the ethical, social and intellectual aims in education and gave much importance to knowledge. Indian education is life long and so systematized that it begins at home under the direct guidance and supervision of mother and father, followed by the acharya. The problem is whether education should subserve social needs or merely conducive to individual development. According to them reconciliation between the rival aims are not only possible but essential.

In modern times particularly in our country, the problems in terms of educational systems prevalent in the educational institution of India are spreading day by day due to

state's control over educational process. There is lack of freedom of inquiry. Educational institutions are the places where the business is to make one a successful man. Hence there should not be any outer imposition or administrative control over the free environment of these institutions. In ancient time education was not state controlled. A Guru was respected more than a king in ancient society. If there is no fair consensus amongst educational planners and policy makers, the knowledge currently imparted in educational institutions, is neither effective nor efficiently organized to fulfill the needs of the present or those foreseeable future. The modern value system is structured on the premise that man has only mental and physical needs. He aspires to live within the limits of his circumscribed individuality. The present system of education has encouraged an increasingly sensate, manipulative or valueless culture. It is the process of learning to live in the natural setting i.e., education for life and through life.

The Indian education system was more students centric and the teaching - learning process was based on three processes in sequence sravana, manana and nidhidyasana. Knowledge is sruti, what is known to the teacher, and is heard from the teacher. The knowledge transmitted is taken into the mind (sravana) and chirned (manana) and assimilated (nidhidyasana) into the consciousness for realization. Vivekananda elaborated the process in a simple way. ie, first you have to hear, then think and then practice. Vivekananda says "You have first to hear about it and understand what it is by constant hearing and thinking. It is hard to understand everything at once. The explanation of everything is after all in you. No one has really taught by another, each one of us has to teach himself. The external teacher offers only the suggestion which rouses the internal teacher to understand things. The things will be made

clear to us by our own power of perception and thought and we shall realize them in our own souls and that realization will grow into the intense power of will" (*Complete works*, Vol.1.93). The traditional Indian concept of the nature of education differs clearly from the Western idea of it. Most Western educationalists believe that knowledge is born out of man's interaction with his environment, but according to Indian philosophers knowledge is inherent in man, something inside him, not born out of the external environment. True knowledge does not come to the individual from outside. It is instead discovered within the individual because man's soul within him is the source of all true knowledge. Vivekananda who belonged to the Indian tradition said that 'All knowledge that the world has ever received come from the mind, 'the infinite library of the Universe is in your mind'. The external world is only the suggestion, the occasion which sets you study your mind. Education according to him has the function of discovering or uncovering the knowledge that is hidden in our mind.

The teacher's function in uncovering knowledge is to provide guidance. Vivekananda's ideas on education are supported by modern western educationalists. Today education is defined as the process of the child's comprehensive development. It is only too readily apparent that this can only take place from within the child itself and that external environment can do no more than provide the occasion. Modern psychologists agree that in every individual there are certain dormant powers which are inborn. Education manifests and develops these powers. Vivekananda was a strong supporter of freedom in education; he believed that it was first a prerequisite of development.

Vivekananda and Tagore in several occasions asserted that the two objectives of education were 'fearlessness and freedom' which has its seeds in the Upanisads. The true

nature of man is 'Pure Awareness Absolute' – the infinite, eternal existence (sat-chit-ananda). So long as one lives in the individual self, the world appears to be small and limited. He is thus subjected to fear of death. When he knows the truth and can say with conviction, 'I am in everything, in everybody, I am in all lives, I am the universe', Aham Brahmasmi, then alone comes the state of fearlessness. In other words, real fearlessness is the outcome of an exalted state of attainment where you know that you are the 'Pure Being', you are everything and everything is in you only. This is very explicit when Vivekananda says that man is potentially divine. Perfection is already in man and the role of education is to bring out this perfection that is already in man. Same is the meaning when Tagore says that education is bringing the best out of man. Mere acquisition of external knowledge is like polishing up the outside when the inside is a mere hollow. 'The ideal of all education, all training should be man making. It is man-making religion that we want. It is man-making theories that we want. It is man-making education all round that we want. Real education is that which enables one to stand on his own legs'. In his opinion the chief aim of education is to build character. He opined that man is made by his ideas, because character formation depends upon the nature of ideas possessed by the individual. Every idea that comes to the mind of man is one more step forward in his mental and physical development. Thoughts have very great power and all kinds of thoughts, good and bad influence not only the mind but also the body. Therefore the aim of education should be man making.

Vivekananda did not conclude his educational philosophy only by talking of the aims of education. He has also expressed his views on the methods of education. There are no two opinions that the educator's task is to help the educand in manifesting and expressing abilities

and spiritual elements possessed by the educand. All modern educationalists agree with him on this point. Vivekananda also agrees with modern educationalists that the educand learns everything through his own actions. Education helps the individual to recognise his own cultural heritage and explores it in his struggle for life. The educational philosophy of Vivekananda and Tagore had the unique thread of ancient Indian philosophy and is in continuation with the great seers of antiquity. In addition to this their in depth knowledge, and western philosophy and exposition to western education process have strengthened their perception and advocated incorporating the modern scientific knowledge into the educational system.

The path of education is no bed of roses. Every educand faces his own set of problems which are unique to him. The skilled educator guides the educand around those obstacles and pushes the educand forward. But the educator can successfully solve these difficulties only if he has adequate knowledge of human psychology.

Vivekananda has placed great emphasis upon focusing attention, because, in his opinion, concentration is the only key to open the treasure house of knowledge. The literary figures and scientists have to concentrate and contemplate deeply on their subject to unravel the mystery and to realize the truth. The truth of the matter is that greater concentration always helps in working more. But in life one finds that people differ from each other to a very great extent in their receptive ability to concentrate. Education is not to be measured by the number of books that the individual reads, but the extent he can concentrate undeterred by any of the extraneous thoughts to take or mind stuffs once he has taken up the task. Swamiji goes on to emphasize the glory of the power of concentration. For him, the very essence of

education is concentration of mind. 'The more the power of concentration, the greater the knowledge that is acquired'. According to Swami Vivekananda "concentration is the essence of all knowledge, nothing can be done without it. Ninety percent of the thought force is wasted by the ordinary human being and therefore he is committing blunders; the trained man or mind never makes a mistake. When the mind is concentrated and turned back on itself, all within us will be our servants, not our masters" (*Complete works* Vol. VI. 123-124).

Vivekananda's attitude towards the educational method is a synthesising one. He feels that the curriculum must be able to achieve the development of every aspect of the child's personality. On the one had he has stressed the importance of a scientific education while on the other he has pointed out that the teaching of Vedanta is no less important. He was fond of saying that what is really needed in Indian education is a harmony between Western Science and Indian Vedanta. Tagore regretted that our children mostly lacked that curiosity and freshness of the mind which prove to be the best incentive for acquiring knowledge. He also pointed out the great significance of scientific knowledge. The universe has a mechanical aspect where its laws are inexorable. Tagore also warned us against the fatal danger of a system of education which lay excessive stress on scientific knowledge alone to the exclusion of the humanities and things of deeper spiritual significance. To him, an ideal intellectual education would be the synthesis of the scientific and spiritual outlook.

Vivekananda believes that art is an indispensible part of life and therefore an education in science must have supplemented by the teaching or training in arts. He was in favour of replacing the ideal of utility by an ideal of beauty. Vivekananda's synthesising approach is evident from the stress he placed on physical education, a point on which there is general

agreement among all Indian educational philosophers. Vivekananda felt that both self realization and character building are impossible in the absence of physical development and education. He felt that it is necessary to develop both the mind and the body. He glorified power and has opposed weakness in any form. To him power is life and weakness is death. For this reason he said it is more important for the young men to play football than to study the Gita. The emphasis placed on the religious and spiritual elements in education is part of Indian educational philosophical tradition. Vivekananda himself was a saint and a philosopher unparalled in India and abroad.

According to Vivekananda "we have had negative education all along for our boyhood. Nothing positive has been taught to us. We do not know how to use our hands and feet! we master all the facts and be gives concentrating the ancestors of the English, but we are sadly unmindful about our own. We are brought out selfs to believe that we are weak and have no independence in anything. So how can it be but that the shraddha (confidence) is lost . The idea of true Shradda must be brought back once more to us, the faith in our own selves must be reawakened and then only all the problems which face our country will gradually be solved by ourselves (*Complete Works* , Vol. 1. 124 - 25).

Vivekananda was very severely critical of the pattern of education introduced by the British in India, because he felt that it did not conform to our own culture. He pointed out that, under the current pattern of education, all that was occurring was an external change, without any profound inner force being created which may give to the people an inspiration and a means of earning money. Vivekananda's chief objection to this pattern of education was that it turned men into slaves, capable only of slavery and nothing else. Speaking about the

system of education prevailing in the Universities, Vivekananda pointed out that it was no better than an efficient machine for rapidly turning out clerks. The modern higher education system was started in India in 1987 with establishment of the three universities in Madras, Bombay and Calcutta. He ask "take your universities what they have done fifty years of their existence? They have not produced one original man" (*Complete works*, Vol. V, 224). The powers of acquiring ideas by the students through independent efforts insisted upon Tagore also. He wanted that power of thinking and power of imagination are not only for the adult but, ever since childhood, instead of putting all the burden on the memory, the power of thinking and the power of imagination should also be given opportunities for free exercise. True education must aim at making the pupil familiar with and adjusted to the facts and conditions of real life and habitual environments. In the first place if it is not a man making education, it is negative action which is lifeless and incapable of producing original man.

With the help of education, Vivekananda explains man to lead a successful and fruitful life manifesting all his innate potentials to attain spiritual realization free from all bonds. This education is to make a man on embodiment of manliness, piety, wisdom and finally to realize his divine heritage to become God himself. Through education the intelligent man becomes conscious man and the conscious man becomes super conscious man.

Vivekananda's philosophy can be elaborated from his two basic concepts, the first one, and 'man is potentially divine'. The divine means 'perfection' which is clear from his second concept that the life mission of man is the manifestation of this perfection (divinity) already in man. He advocated that yogis of India accomplished this mission of realization of the perfection or the union with the absolute through four yogas, jnana, bhakti, dhyana (raja

yoga) and karma. Vivekananda is developed raja yoga or dhyana profounded by pathanjali. In the form of curriculum, to seek the truth by means of well-defined process and procedure in eight steps. In the final state is the realization state that is the 'samadhi' where the difference between the knower and known dissiminate completely. Thus education is an evolutionary process whereby the individual evolves from dependence to independence, from reliance to self- reliances. The greatest contribution of Vivekananda to modern education is his familiarizing in raja yoga as a system with theoretical background and practical procedure with scientific precision. Recently yoga has been accepted all over the world as an integral system of education for the development of body, mind and soul. The U N has declared June 21 as International Yoga Day to popularize the teachings of yoga.

The most fundamental aim of education was, the ability to use what we learn. Tagore pleaded, our education, from the lowest to the highest stage, had merely led us to amass disjointed scraps of metals which had always remained useless and painful burden with us 'We pass from childhood, carrying a load of a number of mere words and phrases. Again, we are amassing knowledge as we amass food stuffs in 'store room not as the body assimilates its food'. Vivekananda also points out the futility of learning without understanding the essence of what we learn. Education is not the amount of information that is put into your brain and run riot their, undigested, all our life.

A living education should be rooted in the native soil and based on the genius and traditions of the land in respect of its aims, contents, methods and organization. Vivekananda and Tagore suggested that the medium of instruction, at least for early education, should be in mother tongue. "Everyman is capable of receiving knowledge if it is imparted in his own

language" (*Complete works* Vol. 5 263). Education in India, as introduced by the British ruler, was on the contrary largely an imitation of the west. Even the schools that were established in the wake of the National Education Movement failed, in their opinion to achieve their ends, because they were based on foreign models. The worst feature of that education, according to Tagore, was that it created a gulf between our knowledge and our real life.

Education is truly related to life and it should consist of an effort to know the country one lives in, its geographical, historical, economic and cultural perspectives; its races and people, its language and literature, its manners, customs and traditions; its natural assets and liabilities; its flora and fauna; its needs and problems its vicissitudes in the past and its potentiahties in the future. To serve the country, 'Well Tagore often said, 'one must know it well, and without such knowledge no education can claim to be related to the life of the learner'.

Tagore wanted students to learn from the direct sources, from life and society itself. Bookish knowledge, which is second hand, lacks the freshness and vitality of life. Dependence on book also destroys the initiative, alertness and originality of the mind. According to Tagore, knowledge should be derived, as far as possible directly from nature and life. He exhorted the youth of the country to collect, facts about the cultural and economic life of the people from direct sources in an independent and scientific manner. He also recommended frequent excursions and tours during which the pupil, with their senses alert, might observe and learn numerous facts of interests. His ideas of peripatetic education i.e.; learning, while walking, whatever meets the eye and excites interest, also bears on this point. Knowledge thus acquired, will be real, and the process of acquiring it will also be living. In

the ancient education of India the teacher trains the student to acquire knowledge from two sources, one external and the other internal. External the nature and the society, internal is discovering the self, unraveling the inherent potential. ie; in the words of Vivekananda, the manifestation perfection in man, and in the words of Tagore,' bring the best out of man'.

The origin of Tagore's educational theory was his own home life. To him, school was an educational prison. Therefore he sought a form of learning that would be linked organically to the whole of life, the people, the land and its culture. Tagore had asserted that our education made no adequate preparation for Indian culture and gave no inspiration to the Indian mind. He wanted that education must be a process of creative joy. For the development of his sociopolitical thought, he advocated the principle of self-determination in the education of masses.

Tagore's theory is distinctive; he sought a synthesis of East and West in both ideals and methods. His theory is marked by a synthetic, naturalistic, aesthetic and international character. The highest mission of education, he wrote, is to help us realize the inner principle of unity of all knowledge and all the activities of our social and spiritual being. Thus according to Tagore, 'True education is the realization of an inner quality of man, a realization that places human life in harmony with all existence'. He also saw education as the harmonization of the various elements of man's being. If the harmony and unity of the whole man is lost, his inner dharma is destroyed. Tagore also sought an education that was in touch with the whole of life economic, intellectual, social and spiritual.

Tagore had a deep passion for Nature. According to him, Nature in its purity is nearer to God than man whose birth on earth means a fall from the heaven. There is, therefore in the

heart of every child a yearning for the lost paradise to which nature functions as the gateway. For, the fact remains, nature offers to a child a joyous world of personal love, which largely misses after he has been weaned away from the mother breast.

The ideal of education is inner freedom, an inner power and enlightenment of the individual. It was a kind of liberation of the self from all kinds of slavery. It is a kind of emancipation of the intellect from the bookish knowledge. Tagore was against all forms of blind, thoughtless imitation of the western ideals and models in our life and education. Tagore also stood for preparation for complete living. According to him, knowledge includes all training that is useful for service of mankind, and liberation means freedom from all manners of servitude. Tagore was conscious about the significance of sociability and fellow-feeling as an indispensable equipment of an educated person, but he did not like the artificial and unreal system of our education, which was responsible to put a barrier between society and educated people. He also stood for the bond of love and friendship between man and man.

Tagore divides knowledge in to two departments: one is pure knowledge and the other is utilitarian knowledge. Whatever is worth knowing is knowledge. It should be known equally by men and women, not for practical utility but for the sake of knowing. The desire to know is the law of human nature. He believed vocational education is necessary, but this end is only partial and limited in scope and thus must be supplemented by other higher aims.

In tune with the ancient thought Tagore did not lay a one sided emphasis upon either the individualistic or the socialistic aim. He sought to bring about a synthesis of the two by emphasizing both, placing each in the proper perspective against the other. Man has two

aspects, on the one hand, he is isolated and independent, on the other, he is related to all. To ignore any one of these aspects will be unreal.

According to Tagore, the education of the body is the most important factor in the education of an individual. He attached so much importance to the healthy physical development of children in early years that he eloquently advocated their free spontaneous movements and play in joyous natural surroundings. He said, "Even if they learnt nothing they would have ample time for play, climbing trees, diving into ponds, plucking and tearing flowers, perpetuating thousand and one mischiefs on Mother Nature, they would have obtained the nourishment of the body, happiness of mind and the satisfaction of the natural impulses of childhood. Education of the body in the real sense does not consist in play and exercise but in applying the body systematically to some useful work" (Bourai 117). Vivekananda also advocated a mode of education that endorsed an integrated development of the human personality that takes into the consideration the physical, moral, intellectual and spiritual development of the student. Physical development comprising of right kind of diet and a variety of physical exercise that would infuse a sense one's bodily abilities strength and capacities.

To Tagore like Swami Vivekananda the western brand of nationalism is narrower in the conception than the Indian outlook, which believed in the kinship of all mankind. The Indian festivals or religious rituals always kept the entire humanity the entire universe, in view. Indian history, he observed is the history of human chemistry of assimilation of diverse foreign elements. It is not the history of India alone, it is the history of all the races and nations that have come to India and have in course of time blended their identity with the

mainstream of Indian life and culture. Buddha, have preached the message of peace and love as the supreme binding factors among all living creatures and the fact that India has forgotten her kings but has remembered her saints, testifies to the values she has attached to these ideals.

Tagore supported a internationalistic characteristic of education since the old geographical barriers are losing their reality because of modern facility of communication the great federation of men had come closer to one another. He wrote the problems before us, is of one single country, which on this earth, where the races as individuals must find both their freedom of self expression and their bond of federation. He observed that "man is man, machine is machine. and never the twin shall meet" (122). India should share her wealth of the mind and the spirit with the western nations who are badly in need of the same. It is through this precious gift, India would win a place of respect in the comity of nations. The Upanishadic message of brotherhood of all men and Buddha's message of peace and love were needed by the west, Vivekananda while preached the principle of education Tagore experimented his thoughts on education in the real life situations.

Tagore said our curriculum was hopelessly circumscribed by the narrow mechinary and utilitarian aims. It was an examination ridden and the goal was the job alone. There was neither incentive nor the necessity for any serious course of study of a comprehensive nature. To him curriculum was not in terms of certain subjects to be learnt, but in terms of certain activities to be undertaken. Practical activities like drama. excursion. gardening. regional study. laboratory work. drawings, collection for museum, herbarium with co-curriculum activities. games. social service etc. were put into practice. He advocated 'free and

independent reading' of books. He also desired rapid reading in both English and Sanskrit; twenty or thirty books should have been finished by the time a child leave the school. Tagore said that "an educational institution must be economically as well as intellectually productive. There should be a truly realistic curriculum also. It meant knowledge of the country, its people, its needs and conditions, its geography and history, its culture heritage and its problem of future" (123). The total conception of the curriculum should be truly internationalistic in scope.

In the process of education the fundamental aspect should be full of life. Learning can become sound only when its proceeds from the near to the distant, from the familiar to the unfamiliar. Tagore expressed that one should acquire knowledge through independent efforts and thinking as opposed to the method of spoon feeding and thoughtless cramming. The student must be led to think, question and answering has to be conducted, they should think that their education has been real if they venture to criticize the matter contained in the text books. Different problems of everyday life should be presented before them and discussion should be conducted on their solution. Pupil should adopt the role of a discoverer with his power of self confidence. Training in some manner craft should be compulsory for the students of his school. Gandhiji's 'Basic Education' is an adoption of Tagore's idea of vocational education.

Tagore postulated his theory of value of joy in life. 'All creatures born of joy'. Tagore also advocates the principle of curiosity and interest. To very alert mind curiosity is a sign of vitality, a sign of youth. Knowledge is an index of decadent vitality of youth. Tagore regards

punishment as that one voluntarily inflicts on oneself as a sincere gesture of retribution for one's mistake or guilt is the only real form of punishment.

Good education is not possible unless good ideals are transmitted to the society. The atmosphere and activities of the educational institutions should reflect the cultural heritage of nation and also the changing thoughts of its people in relation to the changing conditions and need of the time. Education should be value added, value oriented and relavant to the needs of the society. Tagore opined that to provide egalitarian education in a country like India the cost of education is affordable. English system of education in India was too expensive for the people due to undesirable emphasis on materials and paraphernalia run by heavy administrative machinery. He complained more money was spent on the maintenance of external pomp and grandeur than on the actual educational purpose. Education should nurture feeling of identity and kinship with fellow beings through concrete acts of hospitality and social service without which it ought to be incomplete. To him education helps one to develop life skill and soft skill to solve the numerous practical problems of everyday life, and also enable the student to develop in himself social qualities like friendliness, good manners, co-cooperativeness, tolerance, service, renunciation and large heartedness which make him a good citizen and a valued member of the society. Tagore desired that educational institutions should not be uprooted from their precious past heritage and also should reflect the cherished ideals of a living community. Keeping all these views, Tagore captured by the idea that Santiniketan would be a conference of Eastern and Western thoughts. In his Gitanjali we find,

> " The west has flung it door open.
>
> Present times are pouring from all corners.
>
> All will give and take
>
> Nobody will return with empty hands.
>
> In the sea shore of the great humanity". (Tagore, Gitanjali 119)

A careful study of the views of these two great genius on education and shows that their mind and imagination are greatly influenced by the classic ideals of ancient India and ideals of western science and technology. Some striking similarities are the following.

* The school must allow the children to grow up in natural environment that provided in ancient gurukulas helping to achieve the essential harmony and oneness naturally and spontaneously.
* Both of them adopt that the aim of education is to make all round men. Children must grow in a fearless and free environment. Nourishment, discipline and training of the body, mind and intelligence respectively are necessary to concentrate and contemplate to achieve higher consciousness.
* Both of them agree that education should develop national integration and international understanding. To them education should aim at the unity of mankind and the universal brotherhood.
* Both Tagore and Swamiji tried to combine traditional Indian culture with western ideas.

* Both of them were ardent exponent of freedom and fearlessness. It is only through the fullest development of all this capabilities that a man is likely to achieve his real freedom.
* Vivekananda and Tagore stood for education of the mass, education of women and social education.
* They also gave stress to health education and national integration in any program of education.

Our ancient literature reveals that women in India enjoyed equal right with men in educational, social and political fields. Vivekananda and Tagore realized that mankind is passing through a crisis. The scientific and mechanical way of life is fast and reduces the status of a man as a machine. Disregard for everything old is the fashion of the day; moral and religious values are being undermined. The principles of civilization are being ignored; conflicts of ideals, manners and habits are pervading the atmosphere.

Education today has been reduced to nothing but a systematic training for competition rather than cooperation, cramming of factual data rather than experimental learning. The teaching, learning and evaluation have become mechanical and periodical pumping in and pumping out of information rather than inculcation of a genuine spirit of inquiry. Towards a right kind of education critical reasoning, creative self, expression and active communication with nature and man are necessary.

The present system of education has no grasp of the future. and has no understanding of the skills the student required to face the challenges of the future confidently and

successfully. The student is looking backward instead of forward. We must create a stronger future consciousness. What is needed now is a concentrated focus on the social and personal implication of the future. Our present system of education needs modification. The educational ideals put forwarded by Vivekananda and Tagore would help educationist and educational planners to develop a new system of education based on a new understanding of the meaning and purpose of education and a new concept of learning and teaching, which inspires, supports and promotes self empowerment, creativity and self actualization. The purpose of education should be to enable students to develop their inner resources, become inwardly free to respond to different situations, create something new and contribute more to society than take from it.

The principle of education preached by Vivekananda and Tagore demand a change from miss - education to re-education, a lifelong education, a broad based futuristic education to transform the grim today to a grand tomorrow. The exposition and scheme of education advocated by Vivekananda and Tagore brings to light its constructive, practical and comprehensive character of the student. The sense of dignity is created only when the students become conscious of his own inner spirit and that is the purpose of education. For that, strive to harmonize the traditional values of Indian with the new values brought through the progress of science and technology. Both of them envisaged emphasized scheme of education that emphasis the intellectual, physical, social, moral, economic and spiritual aspects of human life. Through these aspects one can develop an integrated personality. Integral education means conversion of a student's which life into Yoga. The purpose of this yoga is to bring out or manifest all potentialities inherent in the human soul and transform the students into a fully

developed human individual. The entire universe is one family. Education can teach people to realize oneness of the globe. Education stands for international understanding and universal brotherhood. Freedom is considered as an integral aspect of human development. Education is a man-making process and it explores the innate power exists within the men.

Serious drawback of the present system of education imparted in India is the lack of understanding of the true purpose of education and its relation to one's own life. Majority of the students in India pursue education with the sole aim of passing examination as a means of getting good job. These careerist attitudes toward education should change in the emerging new social order known as 'knowledge society'. Self-empowerment has come to be regarded as the aim and purpose of education. The problem with current education is that it lacks a missing fundamental intellectual understanding and experience of pure consciousness. Both s of them seek the solution for all the social and global evils through education and feel that the divine need of awakening man to his spiritual self is the very purpose of education. In the scheme of education, Vivekananda and Tagore lay great stress on physical health because a sound mind resides in a sound body. Quotes the Upanisadic dictum *'nayamatma balahimena labhyah'*: i.e. the self cannot be realized by the physically weak. Both realized the immense potentialities of mind. All success will be the result in the control of mind. Vivekananda went to the extent of defining education as concentration. Both of them gave serious thought on early education of the children. They lay emphasis on the environment at home and school for proper growth of the child. The parents as well as the teachers should inspire the child by the way they live their lives. Both recommend the old institution of Gurukula and similar systems were the student can have ideal character of the teacher or the menter constantly before him,

which serves as the role model to follow. Their education meticulously includes all that which are necessary for the all round development of the body, mind and soul of the student. Education according to them is not merely a means of earning for livelihood nor is it a nursery for grooming citizens. It is an initiation into this life or spirit, a training of human soul in pursuit of truth and practice of virtue.

CPSIA information can be obtained
at www.ICGtesting.com
Printed in the USA
BVHW070120140123
656264BV00010B/1198